1919

BAUHAUS

1928

CONTENTS

* As explained on page 147 this and following sections of the
book are printed without capital letters in accordance with
Bauhaus typographical practice introduced in 1925.

Copyright © 1938 by The Museum of Modern Art　All rights reserved
First paperbound edition 1975, reprinted 1979
Library of Congress Catalog Card Number 75-15063　　ISBN 0-87070-240-8
The Museum of Modern Art
11 West 53 Street
New York, N.Y. 10019
Typography and cover design by Herbert Bayer
Printed in the United States of America by The Murray Printing Company

edited by {
HERBERT BAYER
WALTER GROPIUS
ISE GROPIUS
}

The Museum of Modern Art, New York
Distributed by New York Graphic Society, Boston

PREFACE

It is twenty years since Gropius arrived in Weimar to found the Bauhaus; ten years since he left the transplanted and greatly enlarged institution at Dessau to return to private practice; five years since the Bauhaus was forced to close its doors after a brief rear-guard stand in Berlin.

Are this book, then, and the exhibition which supplements it, merely a belated wreath laid upon the tomb of brave events, important in their day but now of primarily historical interest? Emphatically, no! The Bauhaus is not dead; it lives and grows through the men who made it, both teachers and students, through their designs, their books, their methods, their principles, their philosophies of art and education.

It is hard to recall when and how we in America first began to hear of the Bauhaus. In the years just after the War we thought of German art in terms of Expressionism, of Mendelsohn's streamlined Einstein tower, Toller's *Masse Mensch*, Wiene's *Cabinet of Dr. Caligari*. It may not have been until after the great Bauhaus exhibition of 1923 that reports reached America of a new kind of art school in Germany where famous expressionist painters such as Kandinsky were combining forces with craftsmen and industrial designers under the general direction of the architect, Gropius. A little later we began to see some of the Bauhaus books, notably Schlemmer's amazing volume on the theatre and Moholy-Nagy's *Malerei, Photographie, Film*.

Some of the younger of us had just left colleges where courses in modern art began with Rubens and ended with a few superficial and often hostile remarks about van Gogh and Matisse; where the last word in imitation Gothic dormitories had windows with one carefully cracked pane to each picturesque casement. Others of us, in architectural schools, were beginning our courses with gigantic renderings of

Doric capitals, or ending them with elaborate projects for colonial gymnasiums and Romanesque skyscrapers. The more radical American architects and designers in 1925, ignoring Frank Lloyd Wright, turned their eyes toward the eclectic "good taste" of Swedish "modern" and the trivial bad taste of Paris "modernistic." It is shocking to recall that only one year later the great new Bauhaus building at Dessau was completed.

It is no wonder then that young Americans began to turn their eyes toward the Bauhaus as the one school in the world where modern problems of design were approached realistically in a modern atmosphere. A few American pilgrims had visited Dessau before Gropius left in 1928; in the five years thereafter many went to stay as students. During this time Bauhaus material, typography, paintings, prints, theatre art, architecture, industrial objects, had been included in American exhibitions though nowhere so importantly as in the Paris *Salon des Artistes Décorateurs of 1930*. There the whole German section was arranged under the direction of Gropius. Consistent in program, brilliant in installation, it stood like an island of integrity, in a mélange of chaotic modernistic caprice, demonstrating (what was not generally recognized at that time) that German industrial design, thanks largely to the Bauhaus, was years ahead of the rest of the world.

And the rest of the world began to accept the Bauhaus. In America Bauhaus lighting fixtures and tubular steel chairs were imported or the designs pirated. American Bauhaus students began to return; and they were followed, after the revolution of 1933, by Bauhaus and ex-Bauhaus masters who suffered from the new government's illusion that modern furniture, flat-roofed architecture and abstract painting were degenerate or bolshevistic. In this way, with the help of the fatherland, Bauhaus designs, Bau-

haus men, Bauhaus ideas, which taken together form one of the chief cultural contributions of modern Germany, have been spread throughout the world.

This is history. But, one may ask, what have we in America today to learn from the Bauhaus? Times change and ideas of what constitutes modern art or architecture or education shift with bewildering rapidity. Many Bauhaus designs which were once five years ahead of their time seem now, ten years afterward, to have taken on the character of period pieces. And some of its ideas are no longer so useful as they once were. But this inevitable process of obsolescence was even more active in the Bauhaus while it still existed as an institution for, as Gropius has often insisted, the idea of a Bauhaus style or a Bauhaus dogma as something fixed and permanent was at all times merely the inaccurate conclusion of superficial observers.

Looking back we can appreciate more fully than ever certain magnificent achievements of the Bauhaus which are so obvious that they might be overlooked. It is only eight years since the 1920's came to an end yet I think we can now say without exaggeration that the Bauhaus building at Dessau was architecturally the most important structure of its decade. And we can ask if in modern times there have ever been so many men of distinguished talent on the faculty of any other art school or academy. And though the building is now adorned with a gabled roof and the brilliant teaching force has been dispersed there are certain methods and ideas developed by the Bauhaus which we may still ponder. There are, for instance, the Bauhaus principles:

that most students should face the fact that their future should be involved primarily with industry and mass production rather than with individual craftsmanship;

that teachers in schools of design should be men who are in advance of their profession rather than safely and academically in the rearguard;

that the school of design should, as the Bauhaus did, bring together the various arts of painting, architecture, theatre, photography, weaving, typography, etc., into a modern synthesis which disregards conventional distinctions between the "fine" and "applied" arts;

that it is harder to design a first rate chair than to paint a second rate painting—and much more useful;

that a school of design should have on its faculty the purely creative and disinterested artist such as the easel painter as a spiritual counterpoint to the practical technician in order that they may work and teach side by side for the benefit of the student;

that thorough manual experience of materials is essential to the student of design—experience at first confined to free experiment and then extended to practical shop work;

that the study of rational design in terms of technics and materials should be only the first step in the development of a new and modern sense of beauty;

and, lastly, that because we live in the 20th century, the student architect or designer should be offered no refuge in the past but should be equipped for the modern world in its various aspects, artistic, technical, social, economic, spiritual, so that he may function in society not as a decorator but as a vital participant.

This book on the Bauhaus is published in conjunction with the Museum's exhibition, *Bauhaus 1919–28*. Like the exhibition it is for the most part limited to the first nine years of the institution, the period during which Gropius was director. For reasons beyond the control of any of the individuals involved, the last five years of the Bauhaus could not be represented. During these five years much excellent work was done and the international reputation of the Bauhaus increased rapidly, but, fortunately for the purposes of this book, the fundamental character of the Bauhaus had already been established under Gropius' leadership.

This book is primarily a collection of evidence —photographs, articles and notes done on the

field of action, and assembled here with a minimum of retrospective revision. It is divided into two parts: Weimar, 1919–1925, and Dessau, 1925–1928. These divisions indicate more than a change of location and external circumstances, for although the expressionist and, later, formalistic experiments at Weimar were varied and exciting it may be said that the Bauhaus really found itself only after the move to Dessau. This book is not complete, even within its field, for some material could not be brought out of Germany. At some time a definitive work on the Bauhaus should be written, a well-ordered, complete and carefully documented history prepared by a dispassionate authority, but time and other circumstances make this impossible at present. Nevertheless this book, prepared by Herbert Bayer under the general editorship of Professor Gropius and with the generous collaboration of a dozen Bauhaus teachers, is by far the most complete and authoritative account of the Bauhaus so far attempted.

The exhibition has been organized and installed by Herbert Bayer with the assistance of the Museum's Department of Architecture and Industrial Art.

The Museum of Modern Art wishes to thank especially Herbert Bayer for his difficult, extensive and painstaking work in assembling and installing the exhibition and laying out this book; Professor Walter Gropius, of the Graduate School of Design, Harvard University, for his supervision of the book and exhibition; Mrs. Ise Gropius for her assistance in editing the book; Alexander Schawinsky, formerly of the Bauhaus, and Josef Albers, Professor of Art at Black Mountain College and formerly of the Bauhaus, for their help in preparing the exhibition.

Also Miss Sara Babbitt, Mrs. John W. Lincoln, Mr. Paul Grotz, Mr. Philip Johnson and Mr. Brinton Sherwood, who, as volunteers, have assisted Mr. Bayer and the Museum staff; also those who have generously lent material to the exhibition and contributed photographs for reproduction in the book.

The Museum assumes full responsibility for having invited Professor Gropius, Mr. Bayer, and their colleagues to collaborate in the book and its accompanying exhibition. All the material included in the exhibition has been lent at the Museum's request, in some cases without the consent of the artist.

Alfred H. Barr, Jr., Director
1938

"Men and women of Weimar!
Our old and famous Art School is in danger!

All citizens of Weimar to whom the abodes of our art and culture are sacred, are requested to attend a public demonstration on Thursday, January 22, 1920, at 8 p.m.

The committees, elected by the citizens . . ."

THE BACKGROUND OF THE BAUHAUS by ALEXANDER DORNER

Director of the Art Museum of the Rhode Island School of Design
Formerly Director of the Landesmuseum, Hanover, Germany

It was with such alarms that the people of Weimar greeted the appearance of the Bauhaus in their midst. This reception was not to be blamed on the traditional "spirit of Weimar," a town living more in the past than in the present, —a "Goethe town," an "Athens-on-the-Ilm": anywhere in Germany it would have been much the same in the stormy cultural atmosphere following the catastrophe of 1918.

The Confusion of the Post-War Period

German opinion was divided into extreme factions. On one side were aligned all those who could not understand that the pre-war world was dead; on the other stood men and women determined to learn from the débâcle, and to find a new way of life.

The latter, even outside Germany, were drawn to the Bauhaus as to a magnet; but to those who clung to the past, the Bauhaus was like a red rag. It was remarkable with what unanimity post-war Germans found in every novelty a sign of some ideological program, and this fact in part explains the force of the attack launched against the Bauhaus.

As early as 1919 there was talk of "art-Bolshevism* which must be wiped out" and even then there were appeals to the "national German spirit" of artists who were to "rescue mature art." It was a feverish and tormented nation that drew such drastic distinctions between the old and new and made peaceful growth impossible. Yet this very tension and alertness may have contributed to the quick and clear-cut development of the Bauhaus.

First to protest against the Bauhaus were, of course, the adherents of the old art academies and of the bourgeoisie whom the academies

* It is interesting to note that the same phrase was used in an attack on the exhibition of Impressionist and Post-Impressionist Paintings at the Metropolitan Museum in New York in 1921.

supplied with art—an art carrying on the tradition of eclectic architecture, of monuments and portraits in the grand manner, the depiction of historical glory and decorative landscape—an art accepting almost any historical "style" or eclectic stylistic mélange.

Products of the French official tradition, the academies had originally been intended to train designers for the royal manufactures of porcelain, furniture, tapestries and other decorative material destined for the courts and upper classes. This "applied art" was carefully differentiated from "fine art," though equally dependent on the accepted styles of the past. The disappearance of court life and caste rule spelled the disappearance of the principal market of these state manufactures which, consequently, passed into private hands.

The "modern art" movements which were opposed to the academies all over Europe as well as in Germany presented a bewilderingly confused picture. In Germany there were Expressionism and Dadaism, both forms of unbridled individualism; in Italy, Futurism; in Holland, Russia and Hungary, different abstract and Constructivist movements; in France, Cubism, Purism and Dadaism. These revolutionary movements were often mutually hostile; they possessed no common program save that of opposition to the academies and the academic artist.

It is hard to think of anyone at that time who thought in any terms other than "art for art's sake," who saw beyond the purely personal and romantic experiments of artists trying to express their individual views. The tide of Romanticism was rising to a new height in this post-war period. Called Expressionism, it was still the same Romanticism which for a century had been vaunting individualism in its struggle against academic traditions. The purpose of that struggle had been to enrich art and extend its horizons. But, because it had taken place isolated from life and its practical demands, the creative geniuses of the 19th century and early 20th had to make their way in solitude. Nowhere were there any positive, clear suggestions for

achieving a new productive cooperation between art and life, until the handful of people who made up the German *Werkbund* at last perceived this goal and directed their efforts toward it, steering clear both of the late academicism and the late Romantic Expressionism of their contemporaries.

The Deutsche Werkbund

The *Werkbund* idea had been foreshadowed in the 1880's by William Morris in reaction against the artistic confusion of his day. He called for a return to the cultural integration of the great periods of the past, wherein art, morality, politics and religion all formed one living whole. To him, the ideal was the Gothic cathedral, in the creation of which all artists joined together in the role of craftsmen.

Morris, in some ways a retrogressive Romantic, would have nothing to do with machine production. He strove, rather, for a revival of medieval handicrafts. But, with the means of mass production developed in the industrial revolution, and with the new mass demand, his concentration on the obsolescent techniques of handicraft brought about one of the very things he was trying to prevent—the isolation of the individual artist-craftsman able to produce handmade objects only for a select few.

The progressive phases of Morris' ideas were carried further, toward the end of the century, on the Continent and in the United States. In contrast with England and its "arts and crafts" movement, the Continent and America began, somewhat theoretically, to glorify technology. In the '90's, the Belgian Henry van de Velde* proclaimed the engineer as the true architect of our times, and announced that the new materials developed by modern science, such as steel, reinforced concrete, aluminum, and linoleum, called for a new type of logical structure. (At the same time, however, he was preoccupied with *Art Nouveau* ornament.) By 1900,

* Gropius' predecessor at the Weimar Academy of Arts and Crafts.

Adolf Loos, a Viennese partly trained in the United States, dared to banish all ornament from his buildings. In America, a country of amazing technical proficiency, Louis Sullivan and then Frank Lloyd Wright were the first to insist that "form should follow function." Their work was a great inspiration to their European contemporaries.

In Germany, Hermann Muthesius sought a synthesis between the "machine style" and the Morris "arts and crafts" movement. He founded the *Deutsche Werkbund* in 1907 in an effort to effect real cooperation between the best artists and craftsmen on the one hand, and trade and industry on the other. At the first session of the *Werkbund* Theodor Fischer said, "Mass production and division of labor must be made to produce quality." Therewith the fallacy of Morris' "craftsman's culture" seemed to have been overcome. But no one had yet devised the means of absorbing, either practically or esthetically, the spirit of engineering into art.

The cultural coordination of art and economics, sought but not found by Morris, was not to be achieved even by the *Werkbund* movement. Architects and designers, as well as painters and sculptors, were for the most part still romantic individualists. Muthesius admitted: "We ourselves do not know where we are drifting."

Walter Gropius

It was the youngest of the *Werkbund* leaders, Walter Gropius, who, by founding the Bauhaus, began really to solve the problem.

It would have been unnatural for the young Gropius to have been entirely untouched by late Romantic influence. But, from the very beginning, he differed from his contemporaries in the driving earnestness with which he attacked the problem of reconciling art and an industrialized society.

As early as 1910 he and his master, the architect Behrens, had drafted a *Memorandum on the Industrial Prefabrication of Houses on a Unified Artistic Basis.* The idea of the prefabricated house was borrowed from the United

Henry van de Velde: Weimar Bauhaus building, 1905

Students' studio building, called Prellerhaus

11

States, but Gropius' insistence on solving the problem on a "unified artistic basis" was a new move toward the synthesis of technology and art. In 1911 he demonstrated this in his factory building at Alfeld, and again in 1914 in his office building at the *Werkbund* Exposition at Cologne (both in collaboration with Adolf Meyer). These buildings were the first to show clearly the elements of a new architectural style—free from traditional massiveness, exploiting the new lightness of modern building construction.

The Early Bauhaus at Weimar

Starting with architecture, Gropius extended his interests into the whole field of the arts. While still at the front, he was at work on a new project for art education, encouraged by the Grand Duke of Saxe-Weimar who had already discussed with him the possibility of his assuming the directorship of the Weimar Art Academy. Gropius wanted to combine the Academy with the Weimar Arts and Crafts School to create a "consulting art center for industry and the trades." By achieving this union in 1919 at the Bauhaus, he took a most important and decisive new step, for every student at the Bauhaus was trained by two teachers in each subject—by an artist and a master craftsman. This division of instruction was unavoidable at the beginning, for no teachers were to be found with sufficient mastery of both phases. To develop just such creative "ambidexterity" was the purpose of the Bauhaus.

Because of the character of the artists on the faculty, the first products of the new education quite naturally showed the influence of contemporary "modern" movements, particularly Cubism, evidenced by a somewhat formalistic and arbitrary attitude toward design. The press, quite understandably, sometimes confused the aims of the Bauhaus with the "isms" seen elsewhere, and debated the "entry of Expressionism into the Bauhaus." Today, considering what the Bauhaus eventually became, it is astonishing to realize that it ever had anything to do with Expressionism and Dadaism, but it must be

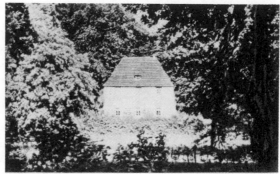

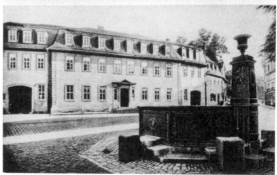

Goethe's garden house, near Weimar.

Goethe's house, Weimar

Weimar. Set in charming surroundings, a center of classic German culture. Residence of the poets Herder, Wieland, Goethe, Schiller, during the golden era of German poetry, and, later, of Liszt and Nietzsche. Here, after the revolution of November, 1918, the National Convention assembled and adopted the Constitution of the New German Republic.

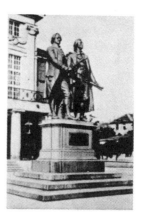

Goethe-Schiller monument, Weimar

remembered how very confused the world of art was when the Bauhaus began.

No one would have prophesied success for Gropius. In the world of art his ideas stood alone amid the chaos of uncoordinated forces. Creative instinct combined with his strength of character made his leadership unique. At the very start he stood firm against relentless opposition and the economic difficulties of the inflation period. With equal perseverance he struggled to develop the right program within the Bauhaus itself.

Fortunately, the first and difficult stage of development was over fairly quickly, and Gropius' idea soon achieved realization: modern artists, familiar with science and economics, began to unite creative imagination with a practical knowledge of craftsmanship, and thus to develop a new sense of functional design.

The Bauhaus at Dessau

In 1925 the Bauhaus was moved from hostile Weimar to hospitable Dessau. By this time, a new generation of teachers had been trained, each of whom was at once a creative artist, a craftsman and an industrial designer, and the dual system of instruction could be abandoned. New ideas began to flow forth in abundance, and from the Bauhaus of this period derive many familiar adjuncts of contemporary life— steel furniture, modern textiles, dishes, lamps, modern typography and layout. The spirit of functional design was carried even into the "fine arts" and applied to architecture, city and regional planning. But to speak of a cut and dried "Bauhaus style" would be to revert to the cultural paralysis of the 19th century with its "free styles." Its integral part, namely the functional foundation of design, was just as full of changing possibilities as our own "technical age." We believe that we have only glimpsed the great potentialities of this technical age, and that the Bauhaus idea has only begun to make its way.

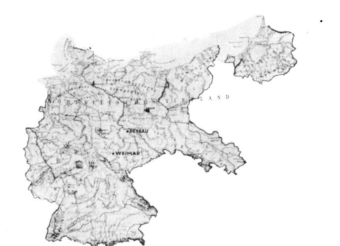

Map of Germany showing location of Weimar and Dessau

13

From a photograph of 1923

GROPIUS, Walter. Architect, writer. Born, Berlin, 1883

1903	Studied architecture, Munich
1905–1907	Studied architecture, Berlin
1907–1910	Assistant to Peter Behrens, Berlin
1910–1914	Private practice
1914–1918	Served in the German army
1918	Appointed Director of the Grossherzogliche Sächsische Kunstgewerbeschule and the Grossherzogliche Sächsische Hochschule für Bildende Kunst
1919	Union of the two schools under the name Bauhaus (Staatliches Bauhaus Weimar)
1925	The Bauhaus moves to Dessau with all teachers and students (Bauhaus Dessau, Hochschule für Gestaltung)
1928	Resignation from post as Director of the Bauhaus to resume private practice Member of the board of the Research Institute for Building Economy of the German Reich
1929	Appointed "Dr. ing. honoris causa," by University of Hanover
1934	Moved to London
1935	Went into partnership with Maxwell Fry, A.R.I.B.A.
1937	Appointed Senior Professor, Department of Architecture, Harvard University
1938	Appointed Chairman of the Department of Architecture, Harvard University
1951	Honorary Doctorate of Technical Science, Western Reserve University, Cleveland, Ohio
1952	Professor Emeritus, Harvard University
1953	Honorary Doctorate of Architecture, North Carolina State College Honorary Doctorate of Arts, Harvard University
1954	International Grand Prix of Architecture (Matarazzo Prize) Sao Paolo, Brazil Honorary Doctorate of Science, University of Sidney, Australia Fellow of the American Institute of Architects
1956	Royal Gold Medal, The Royal Institute of British Architects, London
1957	Hanseatic Goethe Prize, Hamburg

Ise Gropius, née Frank, joined the Bauhaus community in 1923

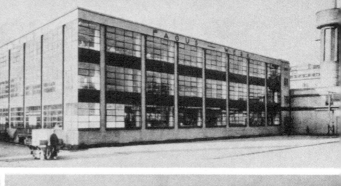

Walter Gropius and Adolf Meyer: Fagus Shoe-last Factory, Alfeld - on - the - Leine. 1911

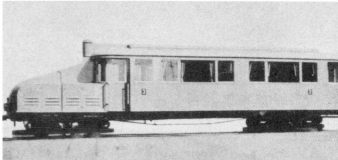

Walter Gropius and Adolf Meyer: Cologne Exposition of the German Werkbund. Hall of Machinery. 1914.

Walter Gropius' most important works before the Bauhaus

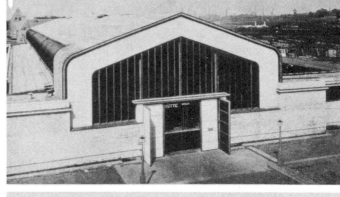

Walter Gropius: Diesel-driven locomotive car designed for a firm in Danzig. 1914

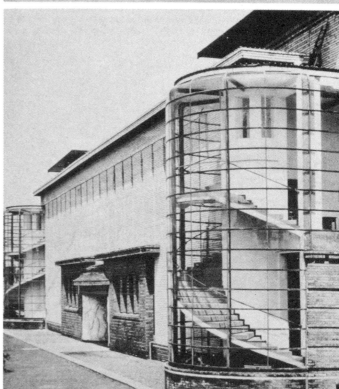

Walter Gropius and Adolf Meyer: Cologne Exposition of the German Werkbund. Administration Building Front view. 1914

Peter Röhl
Program of the opening celebrations of the Bauhaus at the German National Theater at Weimar, 1919

The contract for the direction of the Bauhaus was concluded at Weimar April 1, 1919, between the architect Walter Gropius of Berlin and the office of the Hofmarschall of Weimar with the agreement of the provisional Republican Government of Saxe-Weimar (Sachsen-Weimar-Eisenach) and the Departments of the Ministry of State.

From the FIRST PROCLAMATION of the WEIMAR BAUHAUS:

The complete building is the final aim of the visual arts. Their noblest function was once the decoration of buildings. Today they exist in isolation, from which they can be rescued only through the conscious, cooperative effort of all craftsmen. Architects, painters and sculptors must recognize anew the composite character of a building as an entity. Only then will their work be imbued with the architectonic spirit which it has lost as "salon art."

Architects, sculptors, painters, we must all turn to the crafts

Art is not a "profession." There is no essential difference between the artist and the craftsman. The artist is an exalted craftsman. In rare moments of inspiration, moments beyond the control of his will, the grace of heaven may cause his work to blossom into art. *But proficiency in his craft is essential to every artist.* Therein lies a source of creative imagination.

Let us create a *new guild of craftsmen,* without the class distinctions which raise an arrogant barrier between craftsman and artist. Together let us conceive and create the new building of the future, which will embrace architecture *and* sculpture *and* painting in one unity and which will rise one day toward heaven from the hands of a million workers like the crystal symbol of a new faith.

The first Bauhaus Seal

Lyonel Feininger:
Woodcut from the first proclamation, 1919
⫸→

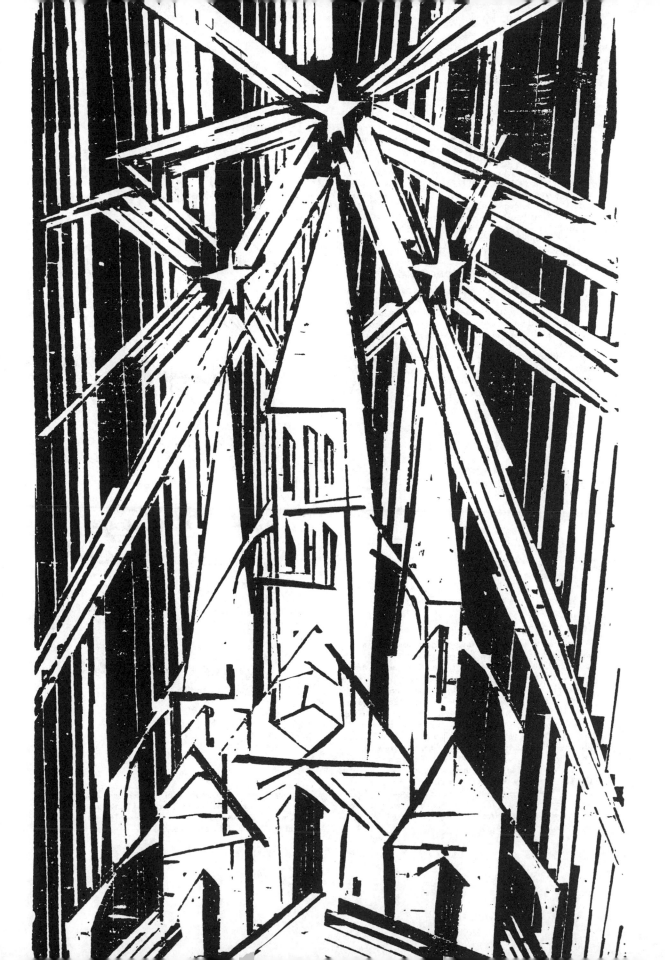

WHO WERE THE TEACHERS?

During the war some vacancies occurred on the staffs of the two schools (the Academy of Pictorial Art and the Academy of Arts and Crafts) which Gropius later united in the Bauhaus. This enabled him to have three masters appointed at the very beginning: Johannes Itten, Lyonel Feininger and Gerhard Marcks in May, 1919. They were joined later by Adolf Meyer, 1919, Georg Muche, 1920, Paul Klee, January, 1921, Oskar Schlemmer, April, 1921, Wassily Kandinsky, June, 1922, and László Moholy-Nagy, 1923. Replacement of certain members of the old staff, who did not fit into the new educational line at the Bauhaus, led to bitter controversy with the older generation of artists in Weimar.

WHERE DID THE STUDENTS COME FROM?

The students of the Weimar Bauhaus came from all over Germany, north and south, and from Austria. They were from seventeen to forty years old, most of them in their early twenties. Two-thirds of them were men, half of whom had served in the army during the last years of the great war. Most of the students had to earn their living, and Gropius therefore persuaded the Weimar Ministry of Education to cancel tuition fees. Furthermore, he managed to give some financial support to those students who produced saleable goods in the Bauhaus workshops.

18

FROM A STUDENT'S LETTER

When I saw the first Bauhaus proclamation, ornamented with Feininger's woodcut, I made inquiries as to what the Bauhaus really was. I was told that "during the entrance examinations every applicant is locked up in a dark room. Thunder and lightning are let loose upon him to get him into a state of agitation. His being admitted depends on how well he describes his reactions." This report, although it exaggerated the actual facts, fired my enthusiasm. My economic future was far from assured, but I decided to join the Bauhaus at once. It was during the post-war years, and to this day I wonder what most Bauhaus members lived on. But the happiness and fullness of those years made us forget our poverty. Bauhaus members came from all social classes. They made a vivid appearance, some still in uniform, some barefoot or in sandals, some with the long beards of artists or ascetics. Some came from the youth movements.

The student body was composed of two hundred Germans, fourteen Austrians, three Germans from the Baltic countries, two Sudeten Germans and two Hungarians. The Bauhaus budget in 1920: 206,406 marks ($ 50,000.00).

PAUL KLEE GERHARD MARCKS LYONEL FEININGER JOHANNES ITTEN

OSKAR SCHLEMMER WASSILY KANDINSKY GEORG MUCHE

ADOLF MEYER

LOTHAR SCHREYER LASZLO MOHOLY-NAGY

THE THEORY AND ORGANIZATION OF THE BAUHAUS
by WALTER GROPIUS

Translation of *Idee und Aufbau des Staatlichen Bauhauses Weimar.*

Published in 1923 at the Bauhausverlag, Munich, during the 4th year of the Bauhaus at Weimar. A few paragraphs and occasional sentences have been omitted, for the sake of brevity. Many of the subheadings have been added.

The dominant spirit of our epoch is already recognizable although its form is not yet clearly defined. The old dualistic world-concept which envisaged the ego in opposition to the universe is rapidly losing ground. In its place is rising the idea of a universal unity in which all opposing forces exist in a state of absolute balance. This dawning recognition of the essential oneness of all things and their appearances endows creative effort with a fundamental inner meaning. No longer can anything exist in isolation. We perceive every form as the embodiment of an idea, every piece of work as a manifestation of our innermost selves. Only work which is the product of inner compulsion can have spiritual meaning. Mechanized work is lifeless, proper only to the lifeless machine. So long, however, as machine-economy remains an end in itself rather than a means of freeing the intellect from the burden of mechanical labor, the individual will remain enslaved and society will remain disordered. The solution depends on a change in the individual's attitude toward his work, not on the betterment of his outward circumstances, and the acceptance of this new principle is of decisive importance for new creative work.

The decadence of architecture

The character of an epoch is epitomized in its buildings. In them, its spiritual and material resources find concrete expression, and, in consequence, the buildings themselves offer irrefutable evidence of inner order or inner confusion. A vital architectural spirit, rooted in the entire life of a people, represents the interrelation of all phases of creative effort, all arts, all techniques. Architecture today has forfeited its status as a unifying art. It has become mere scholarship. Its utter confusion mirrors an uprooted world which has lost the common will necessary for all correlated effort.

New structural elements develop very slowly, for the evolution of architectural form is dependent not only upon an immense expenditure of technical and material resources, but also upon the emergence of new philosophical concepts deriving from a series of intuitive perceptions. The evolution of form, therefore, lags far behind the ideas which engender it.

The art of architecture is dependent upon the cooperation of many individuals, whose work reflects the attitude of the entire community. In contrast, certain other arts reflect only narrow sections of life. The art of architecture and its

many branches should be not a luxury, but the life-long preoccupation of a whole people. The widespread view that art is a luxury is a corruption born of the spirit of yesterday, which isolated artistic phenomena (l'art pour l'art) and thus deprived them of vitality. At the very outset the new architectural spirit demands new conditions for all creative effort.

The "academy"

The tool of the spirit of yesterday was the "academy." It shut off the artist from the world of industry and handicraft, and thus brought about his complete isolation from the community. In vital epochs, on the other hand, the artist enriched all the arts and crafts of a community because he had a part in its vocational life, and because he acquired through actual practice as much adeptness and understanding as any other worker who began at the bottom and worked his way up. But lately the artist has been misled by the fatal and arrogant fallacy, fostered by the state, that art is a profession which can be mastered by study. Schooling alone can never produce art! Whether the finished product is an exercise in ingenuity or a work of art depends on the talent of the individual who creates it. This quality cannot be taught and cannot be learned. On the other hand, manual dexterity and the thorough knowledge which is a necessary foundation for all creative effort, whether the workman's or the artist's, can be taught and learned.

Isolation of the artist

Academic training, however, brought about the development of a great art-proletariat destined to social misery. For this art-proletariat, lulled into a dream of genius and enmeshed in artistic conceit, was being prepared for the "profession" of architecture, painting, sculpture or graphic art, without being given the equipment of a real education—which alone could have assured it of economic and esthetic independence. Its abilities, in the final analysis, were confined to a sort of drawing-painting that had no relation to the realities of materials, techniques or economics. Lack of all vital connection with the life of the community led inevitably to barren esthetic speculation. The fundamental pedagogic mistake of the academy arose from its preoccupation with the idea of the individual genius and its discounting the value of commendable achievement on a less exalted level. Since the academy trained a myriad of minor talents in drawing and painting, of whom scarcely one in a thousand became a genuine architect or painter, the great mass of these individuals, fed upon false hopes and trained as one-sided academicians, was condemned to a life of fruitless artistic activity. Unequipped to function successfully in the struggle for existence, they found themselves numbered among the social drones, useless, by virtue of their schooling, in the productive life of the nation.

With the development of the academies genuine folk art died away. What remained was a drawing-room art detached from life. In the 19th century this dwindled to the production of individual paintings totally divorced from any relation to an architectural entity. The second half of the 19th century saw the beginning of a protest against the devitalising influence of the academies. Ruskin and Morris in England, van de Velde in Belgium, Olbrich, Behrens and others in Germany, and, finally, the Deutsche Werkbund, all sought, and in the end discovered, the basis of a reunion between creative artists and the industrial world. In Germany, arts and crafts (Kunstgewerbe) schools were founded for the purpose of developing, in a new generation, talented individuals trained in industry and handicraft. But the academy was too firmly established: practical training never advanced beyond dilettantism, and draughted and rendered "design" remained in the foreground. The foundations of this attempt were laid neither wide enough nor deep enough to avail much against the old l'art pour l'art attitude, so alien to, and so far removed from life.

Dearth of industrial designers

Meanwhile, the crafts—and more especially the industries—began to cast about for artists. A demand arose for products outwardly attractive as well as technically and economically acceptable. The technicians could not satisfy it. So manufacturers started to buy so-called "artistic designs." This was an ineffective substitute, for the artist was too much removed from the world about him and too little schooled in technique and handicraft to adjust his conceptions of form to the practical processes of production. At the same time, the merchants and technicians lacked the insight to realize that appearance, efficiency and expense could be simultaneously controlled only by planning and producing the industrial object with the careful cooperation of the artist responsible for its design. Since there was a dearth of artists adequately trained for such work, it was logical to establish the following basic requirements for the future training of all gifted individuals: a *thorough practical, manual training in workshops actively engaged in production, coupled with sound theoretical instruction in the laws of design.*

Analysis of the designing process

The objective of all creative effort in the visual arts is to give form to space. . . . But what is space, how can it be understood and given a form?

. . . Although we may achieve an awareness of the infinite we can give form to space only with finite means. We become aware of space through our undivided Ego, through the simultaneous activity of soul, mind and body. A like concentration of all our forces is necessary to give it form. Through his intuition, through his metaphysical powers, man discovers the immaterial space of inward vision and inspiration. This conception of space demands realization in the material world, a realization which is accomplished by the brain and the hands.

The brain conceives of mathematical space in terms of numbers and dimensions. . . . The hand masters matter through the crafts, and with the help of tools and machinery.

Conception and visualization are always simultaneous. Only the individual's capacity to feel, to know and to execute varies in degree and in speed. True creative work can be done only by the man whose knowledge and mastery of the physical laws of statics, dynamics, optics, acoustics equip him to give life and shape to his inner vision. In a work of art the laws of the physical world, the intellectual world and the world of the spirit function and are expressed simultaneously.

The Bauhaus at Weimar

Every factor that must be considered in an educational system which is to produce actively creative human beings is implicit in such an analysis of the creative process. At the "State Bauhaus at Weimar" the attempt was made for the first time to incorporate all these factors in a consistent program.

In 1915, during the war, the author had been summoned to an audience with the Grand Duke of Saxe-Weimar to discuss his taking over the Academy for Arts and Crafts from the distinguished Belgian architect, Henry van de Velde, who had himself suggested Gropius as his successor. Having asked for, and been accorded, full powers in regard to reorganization, in the spring of 1919 the author assumed the directorship of the Grand Ducal Saxon Academy for Pictorial Art (Grossherzogliche Sächsische Hochschule für Bildende Kunst) as well as of the Grand Ducal Saxon Academy for Arts and Crafts (Grossherzogliche Sächsische Kunstgewerbeschule) and united them under the new name of "State Bauhaus" (Staatliches Bauhaus). The theoretical curriculum of an art academy combined with the practical curriculum of an arts and crafts school was to constitute the basis of a comprehensive system for gifted students. Its credo was: "The Bauhaus strives to coordinate all creative effort, to achieve, in a new architecture, *the unification of all training in art and design.* The ultimate, if distant, goal of

22

the Bauhaus is the *collective work of art*—the Building—in which no barriers exist between the structural and the decorative arts."

The guiding principle of the Bauhaus was therefore the idea of creating a new unity through the welding together of many "arts" and movements: a unity having its basis in Man himself and significant only as a living organism.

Human achievement depends on the proper coordination of all the creative faculties. It is not enough to school one or another of them separately: they must all be thoroughly trained at the same time. The character and scope of the Bauhaus teachings derive from the realization of this.

THE CURRICULUM

The course of instruction at the Bauhaus is divided into:

I. Instruction in crafts (Werklehre):

STONE	WOOD	METAL	CLAY	GLASS	COLOR	TEXTILES
Sculpture workshop	Carpentry workshop	Metal workshop	Pottery workshop	Stained glass workshop	Wall-painting workshop	Weaving workshop

A. Instruction in materials and tools

B. Elements of book-keeping, estimating, contracting

II. Instruction in form problems (Formlehre):

1. Observation	2. Representation	3. Composition
A. Study of nature	A. Descriptive geometry	A. Theory of space
B. Analysis of materials	B. Technique of construction	B. Theory of color
	C. Drawing of plans and building of models for all kinds of constructions	C. Theory of design

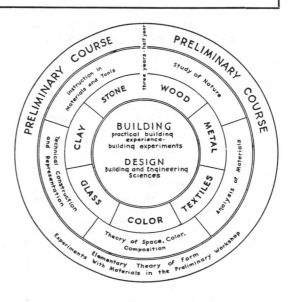

Supplementary instruction

Lectures in fields relating to art and science, past and present.

The curriculum includes three departments (compare with the plan):

1. The preliminary course, lasting half a year. Elementary instruction in problems of form, combined with practical experiments with different materials in the workshops for beginners.

Result: Admission to one of the workshops.

2. Instruction in a craft in one of the workshops after signing legal articles of apprenticeship; advanced instruction in form. Three year course.

Result: Journeyman's Diploma of the Chamber of Crafts (Gesellenbrief der Handwerkskammer) and, under certain circumstances, Diploma of the Bauhaus.

3. Instruction in architecture.

Practical participation in buildings under construction and, for especially talented journeymen, independent architectural training in the Bauhaus Research Department.

Duration: depending on achievement and special circumstances. Architectural activity and experimental work represent a continuation of instruction in crafts and form.

Result: Master's Diploma of the Chamber of Crafts and, under special circumstances, Diploma of the Bauhaus.

During the entire curriculum a practical course in the fundamental relationships of sound, color and form is followed, designed to harmonize the physical and psychic qualities of the individual.

The Preliminary Course (Vorlehre*)

Practical and theoretical studies are carried on simultaneously in order to release the creative powers of the student, to help him grasp the physical nature of materials and the basic laws of design. Concentration on any particular stylistic movement is studiously avoided. Observa-

* The preliminary course was developed by Johannes Itten; he continued and enlarged at the Bauhaus the courses he had already been giving in 1918 in Vienna. At the Bauhaus, the preliminary course was required as preparation for work in the workshops.

tion and representation—with the intention of showing the desired identity of Form and Content—define the limits of the preliminary course. Its chief function is to liberate the individual by breaking down conventional patterns of thought in order to make way for personal experiences and discoveries which will enable him to see his own potentialities and limitations. For this reason collective work is not essential in the preliminary course. Both subjective and objective observation will be cultivated: both the system of abstract laws and the interpretation of objective matter.

Above all else, the discovery and proper valuation of the individual's means of expression shall be sought out. The creative possibilities of individuals vary. One finds his elementary expressions in rhythm, another in light and shade, a third in color, a fourth in materials, a fifth in sound, a sixth in proportion, a seventh in volumes or abstract space, an eighth in the relations between one and another, or between the two to a third or fourth.

All the work produced in the preliminary course is done under the influence of instructors. It possessses artistic quality only in so far as any direct and logically developed expression of an individual which serves to lay the foundations of creative discipline can be called art.

Instruction in crafts and form problems

In earlier centuries when there was no academic instruction in the crafts or arts, students were taught independently by a master who was a craftsman as well as an artist. Such instruction would still be the best. But, because of the disastrous secession of art from the workaday life of the people, in our time such creative versatility no longer exists and it is therefore impossible for one man to undertake a student's entire art education. Synthesis is the only solution: coordinated instruction by two masters, one a craftsman, the other an artist. Thus, doubly trained, a future generation of creatively gifted workers may once more achieve a new productive coordination, and may gradually

become indispensable collaborators in the working life of the people. With this in mind the Bauhaus has ruled (1) that every apprentice and journeyman is taught by two masters, a craftsman and an artist, who work in close cooperation; (2) that instruction in crafts and in the theory of form are fundamental: no apprentice or journeyman can be excused from either.

Production work in the workshop of the preliminary course. Work in all the crafts under the technical supervision of the respective masters.	Studies in materials. Free creative work in different materials	Theory of form and color	
Drawing from Nature	Mathematics Physics Mechanics	Draughting and technical Construction	Synthetic study of space
General coordination (Harmonisierungslehre)			

Instruction in crafts

Training in a craft is a prerequisite for collective work in architecture. This training purposely combats the dilettantism of previous generations in the applied arts. Every apprentice, by signing the articles issued by the Chamber of Crafts, engages himself to work through the lawfully prescribed period of apprenticeship. The teaching of a craft serves solely to train the hand and to ensure technical proficiency; it is by no means an end in itself. Its aim is to add to a many-sided education rather than to develop the specialized craftsman.

The Bauhaus believes the machine to be our modern medium of design and seeks to come to terms with it. But it would be senseless to launch a gifted apprentice into industry without preparation in a craft and hope thereby to reestablish the artist's lost contact with the world of production. He would be stifled by the materialistic and one-sided outlook predominant in factories today. A craft, however, cannot conflict with the feeling for work which, as an artist, he inevitably has, and it is therefore his best opportunity for practical training.

The principal difference between factory production and handicraft lies not in the machine's superiority over more primitive tools as an instrument of technical precision, but in the fact that in the factory each operation involved in manufacturing a product is performed by a different man, whereas the craft product is made entirely by one person. But if industry is to develop, the use of machinery and the division of labor must be maintained. Neither factor is in itself responsible for the loss of creative unity which has resulted from technological development. The root of the evil exists rather in the much too materialistic attitude of our times and in the loss of contact between the individual and the community.

It follows that the Bauhaus does not pretend to be a crafts school. Contact with industry is consciously sought, for the old trades are no longer very vital and a turning back to them would therefore be an atavistic mistake. Craftsmanship and industry are today steadily approaching one another and are destined eventually to merge into one. Such a new productive union will give every individual that understanding of and desire for cooperation which is essential to creative work. In this union the old craft workshops will develop into industrial laboratories: from their experimentation will evolve standards for industrial production.

The teaching of a craft is meant to prepare for designing for mass production. Starting with the simplest tools and least complicated jobs, he gradually acquires ability to master more intricate problems and to work with machinery, while at the same time he keeps in touch with the entire process of production from start to finish, whereas the factory worker never gets beyond the knowledge of one phase of the process. Therefore the Bauhaus is consciously seeking contacts with existing industrial enterprises, for the sake of mutual stimulation. From these contacts with industry the appren-

tice and, later, the journeyman learn not only to extend their technical experience but also to consider, in carrying out their work, the unavoidable demands which industry makes on the individual to economize on time and means. In the same measure, the academic superciliousness of another day constantly dwindles, and respect for hard realities unites individuals engaged in a common work.

After three years of thorough training, the apprentice undergoes a work-test in the presence of a committee of established craftsmen. Having passed this, he becomes a publicly certified journeyman. Every journeyman at the Bauhaus who is publicly certified is entitled, as soon as he considers himself sufficiently advanced, to a further test as "Bauhaus journeyman"; the requirements of this test are more severe than the public test, especially in regard to the journeyman's creative ability.

Instruction in form problems

Intellectual education runs parallel to manual training. The apprentice is acquainted with his future stock-in-trade—the elements of form and color and the laws to which they are subject. Instead of studying the arbitrary individualistic and stylised formulae current at the academies, he is given the mental equipment with which to shape his own ideas of form. This training opens the way for the creative powers of the individual, establishing a basis on which different individuals can cooperate without losing their artistic independence. Collective architectural work becomes possible only when every individual, prepared by proper schooling, is capable of understanding the idea of the whole, and thus has the means harmoniously to coordinate his independent, even if limited, activity with the collective work. Instruction in the theory of form is carried on in close contact with manual training. Drawing and planning, thus losing their purely academic character, gain new significance as auxiliary means of expression. We must know both vocabulary and grammar in order to speak a language; only

then can we communicate our thoughts. Man, who creates and constructs, must learn the specific language of construction in order to make others understand his idea. Its vocabulary consists of the elements of form and color and their structural laws. The mind must know them and control the hand if a creative idea is to be made visible. The musician who wants to make audible a musical idea needs for its rendering not only a musical instrument but also a knowledge of theory. Without this knowledge, his idea will never emerge from chaos.

A corresponding knowledge of theory—which existed in a more vigorous era—must again be established as a basis for practice in the visual arts. The academies, whose task it might have been to cultivate and develop such a theory, completely failed to do so, having lost contact with reality. Theory is not a recipe for the manufacturing of works of art, but the most essential element of collective construction; it provides the common basis on which many individuals are able to create together a superior unit of work; theory is not the achievement of individuals but of generations.

The Bauhaus is consciously formulating a new coordination of the means of construction and expression. Without this, its ultimate aim would be impossible. For collaboration in a group is not to be obtained solely by correlating the abilities and talents of various individuals. Only an apparent unity can be achieved if many helpers carry out the designs of a single person. In fact, the individual's labor within the group should exist as his own independent accomplishment. Real unity can be achieved only by coherent restatement of the formal theme, by repetition of its integral proportions in all parts of the work. Thus everyone engaged in the work must understand the meaning and origin of the principal theme.

Forms and colors gain meaning only as they are related to our inner selves. Used separately or in relation to one another they are the means of expressing different emotions and movements: they have no importance of their own.

Red, for instance, evokes in us other emotions than does blue or yellow; round forms speak differently to us than do pointed or jagged forms. The elements which constitute the "grammar" of creation are its rules of rhythm, of proportion, of light values and full or empty space. Vocabulary and grammar can be learned, but the most important factor of all, the organic life of the created work, originates in the creative powers of the individual.

The practical training which accompanies the studies in form is founded as much on observation, on the exact representation or reproduction of nature, as it is on the creation of individual compositions. These two activities are profoundly different. The academies ceased to discriminate between them, confusing nature and art—though by their very origin they are antithetical. Art wants to triumph over Nature and to resolve the opposition in a new unity, and this process is consummated in the fight of the spirit against the material world. The spirit creates for itself a new life other than the life of nature.

Each of these departments in the course on the theory of form functions in close association with the workshops, an association which prevents their wandering off into academicism.

Instruction in architecture

Only the journeyman who has been seasoned by workshop practice and instruction in the study of form is ready to collaborate in building.

The last and most important stage of Bauhaus education is the course in architecture with practical experience in the Research Department* as well as on actual buildings under construction. No apprentices are admitted to the Research Department: only certified journeymen capable of working out by themselves technical and formal problems. They have access to the draughting office adjoining the Research Department, as well as to all the workshops, in or-

* The Research Department for experimental work was only partially realized, due to lack of space and funds.

der to enable them to study other crafts than their own. They are invited to collaborate both on the plans and the actual construction of buildings for which the Bauhaus has been commissioned, so that they may have the experience of cooperating with all the building trades and, at the same time, earn their living.

In so far as the Bauhaus curriculum does not provide advanced courses in engineering—construction in steel and reinforced concrete, statics, mechanics, physics, industrial methods, heating, plumbing, technical chemistry — it is considered desirable for promising architecture students, after consultation with their masters, to complete their education with courses at technical and engineering schools. As a matter of principle, journeymen should have experience (machine work) in manufacturing workshops other than those at the Bauhaus.

The new approach to architecture

The most important condition for fruitful collaboration on architectural problems is a clear understanding of the new approach to architecture. Architecture during the last few generations has become weakly sentimental, esthetic and decorative. Its chief concern has been with ornamentation, with the formalistic use of motifs, ornaments and mouldings on the exterior of the building—as if upon a dead and superficial mass—not as part of a living organism. In this decadence architecture lost touch with new methods and materials; the architect was engulfed in academic estheticism, a slave to narrow conventions, and the planning of cities was no longer his job.

This kind of architecture we disown. We want to create a clear, organic architecture, whose inner logic will be radiant and naked, unencumbered by lying façades and trickeries; we want an architecture adapted to our world of machines, radios and fast motor cars, an architecture whose function is clearly recognizable in the relation of its forms.

With the increasing firmness and density of modern materials—steel, concrete, glass—and

with the new boldness of engineering, the ponderousness of the old method of building is giving way to a new lightness and airiness. A new esthetic of the Horizontal is beginning to develop which endeavors to counteract the effect of gravity. At the same time the symmetrical relationship of parts of the building and their orientation toward a central axis is being replaced by a new conception of equilibrium which transmutes this dead symmetry of similar parts into an asymmetrical but rhythmical balance. The spirit of the new architecture wants to overcome inertia, to balance contrasts.

Since architecture is a collective art, its welfare depends on the whole community. As an extreme instance, the monument is only significant when it springs from the will of the whole nation. This will does not yet exist today. But even the construction of absolutely necessary housing is at a standstill thanks to the makeshift economies of our time. Nowhere are the fundamental problems of building studied as such.

Standardization of units

For this reason the Bauhaus has set itself the task of creating a center for experimentation where it will try to assemble the achievements of economic, technical and formal research and to apply them to problems of domestic architecture in an effort to combine the greatest possible standardization with the greatest possible variation of form. Therefore the buildings which are to be thought of as outgrowths of modern technique and design may be conceived as an assembly of prefabricated and standardized parts so applied as to fulfill the varying requirements of those to be housed.

The artist and the technician must collaborate in carrying out this task. Any industrially produced object is the result of countless experiments, of long, systematic research, in which business men, technicians and artists participate to determine a standard type. To an even greater degree, the standardization of building units for industrial production will require the generous cooperation of all concerned, in busi-

ness, in engineering, in art. Such cooperation would be a real demonstration of farsightedness. It would, in the end, prove more economical than the use of substitutes.

The Bauhaus has taken the first steps toward such collaboration with the building of an experimental house at its 1923 exhibition, which was an actual demonstration of new conceptions of housing as well as of new technical methods.

Every architect must understand the significance of the city in order to be able to engage actively in city planning; he must recognize *"simplicity in multiplicity"* as a guiding principle in the shaping of its character. Form elements of typical shape should be repeated in series. All the building parts should be functional limbs of the comprehensive organism which depends simultaneously on building, street and means of transportation.

The investigation of these problems constitutes the final stage of the course in building. A student who has achieved technical perfection and absorbed all that the Bauhaus can teach him can be certified a master.

The goal of the Bauhaus curriculum

Thus the culminating point of the Bauhaus teaching is a demand for a new and powerful working correlation of all the processes of creation. The gifted student must regain a feeling for the interwoven strands of practical and formal work. The joy of building, in the broadest meaning of that word, must replace the paper work of design. Architecture unites in a collective task all creative workers, from the simple artisan to the supreme artist.

For this reason, the basis of collective education must be sufficiently broad to permit the development of every kind of talent. Since a universally applicable method for the discovery of talent does not exist, the individual in the course of his development must find for himself the field of activity best suited to him within the circle of the community. The majority become interested in production; the few extraordinarily gifted ones will suffer no limits to their activity. After

they have completed the course of practical and formal instruction, they undertake independent research and experiment.

Modern painting, breaking through old conventions, has released countless suggestions which are still waiting to be used by the practical world. But when, in the future, artists who sense new creative values have had practical training in the industrial world, they will themselves possess the means for realizing those values immediately. They will compel industry to serve their idea and industry will seek out and utilize their comprehensive training.

The Stage

Theatrical performance, which has a kind of orchestral unity, is closely related to architecture. As in architecture the character of each unit is merged into the higher life of the whole, so in the theater a multitude of artistic problems form a higher unity with a law of its own.

In its origins a theater grew from a metaphysical longing; consequently it is the realization of an abstract idea. The power of its effect on the spectator and listener thus depends on the successful translation of the idea into optically and audibly perceptible forms.

This the Bauhaus attempts to do. Its program consists in a new and clear formulation of all problems peculiar to the stage. The special problems of space, of the body, of movement, of form, light, color and sound are investigated; training is given in body movements, in the modulation of musical and spoken sounds; the stage space and figures are given form.

The Bauhaus theater seeks to recover primordial joy for all the senses, instead of mere esthetic pleasure.

Conclusion: the Bauhaus in education

An organization based on new principles easily becomes isolated if it does not constantly maintain a thorough understanding of all the questions agitating the rest of the world. In spite of all the practical difficulties, the basis of the growing work of the Bauhaus can never be too broad. Its responsibility is to educate men and women to understand the world in which they live and to invent and create forms symbolizing that world. For this reason the educational field must be enlarged on all sides and extended into neighboring fields, so that the effects of new experiments may be studied.

The education of children when they are young and still unspoiled is of great importance. The new types of schools emphasizing practical exercises, such as the Montessori schools, provide an excellent preparation for the constructive program of the Bauhaus since they develop the entire human organism. The old conservative schools were apt to destroy the harmony within the individual by all but exclusive headwork. The Bauhaus keeps in touch with new experiments in education.

During the first four years of constructive work, many ideas and problems have evolved from the original idea of the Bauhaus. They have been tested in the face of fierce opposition. Their fruitfulness and salutary effect on all phases of modern life have been demonstrated.

29

The later Bauhaus seal, designed by Oskar Schlemmer, 1922

PRELIMINARY COURSE

PRELIMINARY COURSE: ITTEN

The backbone of the Bauhaus system was the preliminary course, the foundations of which were laid by Johannes Itten. Gropius had met Itten in 1918 in Vienna, where he was directing a private school, and—impressed by his theory of education—Gropius called him to the Bauhaus as the first collaborator. The following fundamentals of Itten's teachings were retained in part at the Bauhaus, in spite of various additions and changes made by other instructors.

1 Detailed study of nature (see plates opposite), especially: (a) representation of materials and (b) experiments with actual materials.

2 Plastic studies of composition, with various materials (see plates, page 33).

3 Analyses of old masters (see plates ,page 34).

Herbert Bayer: Drawing in various media of different textures 1921

H. Hoffmann: Drawing from nature. Various materials. 1920

E. Dieckmann: Composition using commonplace materials. Exercise designed to develop sense of touch and subjective feeling for material

Drawing of contrasting materials

L. Leudesdorff-Engstfeld:
Drawing showing charac-
teristic structure of wood.
1922

Max Bronstein: Composition. Various materials different in character, but unified by rhythmic arrangement. 1922

Ludwig Hirschfeld-Mack: Line drawing (curved shapes). Ink. 1922

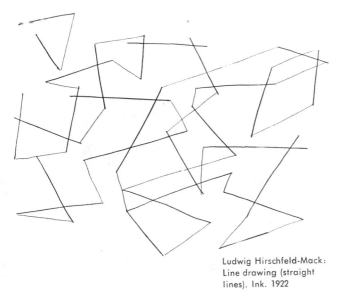

Ludwig Hirschfeld-Mack: Line drawing (straight lines). Ink. 1922

N. Wassiljeff: Composition. Exercise in combination of simplest plastic and rhythmic forms. 1922

PRELIMINARY COURSE, WEIMAR April/May, 1922

Each Bauhaus student is at first admitted for a trial period of six months to work in the preliminary course. This course is intended to liberate the student's creative power, to give him an understanding of nature's materials, and to acquaint him with the basic principles which underlie all creative activity in the visual arts. Every new student arrives encumbered with a mass of accumulated information which he must abandon before he can achieve perception and knowledge that are really his own. If he is to work in wood, for example, he must know his material *thoroughly*; he must have a "feeling" for wood. He must also understand its relation to other materials, to stone and glass and wool. Consequently, he works with these materials as well, combining and composing them to make their relationships fully apparent.

Preparatory work also involves exact depiction of actual materials. If a student draws or paints a piece of wood true to nature in every detail, it will help him to understand the material. The work of old masters, such as Bosch, Master Francke or Grünewald also offers instruction in the study of form, which is an essential part of the preliminary course. This instruction is intended to enable the student to perceive the harmonious relationship of different rhythms and to express such harmony through the use of one or several materials. The preliminary course concerns the student's whole personality, since it seeks to liberate him, to make him stand on his own feet, and makes it possible for him to gain a knowledge of both material and form through direct experience.

A student is tentatively admitted into a workshop after a six month's trial period if he has sufficiently mastered form and materials to specialize in work with one material only. If he has a talent for wood, he goes into the carpentry shop; if his preference is for woven materials, he goes into the weaving workshop. At the conclusion of a second successful trial period of six months he is definitely admitted to the workshop as an apprentice. Three years as an apprentice make him eligible for examinations to become a journeyman.

As a matter of principle, each apprentice has to do his own designing. No outside designs, not even designs made by Bauhaus masters, may be executed in the workshops. (from Bibl. no. 6.)

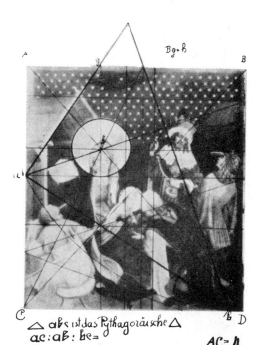

Johannes Itten: Diagram-
matic analysis of the
Adoration of the Magi by
Master Francke. c. 1919
From Johannes Itten's
Tagebuch

Erna Niemeyer. Light and
shade analysis of an
Annunciation. 1922

Johannes Itten: Study of
hand positions while
drawing the figure eight.
1919. From Johannes
Itten's *Tagebuch*

Johannes Itten: Geometric
analysis of the Adoration
of the Magi, by Master
Francke (Hamburg,
Kunsthalle). c. 1919. From
Johannes Itten's *Tagebuch*

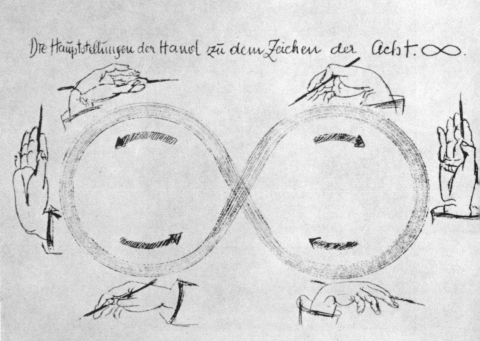

Theo van Doesburg and C. van Eesteren: House for an artist. 1923

THEO VAN DOESBURG:

Attracted by the endeavours of the Bauhaus, Theo van Doesburg and several other artists not belonging to the Bauhaus organized a section of the "Stijl" movement* in Weimar in 1922. Doesburg's preoccupation with problems of pure form was not in harmony with the Bauhaus ideal of educating the individual in the interests of the whole community, nor with its emphasis on technical training. His influence on a group of the students gradually waned, though there is little doubt that his visit to Weimar helped to clarify the problem of creative design.

* The "Stijl" group was formed at Leyden in 1917 and included in addition to Doesburg, the painter Piet Mondrian, the architect J. J. P. Oud and many others. The "Stijl" artists developed a style in which the principle form was the rectangle, the principle colors pure red, blue and yellow, and principle compositional device a carefully balanced asymmetry. The Bauhaus published books by all the leading "Stijl" designers (Bibl. nos. 20, 21 and 25). For an account of the Stijl, see Cubism and Abstract Art, the Museum of Modern Art, 1936, pp. 140-152.

K. Schwerdtfeger: Study in space. 1921

E. Mögelin: Cubic composition. Exercise in observation of static-dynamic relations. 1922

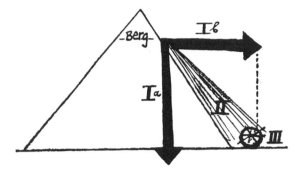

Paul Klee: Line and plane: three stages. At left, the active line (produced by a moving point); at right, the active plane (pro- duced by a moving line); in the middle, intermediate or transitional territory with linear forms giving the effect of planes

Paul Klee: Active, inter- mediate and passive fac- tors: the watermill. (I) The conflict of the two forces, (a) gravity and (b) the resisting mountain (both active factors), is expressed by (II) the diagonal water- fall (intermediate factor) which turns (III) the mill (passive factor)

Paul Klee: Active inter- mediate and passive fac- tors: (I) the waterfall (ac- tive); (II) the mill wheels (intermediate); (III) the trip hammer (passive)

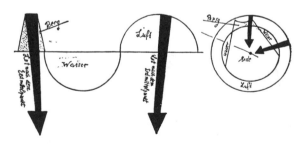

Paul Klee: Earth, water and air. Symbols of the province of statics are the plummet, which points to- ward the center of the earth, and the balance

I. Kerkovius: Study from
nature. Linear analysis.
1922

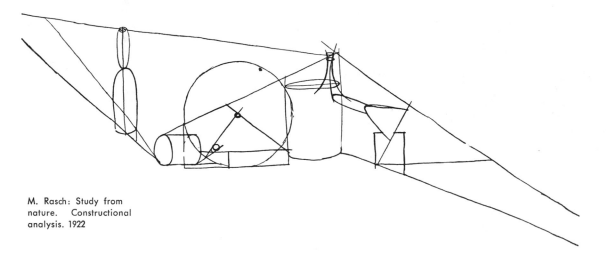

M. Rasch: Study from
nature. Constructional
analysis. 1922

COLOR EXPERIMENTS

Ludwig Hirschfeld - Mack: Experiments in the qualities of black and white. White is aggressive, advancing, centrifugal and dynamic; black is passive, receding, centripetal and static

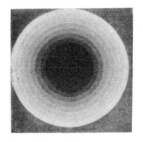 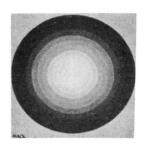

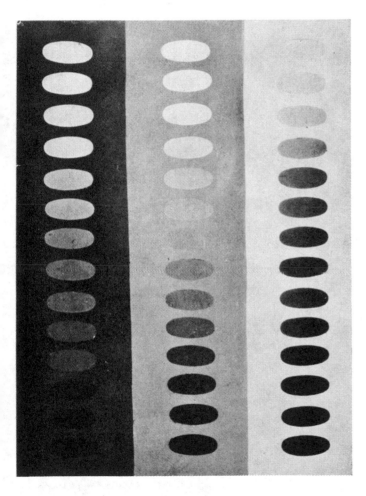 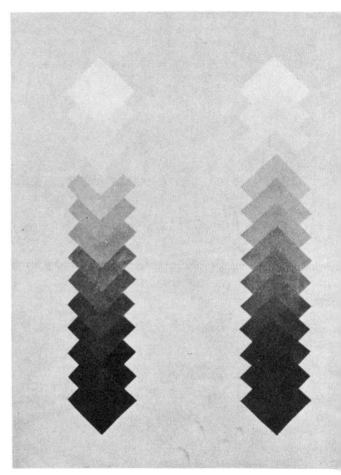

Ludwig Hirschfeld - Mack: Experiments in the qualities of black and white when mixed with colors. Colors mixed with black tend to recede; colors mixed with white tend to advance

Ludwig Hirschfeld - Mack: Experiments in the qualities of black and white. Similar shapes in tones shading from black to white appear to be advancing or receding according to the order in which they are superimposed

CARPENTRY WORKSHOP

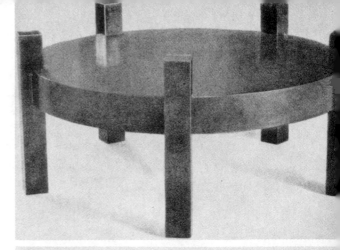

THE ROLE OF HANDICRAFTS AT THE BAUHAUS

Gropius was subjected to numerous attacks, even from those who took a friedly interest in his work, on the ground that his insistence on the value of training in a craft was anachronistic. They denied that industry had any use for handicrafts. But Gropius stuck to his guns. He saw that there were not enough men trained as craftsmen to supply industry with the specialized workers it needed and that industry was therefore trying to give craft instruction in its own workshops. He concluded from this that the handicraft tool and the industrial machine differed in scale but not in kind and that even the most refined machine could be operated productively only by a man whose understanding of its development derived from his own thorough analysis of the relation between tool and material. Hence he considered instruction in crafts at the Bauhaus a means of achieving that understanding and established simultaneous schooling of hand and mind as the basic pedagogic principle of all Bauhaus training.

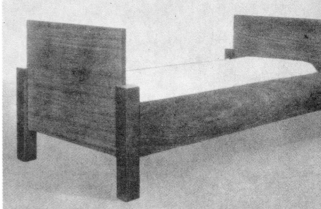

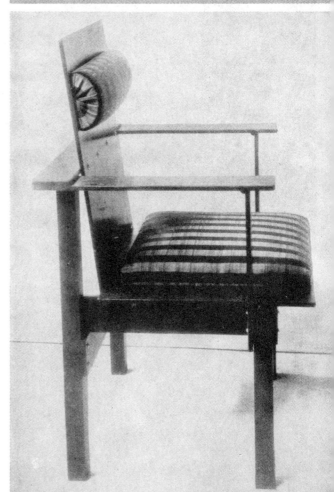

FUNDAMENTAL DIFFERENCE BETWEEN THE BAUHAUS and OTHER CONTEMPORARY ART SCHOOLS

The discrepancy of form in Bauhaus products of the first few years was often misinterpreted by the press and even by friends of the Bauhaus who failed to recognize in this variety a logical result of the director's educational plan. In contrast to other contemporary art schools whose students were trained to learn from existing forms produced by artists of former periods or by their own teachers, the Bauhaus emphasized the method of creative approach. It strove to provide an objective education in design in which the institution as a whole participated. Each individual, accordingly, had to find, even if indirectly, his own way toward the common aim. His initiative and probable detours were not to be obstructed by authoritative outside pressure; no seeming harmony in style was to be achieved prematurely by the adoption of ready-made forms. These pedagogic methods insured a slow organic development and brought about the genuine unity of form which all Bauhaus products attained in later years.

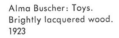
Marcel Breuer: Polished
black table. 1921

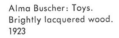
E. Dieckmann: Bed. 1922

Marcel Breuer: Dressing
table. 1923

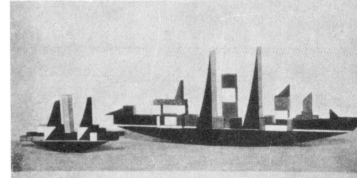

Alma Buscher: Toys.
Brightly lacquered wood.
1923

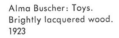
Marcel Breuer: Chair.
1922

Josef Albers: Shelves for
magazines. Light and dark
oak. 1923

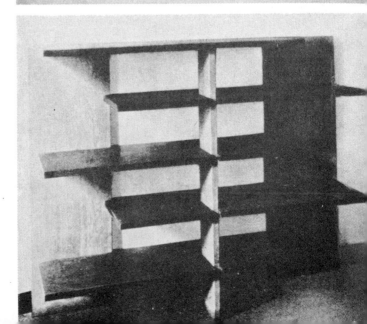

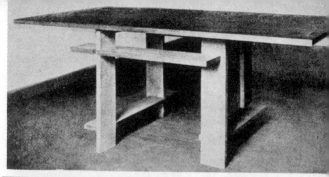

Josef Albers: Conference
table. Light and dark oak.
1923

42

Peter Keler: Cradle. 1922

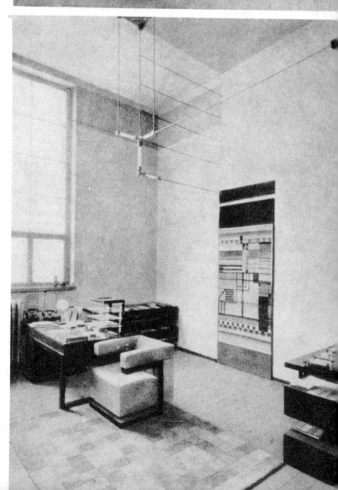

Walter Gropius: Weimar
Bauhaus. Director's room.
1923

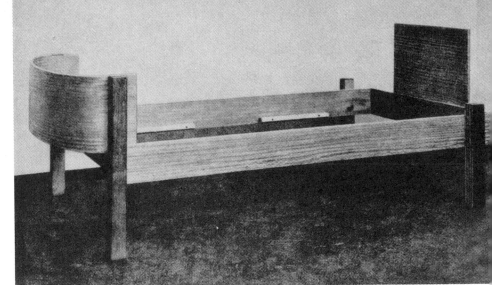

Marcel Breuer: Bed.
Lemonwood and walnut.
1923

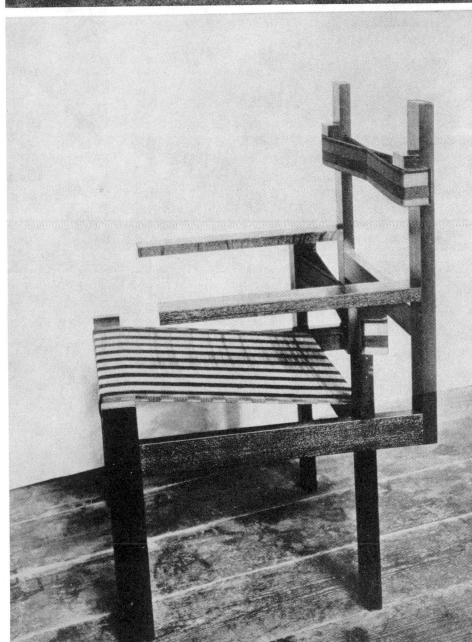

Marcel Breuer: Chair.
Fabric seat and back rest.
1924

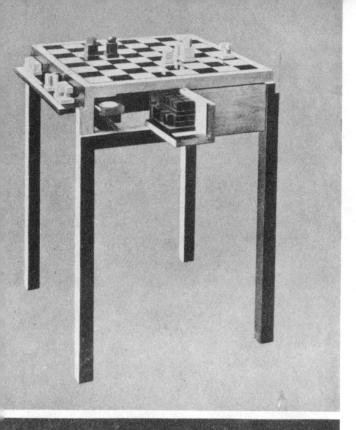

H. Nösselt: Chess table.
Red beechwood, partly
stained black. 1925

 J. Hartwig: Chess set.
1924

 Pawn and *Castle* move on
lines parallel to the edges
of the board: expressed by
the cube.

 Knight moves on a right
angle: right angle sur-
mounting square.

 Bishop moves diagonally:
cube with cross cut from
top on diagonal.

 King moves one square
straight or diagonally: a
small cube set diagonally
on a larger cube.

 Queen, the most active
piece, moves any number
of spaces straight or diag-
onally: cylinder and ball,
in sharp contrast to the
cube, symbol of weight
and mass, which charac-
terizes the *King*, *Castle*
and *Pawn*.

J. Hartwig: Chess set.
1924

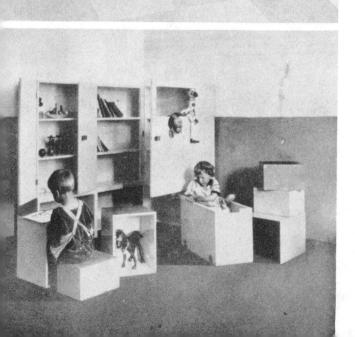

Alma Buscher: Play
cupboard in use. Storage
cabinets can also be used
as tables, chairs, and carts

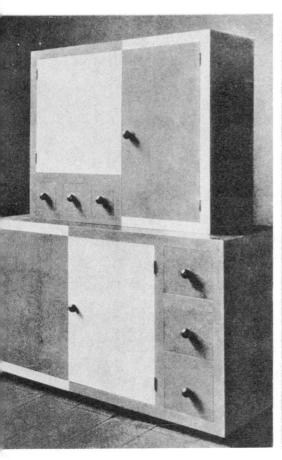

Marcel Breuer: Kitchen
cabinet. Wood lacquered
in color. 1923

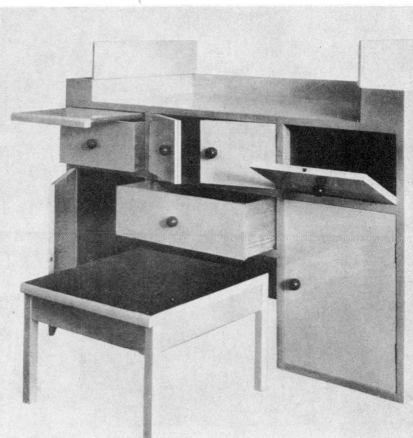

Alma Buscher: Nursery
commode. Brightly
lacquered wood. 1924

Marcel Breuer: Desk
backed with bookshelves.
Plywood lacquered in two
colors. 1924

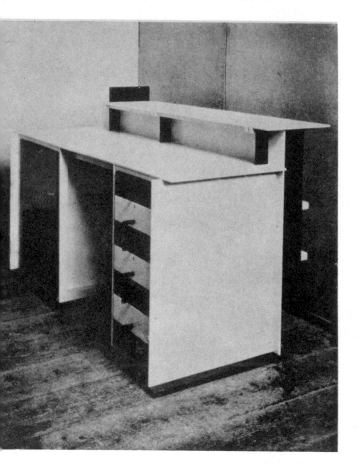

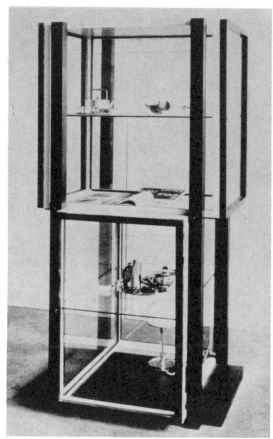

Marcel Breuer: Showcase.
Glass and wood lacquered
in black and white. 1925

Marcel Breuer: Wooden
chair. Fabric seat and back
rest. 1926

STAINED GLASS WORKSHOP

Stained glass workshop. 1923

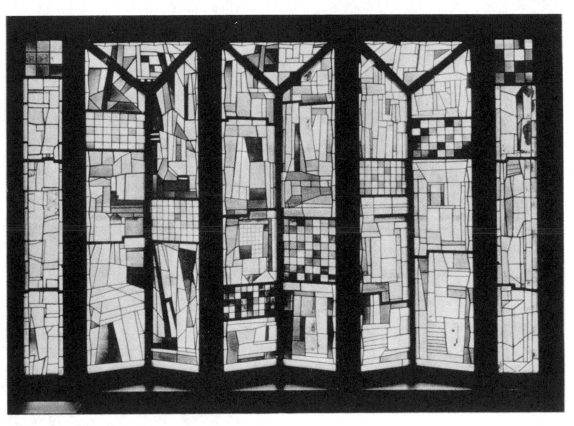

Josef Albers: Stained glass in the stair well, Sommerfeld house in Berlin, by Gropius. 1922

POTTERY WORKSHOP

In Dornburg near Weimar a traditional pottery center

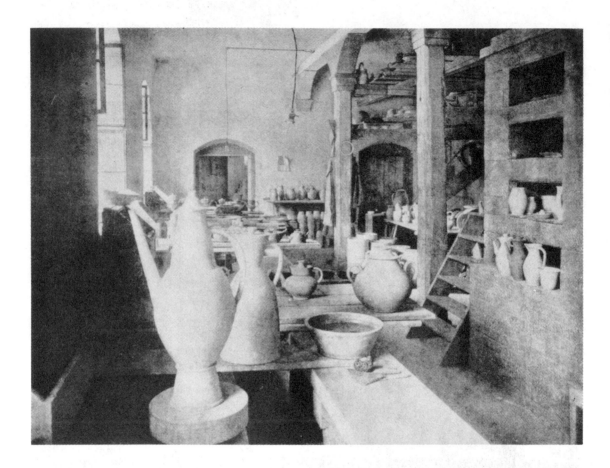

Pottery workshop,
Dornburg

DORNBURG. Romantic
town on the river Saale.
One of Goethe's favorite
retreats

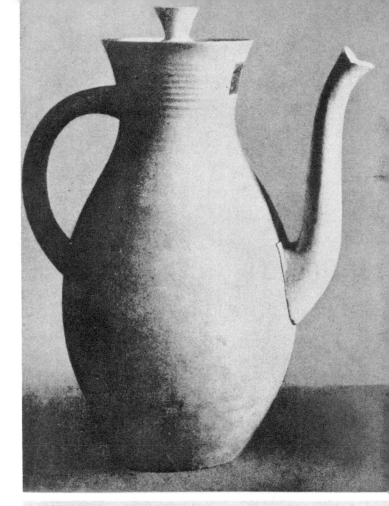

O. Lindig: Plaster model
of a coffee pot designed
for mass production

O. Lindig: Earthenware
jug. Decorated by
Gerhard Marcks 1922

O. Lindig: Water pitcher

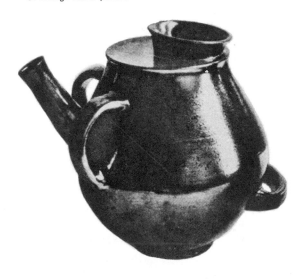

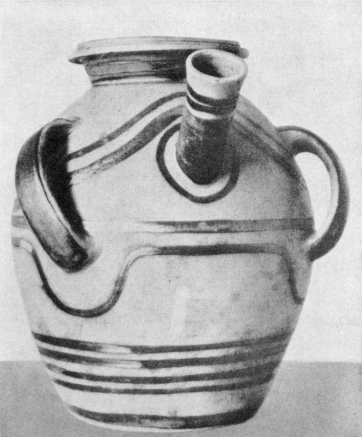

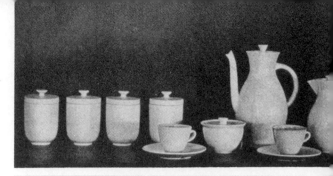

Left T. Bogler: Cannisters.
Right O. Lindig: Cocoa
set. Porcelain designed for
mass production. Executed
by the Älteste Volkstädter
Porzellanfabrik. 1923

O. Lindig: Glazed earth-
enware cocoa pot. 1922

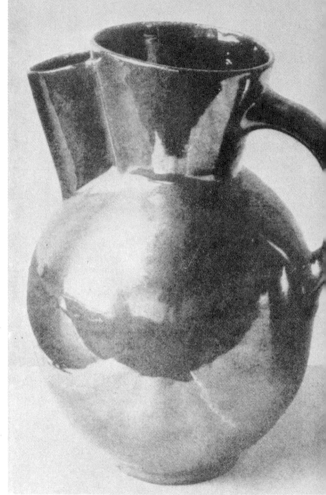

50

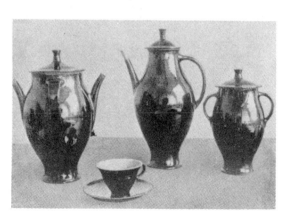

O. Lindig: Coffee set. 1922

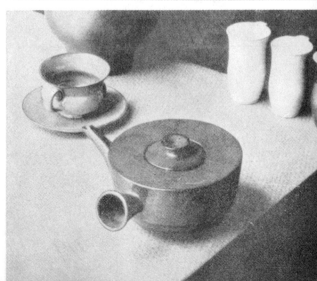

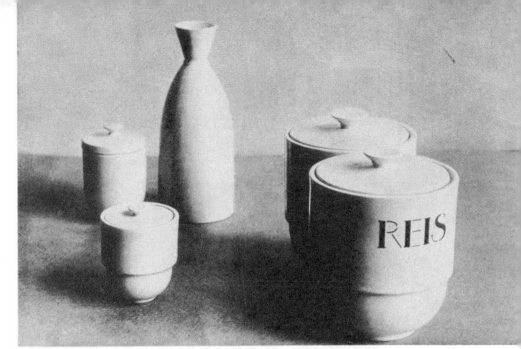

T. Bogler: Earthenware kitchen containers designed for mass production. Executed by the Steingutfabrik, Velten-Vordamm. 1923

O. Lindig: Earthenware coffee pots designed for mass production.

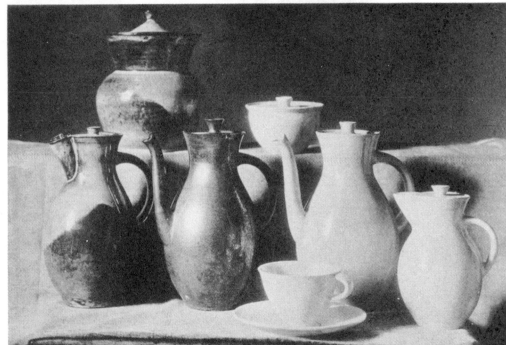

◄▨
Left O. Lindig: Cup. Cast.
Right Margarete Friedlander: Mugs. Turned.
Bottom T. Bogler: Teapot. Cast. 1923

T. Bogler: Coffee machine designed for mass production. Executed by the Staatliche Porzellanmanufaktur, Berlin. 1923

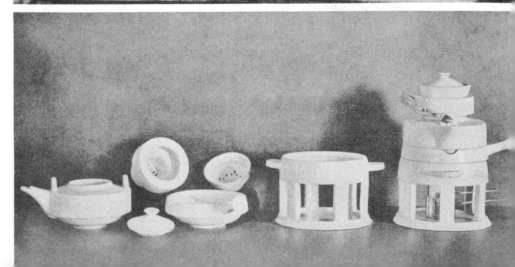

METAL WORKSHOP

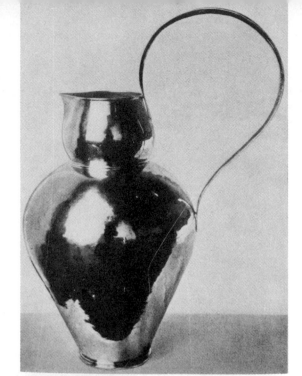

J. Pap: Steel and nickeled
brass floor lamp. 1923

J. Pap: Water pitcher.
Copper, bronze and brass.
1922

K. Jucker: Brass samovar
lined with silver. c. 1922

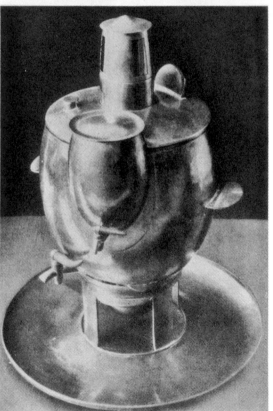

Marianne Brandt: Metal
teapot. 1924

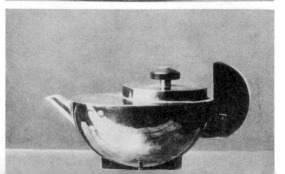

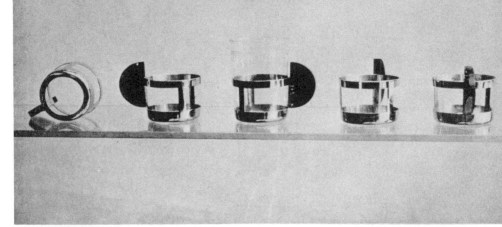

M. Krajewski: Silver-bronze
tea-glass holders with ebony
handles. 1924

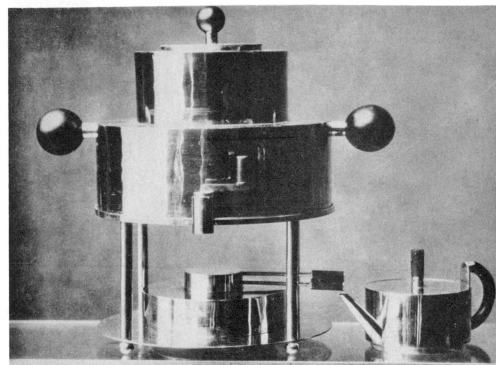

J. Knau: Samovar with spirit
lamp and small pot for tea
essence. Silver-bronze with
silver lining and ebony
handles. 1924

Naum Slutzky: Pendant.
Silver, wood, ivory and
quartz. 1923

Naum Slutzky: Ring with
setting designed to permit
change of stones.
Component parts and the
whole. 1924

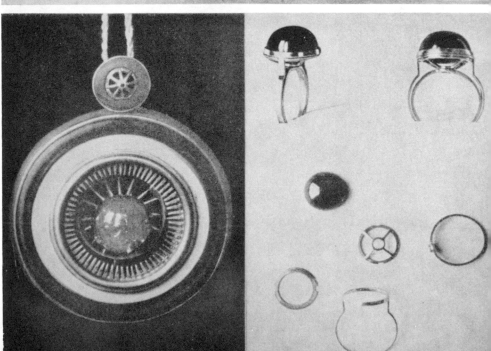

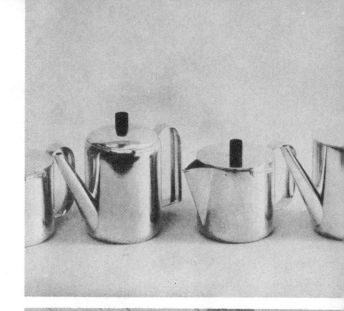

Marianne Brandt: Coffee-
and teapots designed for
mass production. 1926

Walter Gropius: Lighting
fixture of tubular bulbs.
Wired through thin
aluminum tubes. 1923

54

Marianne Brandt:
Silver-bronze tea set with
ebony handles. 1924

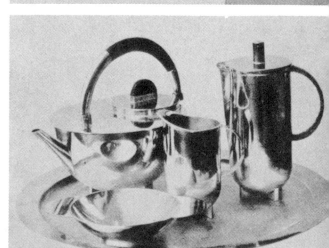

Metal workshop. Weimar.

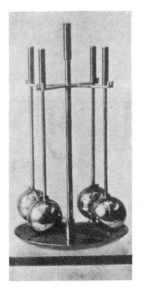

K. Jucker and
W. Wagenfeld: Glass
lamp. Shade of milky glass.
Wired through a silver-
bronze tube within the
glass tube. 1923-1924
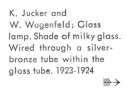

O. Rittweger and
W. Tümpel: Silver-bronze
tea balls and stand. 1924

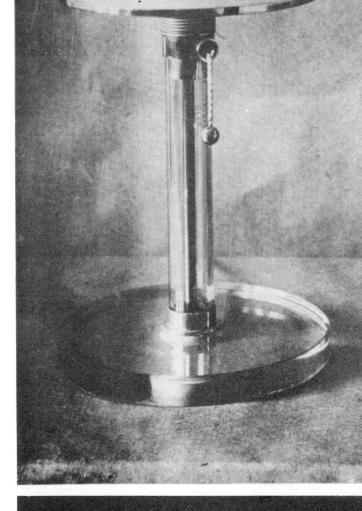

Josef Albers: Glass berry
dishes with metal rims and
wooden ball feet. 1923

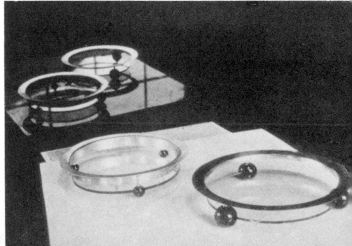

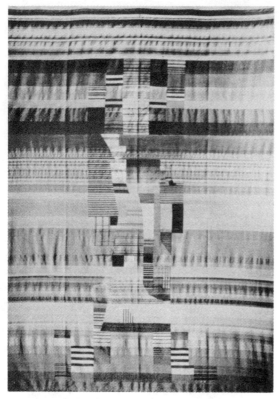

Guntha Sharon-Stölzl:
Wall hanging. c. 1924

56

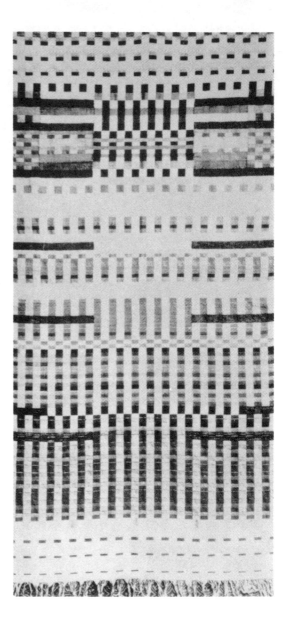

B. Otte: Wall hanging.
Yellow, gray, brown, violet,
white. Cotton. 1924

Guntha Sharon-Stölzl:
Woven cover, Gray and
white. Wool and rayon.
1923

Ruth Hollós: Woven cover.
Repeated pattern adopted
for machine production
derived from handwoven
cover at right

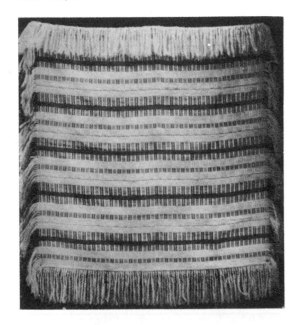

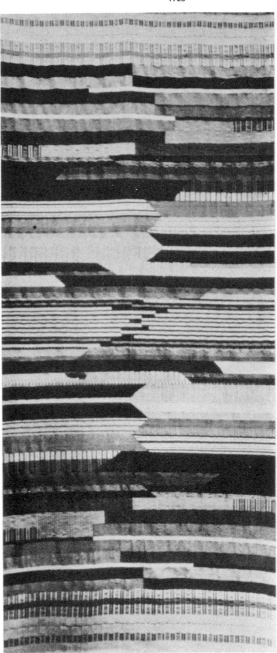

57

Ruth Citroën-Vallentin:
Appliqué and embroid-
ered hanging for child's
room. 1923

Guntha Sharon-Stölzl:
Tapestry. 1927

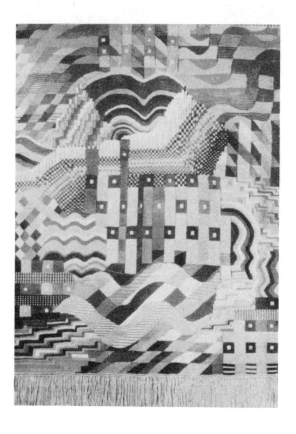

58

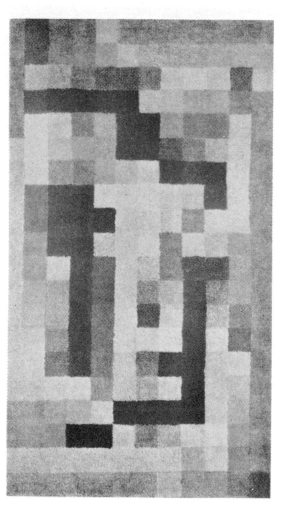

G. Hantsch: Knotted rug.
Smyrna wool. 1924

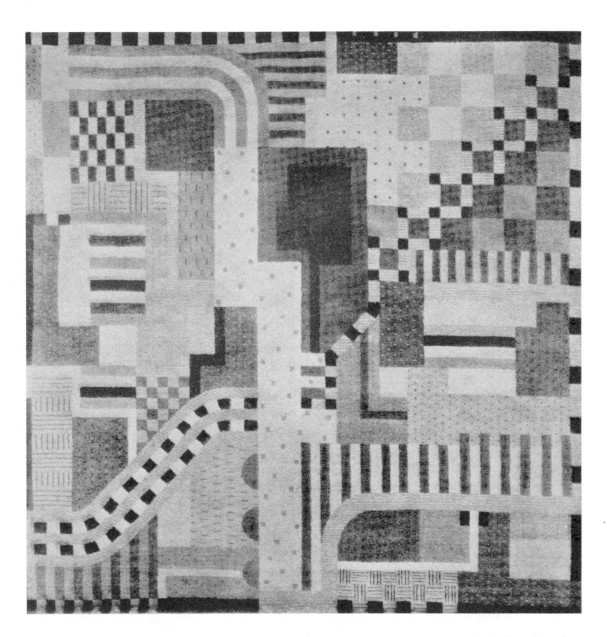

Martha Erps: Knotted rug.
Smyrna wool

STAGE WORKSHOP

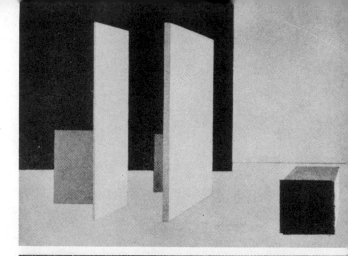

Kurt Schmidt: Stage set for
The Mechanical Ballet.
1923

Oskar Schlemmer: Figure
from *The Triadic Ballet*

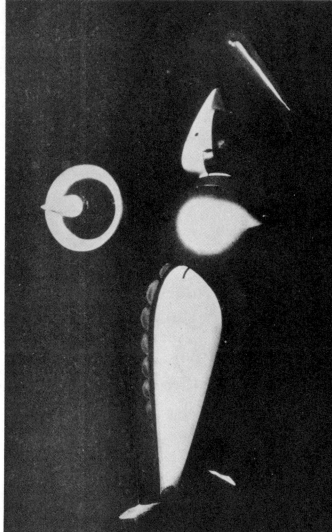

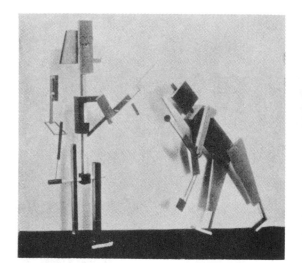

Kurt Schmidt: design;
T. Hergt: execution.
Marionettes for *The
Adventures of the Little
Hunchback*

Kurt Schmidt with F. W.
Bogler and Georg
Teltscher: Figures for *The
Mechanical Ballet.* First
produced in Jena, 1923

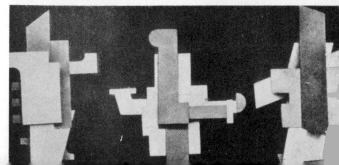

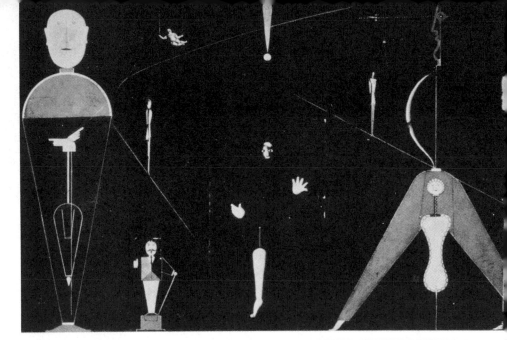

Oskar Schlemmer: *The Figural Cabinet*. Second Version. Photomontage. 1922

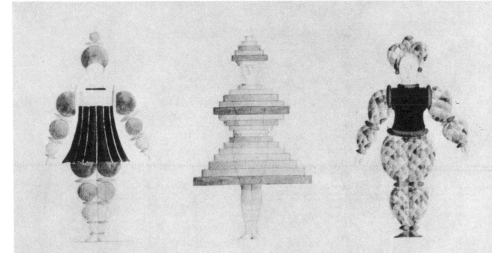

Oskar Schlemmer: Costume designs for *The Triadic Ballet*. 1922

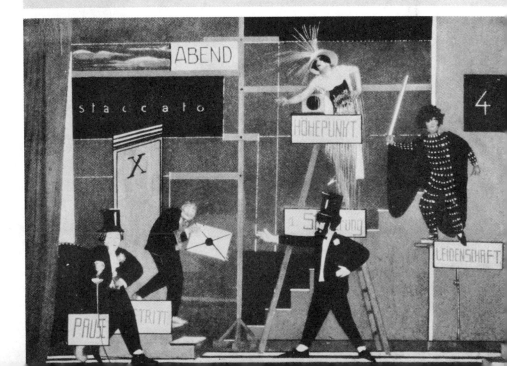

Oskar Schlemmer: Design for a scene of *Meta, or the Pantomime of Places*. First produced in Weimar, 1924

Oskar Schlemmer: Disk dancers from *The Triadic Ballet*. Photomontage

Oskar Schlemmer: Delineation of space by human figures. Theoretical drawings. 1924

Alexander Schawinsky: Tap dancer and tap dancing robot, 1925

Farkas Molnár: U-Theater in action

Oskar Schlemmer: **The Triadic Ballet** ("Das Triadische Ballet"), begun at Stuttgart in 1912.
Ballet in three acts; a climatic development; dance scenes, the meaning of which is intensified as jest becomes earnest. The first act, gay and burlesque, is danced against lemon-yellow stage sets.
The second act is a festive ritual on a pink stage.

The third act, on an all black stage, has a mysterious, fantastic character.
The twelve different dance scenes in eighteen different costumes are executed by three dancers in turn, two male and one female. The costumes consist of padded tights on one side and, on the other, rigid papier-maché forms, with colored or metallic surfaces.

(from Bibl. no. 19)

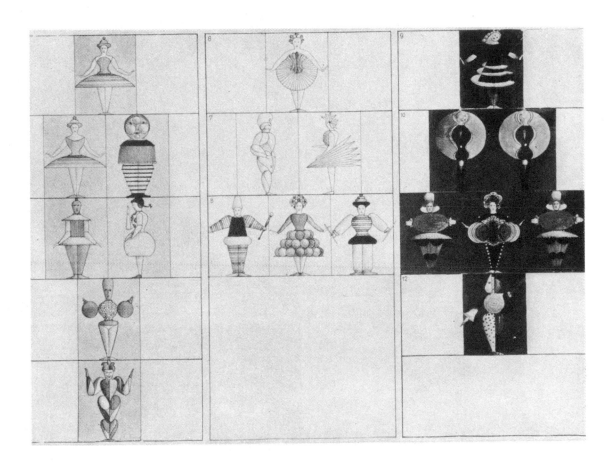

Oskar Schlemmer:
Costumes for the three acts
of *The Triadic Ballet*

63

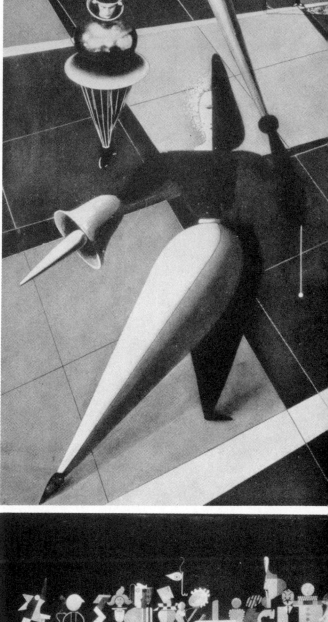

Oskar Schlemmer: Figures in space for *The Triadic Ballet*. Photomontage

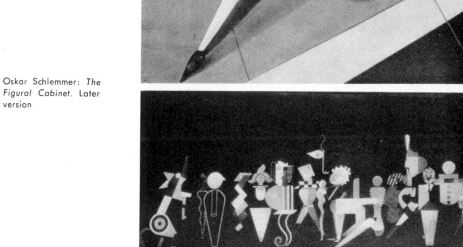

Oskar Schlemmer: *The Figural Cabinet*. Later version

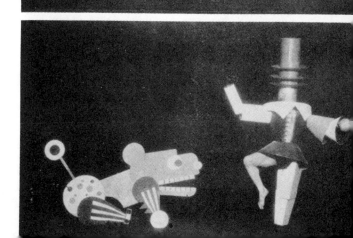

Schawinsky and Fritsch: Scene from *The Circus*. First produced at the Bauhaus, 1924

K. Schwerdtfeger:
Reflected light composition

THE REFLECTED LIGHT COMPOSITIONS OF HIRSCHFELD-MACK

Analogous to the abstract films of Eggeling, Richter and Ruttmann were the reflected light compositions (Reflektorische Lichtspiele) of Ludwig Hirschfeld-Mack. He first produced these on the Weimar Bauhaus in 1922 and later at the People's Theater (Volksbühne) in Berlin. He described his innovation as follows in the *Berliner Börsenkurier* of August 24, 1924:

"Yellow, red, green, blue, in glowing intensity, move about on the dark background of a transparent linen screen — up, down, sideways — in varying tempi. They appear now as angular forms — triangles, squares, polygons — and again in curved forms — circles, arcs and wave-like patterns. They join, and overlappings and color-blendings result.

"At the Bauhaus in Weimar we worked for two years on the development of these reflected light compositions, which had begun as a chance discovery during a simple shadow-play entertainment . . .

After much experiment, control was successfully achieved over what had originally been accidental and by the time it was ready for public display, the process had been matured technically and artistically . . ."

FARBEN-SONATINE II (Rot) von Ludwig Hirschfeld-Mack

Ludwig Hirschfeld-Mack:
Color sonatina in red

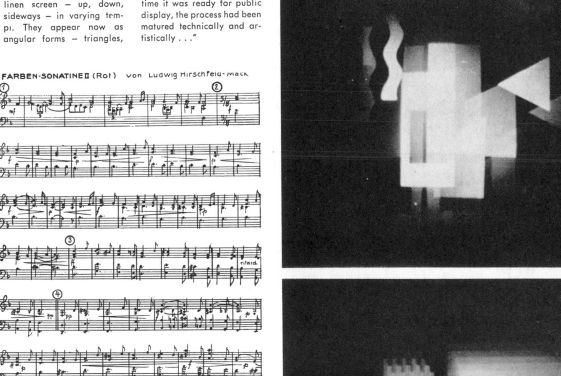

Ludwig Hirschfeld-Mack:
Center and bottom Reflected light compositions

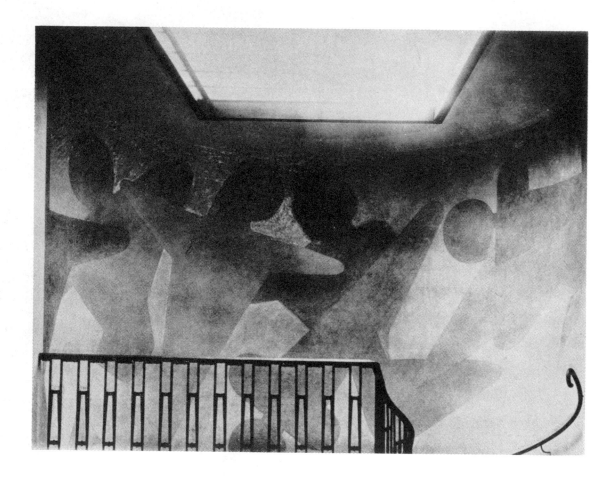

Oskar Schlemmer: Mural
at the head of the stair
well, Weimar Bauhaus.
1921-1922

The following interiors were executed in color by the **wall-painting workshop:**

Theater in Jena, 1922 (building by Gropius)

Sommerfeld House, Berlin, 1922 (building by Gropius)

Otte House, Berlin, 1922 (building by Gropius)

Room at the No-jury Exhibition in Berlin, 1922, from designs by Kandinsky

House "Am Horn," Weimar, 1923 (building by Muche with collaboration of the Bauhaus Architecture Department)

Many private residences

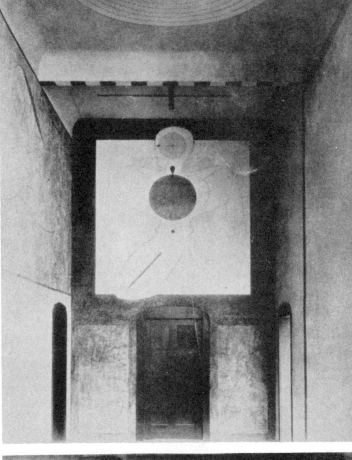

Oskar Schlemmer: Mural in fresco and oils in the entrance hall, Weimar Bauhaus. 1921-1922

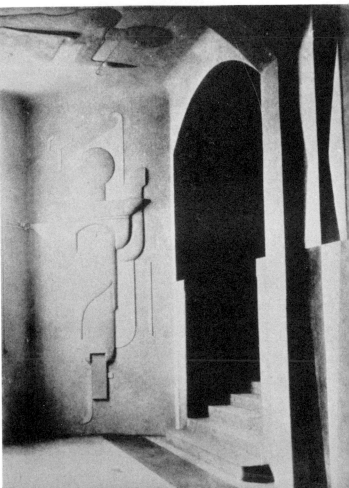

Oskar Schlemmer: Murals and relief in the entrance hall, Weimar Bauhaus. 1921-1922

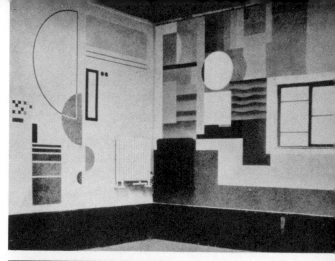

Questionnaire given to all Bauhaus members to investigate psychological relationship between form and color.

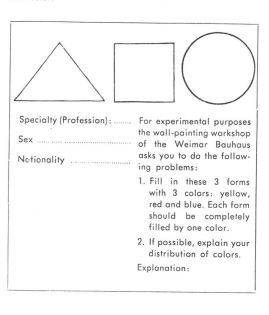

Specialty (Profession):

Sex

Notionality

For experimental purposes the wall-painting workshop of the Weimar Bauhaus asks you to do the following problems:

1. Fill in these 3 forms with 3 colors: yellow, red and blue. Each form should be completely filled by one color.

2. If possible, explain your distribution of colors.

Explanation:

68

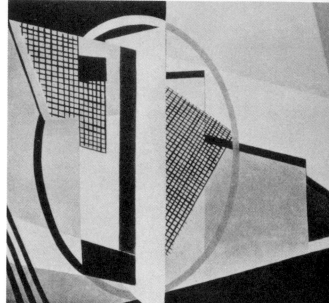

W. Menzel: Fresco in the wall-painting workshop, Weimar

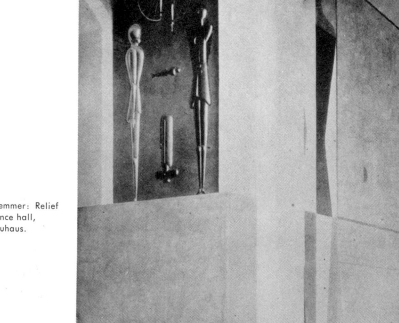

Oskar Schlemmer: Relief in the entrance hall, Weimar Bauhaus. 1921-1922

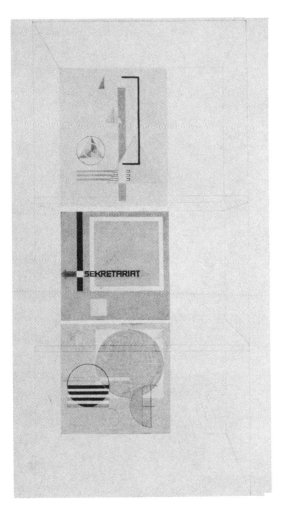

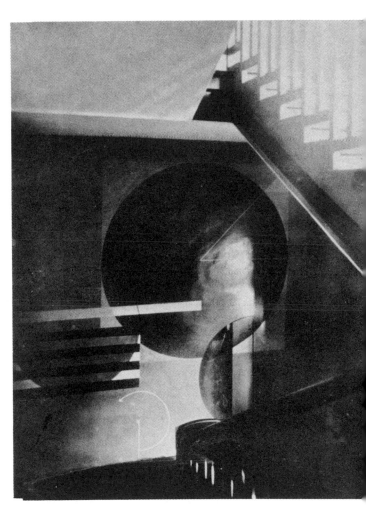

Herbert Bayer: Design for
murals in the stair well,
Weimar Bauhaus. Various
techniques. First floor:
composition in dark blue;
circle. Second floor: com-
position in bright red;
square. Third floor: com-
position in light yellow;
triangle. Application of
experiments in the rela-
tionship between colors
and forms. 1923

Herbert Bayer: Mural in
the stair well, ground floor,
Weimar Bauhaus. 1923

DISPLAY DESIGN

Although there was no specific workshop for exhibition technique, new ideas were developed and fundamental principles outlined

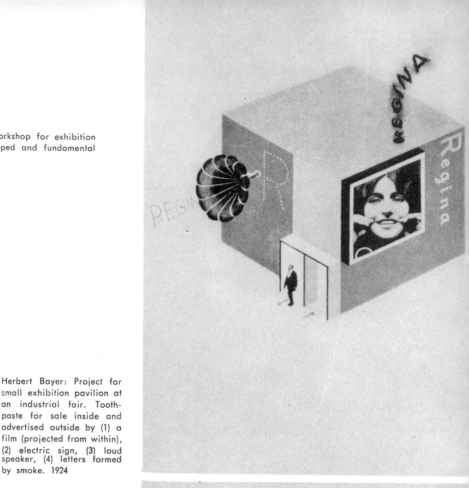

Herbert Bayer: Project for small exhibition pavilion at an industrial fair. Toothpaste for sale inside and advertised outside by (1) a film (projected from within), (2) electric sign, (3) loud speaker, (4) letters formed by smoke. 1924

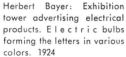

Herbert Bayer: Exhibition tower advertising electrical products. E l e c t r i c bulbs forming the letters in various colors. 1924

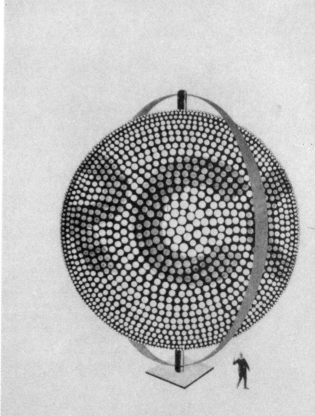

Herbert Bayer: Exhibition pavilion. Revolving sphere covered with electric bulbs forming the letters in various colors. 1924

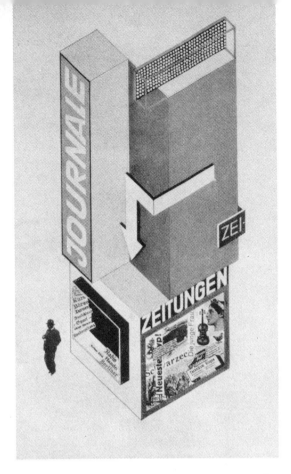

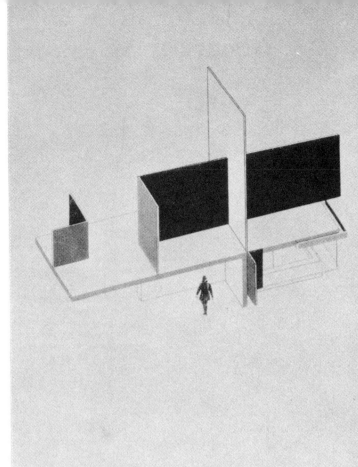

Herbert Bayer: Kiosk designed for the sale and advertisement of newspapers. Small base supporting tall angular superstructure with many different colored areas for posters. 1924

Herbert Bayer: Open streetcar waiting room with news stand. Colored advertisements for various products on the roof. Simple construction adapted to mass production. 1924

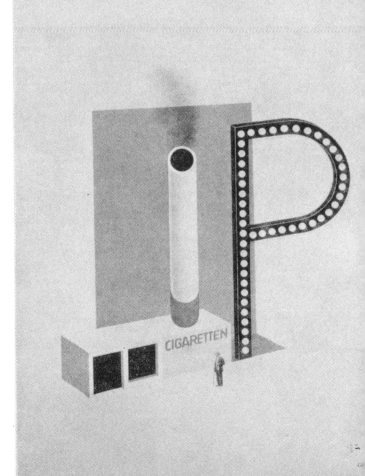

Herbert Bayer: Kiosk designed for the sale and advertisement of a brand of cigarettes. 1924

ARCHITECTURE

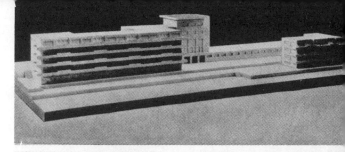

Walter Gropius and Adolf Meyer: Model of proposed academy of philosophy. 1923

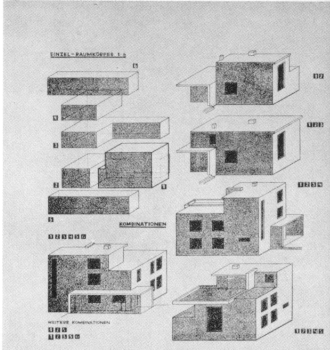

Architecture department: Standardized serial houses. Drawing shows the various units of which the houses are composed according to the needs of the inhabitants. 1921

THE ARCHITECTURE DEPARTMENT

It had been Gropius' intention to reinforce the courses in architecture with a broad program of practical work, but he was hindered in this by lack of understanding on the part of the authorities and by the effects of inflation. He raised money privately to build the house "Am Horn" for the 1923 exhibition, hoping that it would mark the beginning of an extensive housing development. The Thuringian government leased the land surrounding the house "Am Horn" to the Bauhaus and an elaborate building scheme for additional houses was drawn up, but the funds for their construction were never forthcoming.* The correspondence between the Bauhaus administration and the various political regimes reveals both the bureaucratic indolence and the tragic financial impotence which prostrated the country at the time. Nevertheless, in order to assure the workshops some measure of practical building experience, Gropius employed them on his private architectural commissions, including the construction of the theater in Jena and the Sommerfeld residence in Berlin.

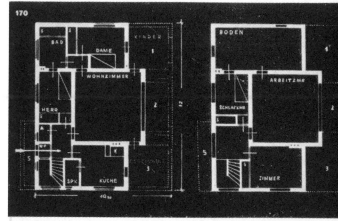

* In order to use the land the director could, therefore, do nothing but turn it over to the students, to be cultivated in their spare time as a service to the Bauhaus community. The garden produce was sold in the Bauhaus canteen. When the progressive catastrophe of inflation menaced this activity Gropius sold an historic family heirloom—a silver table service and linen which had belonged to Napoleon.

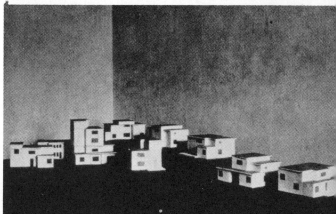

Architecture department: *Below* models showing variations of houses composed of standardised units; *above* plans. 1921

W. Gropius: Sommerfeld House, Berlin, 1921. For the first time Bauhaus workshops actually collaborated in decorating and furnishing the rooms.

Walter Gropius and Adolf Meyer: Model for a house, 1922

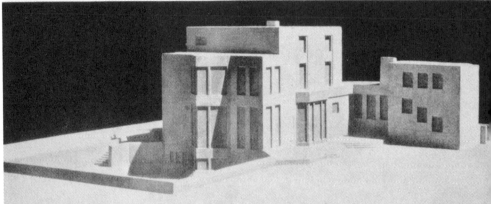

Fred Forbat: Atelier-house and typical floor plan. Three studios and adjacent bedrooms, kitchenette and lavatory. 1922

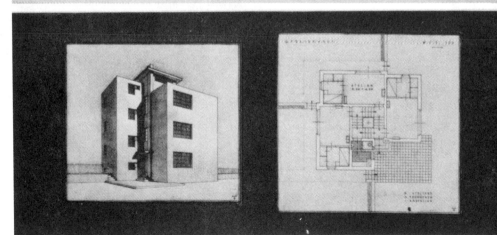

"The Bauhaus settlement was also born from necessity. A vegetable and fruit farm, leased from the State, was worked by the Bauhaus and made the kitchen independent of price fluctuations in the markets. A plan was being evolved for single houses and apartments for Bauhaus members in a beautiful section of Weimar, adjoining the farm. The construction of these community buildings was to be directed by the Bauhaus and to provide contracts for the workshops. Inquiries concerning the Bauhaus settlement were answered by the 'Bauhaussiedlung. G. m. b. H.,' Staatliches Bauhaus, Weiwar."

(From Bibl. no. 4F)

Architecture department: General view of the Bauhaus community planned for Weimar. The house "Am Horn," 1923 (lower left), was the only building completed. Drawing by F. Molnár.

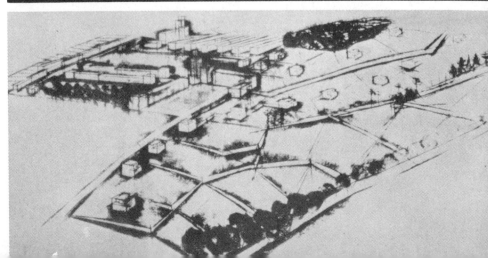

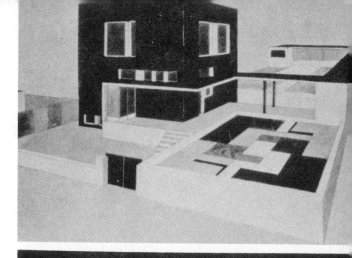

Farkas Molnár: Project for a house; "The Red Cube." 1922

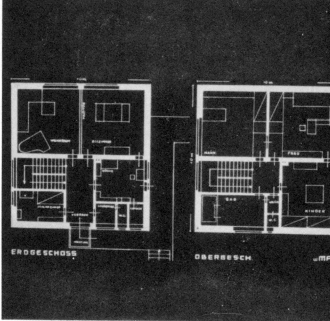

Farkas Molnár: Plans for "The Red Cube." Left: first floor. Right: second floor. 1922

Walter Gropius and Adolf Meyer: Entrance façade of remodeled municipal theater, Jena. 1922

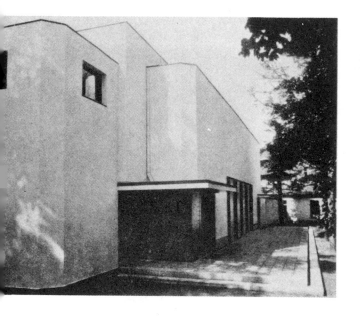

Walter Gropius: Design for a study. Drawing by Herbert Bayer. 1922

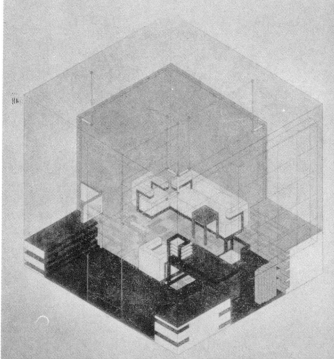

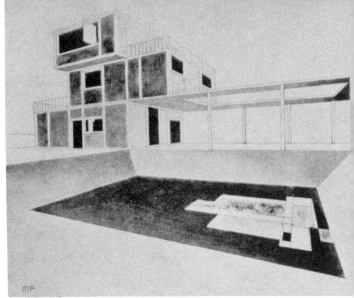

Farkas Molnár: Project for a wood frame house. 1922

Farkas Molnár: Project for a U-theater

Walter Gropius and Adolf Meyer: Project submitted to the Chicago Tribune Competition. Reinforced concrete. 1922

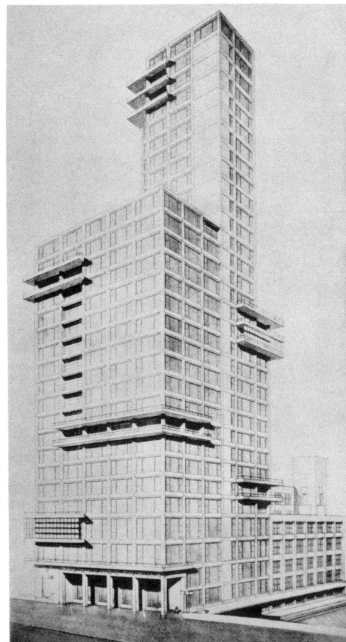

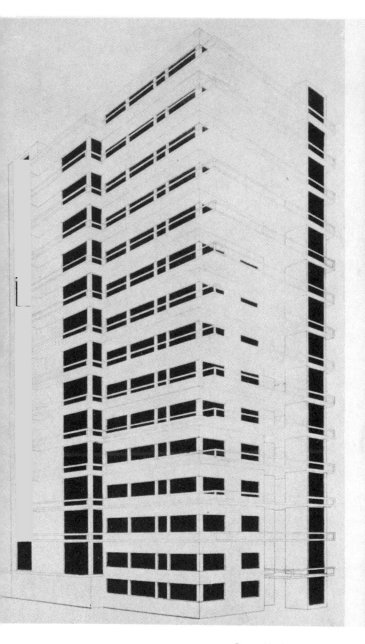

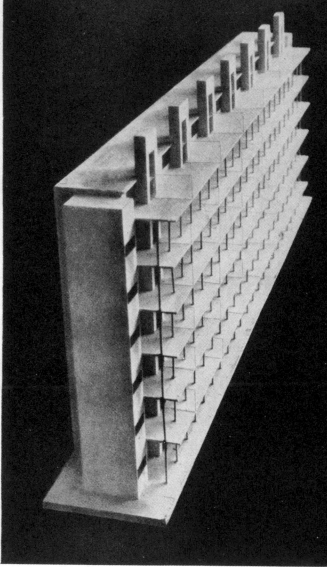

Georg Muche: Project for
an apartment house.
Reinforced concrete. 1924

Marcel Breuer: Model of
proposed apartment
house. 1924

TYPOGRAPHY AND LAYOUT

Albums of lithographs, woodcuts and copperplate engravings (Bibl. nos. 2, 3A, B, C, D, 5, 7) were printed in a **workshop equipped with hand presses.** The albums were bound in the well equipped Bauhaus bindery.

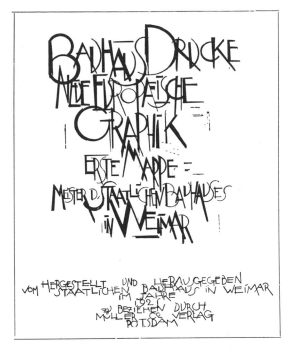

Lyonel Feininger: Title page. *Europäische Graphik*. Woodcut. 1921

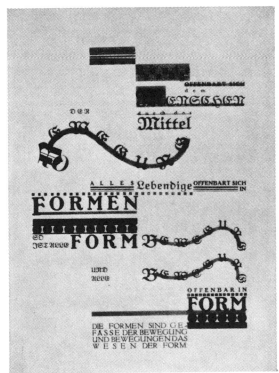

Johannes Itten: Typographical design. Page from *Utopia*. 1921

L. Moholy-Nagy: Title
page. *Staatliches Bauhaus
in Weimar 1919–1923*

TYPOGRAPHY AS A MEANS OF COMMUNICATION
by MOHOLY-NAGY

It must be clear communication in its most vivid form.

Clarity must be especially stressed for clarity is the essence of modern printing in contrast to ancient picture writing.

Therefore, first of all: *absolute clarity* in all typographical work. Communication ought not to labor under preconceived esthetic notions. Letters should never be squeezed into an arbitrary shape—like a square.

A new typographic language must be created, combining elasticity, variety and a fresh approach to the materials of printing,-a language whose logic depends on the appropriate application of the processes of printing.

(from Bibl. no. 8)

THE BAUHAUS PRESS

On the occasion of the 1923 exhibition, the first Bauhaus publication was issued by the newly founded Bauhaus Press (Bauhausverlag), Weimar-Munich (later Albert Langen Verlag, Munich), in collaboration with Karl Nierendorf, Cologne. The book, **STAATLICHES BAUHAUS IN WEIMAR 1919–1923**, edited by Gropius and Moholy-Nagy, is chiefly a record of Bauhaus activities during the first three years.

⫸►

The further aim of the Bauhaus Press was to edit a series of books as evidence of the integration of cultural problems. These Bauhaus books are listed in the bibliography.

Herbert Bayer: Cover
design. First Bauhaus
book. 1923

L. Moholy-Nagy: Page
layout. *Staatliches
Bauhaus in Weimar
1919–1923*

Joost Schmidt: Title page.
Special Bauhaus number
of *Junge Menschen.* 1924

THE 14 VOLUMES OF THE BAUHAUS PRESS

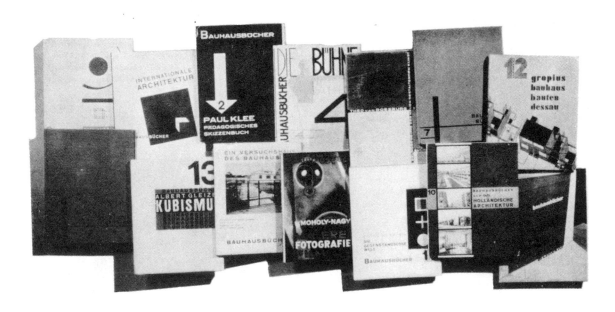

WEIMAR EXHIBITION 1923

"Art and Technics, a New Unity,,

In 1923 the Thuringian Legislative Assembly (Landtag) asked for a Bauhaus exhibition—which would serve as a report on what had been accomplished in four years. (This was contrary to the intentions of the Director, who would have preferred to postpone a public display until more mature results had been obtained.) Every department hummed with activity in order that the exhibition might be a thorough presentation of the ideas which animated the Bauhaus. Gropius stated the theme: **"ART AND TECHNICS, A NEW UNITY."** The exhibition included:

EXHIBITIONS IN THE MAIN BAUHAUS BUILDING:

	designs, murals, reliefs in various vestibules, staircases and rooms; international exhibition of modern architecture.
in the workshops:	products of the workshops.
in the classrooms:	theoretical studies; the preliminary course.
in the State Museum at Weimar:	Bauhaus painting and sculpture.
on the ground of the Bauhaus "settlement" (Siedlung):	one-family house "Am Horn," built and furnished by the Bauhaus workshops.

"BAUHAUS WEEK" PROGRAM:

lectures:	Walter Gropius, "Art and Technics, a New Unity"
	Wassily Kandinsky, "On Synthetic Art"
	J. J. P. Oud, "New Building in Holland"
performances:	Oskar Schlemmer, "Das Triadische Ballett"
	the class in stagecraft, mechanical vaudeville
	C. Koch, lecture with films
	concerts conducted by H. Scherchen
	Program: Hindemith, Busoni, Krenek, Stravinsky
	(Most of the composers were present at the concerts.)
other entertainments:	paper lantern festival, fireworks, dance with music by Bauhaus jazz-band, reflected light compositions

Entrance to the 1923 Exhibition. Poster by Herbert Bayer

Oskar Schlemmer: Cover design for prospectus of the 1923 Exhibition

Fifteen thousand persons visited the Bauhaus exhibition in Weimar, 1923.

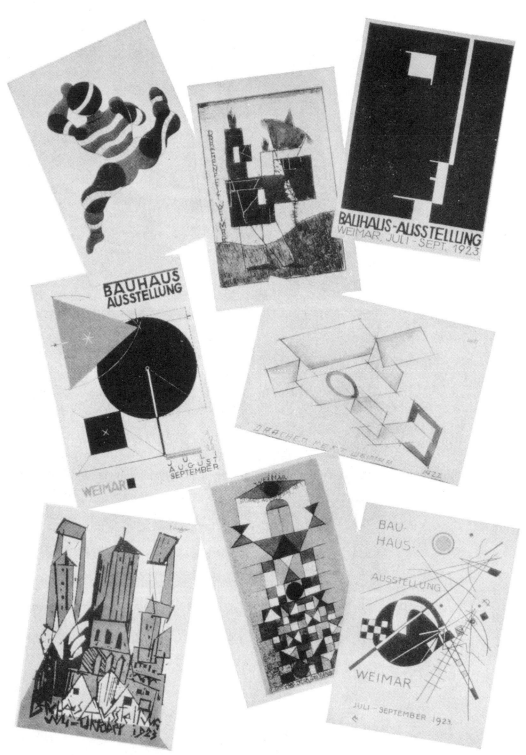

Postcards printed for the George Teltscher Ludwig Hirschfeld-Mack Herbert Bayer
1923 Exhibition Herbert Bayer Farkas Molnár
 Lyonel Feininger Paul Klee Wassily Kandinsky

Experimental building, the
house "Am Horn,"
Weimar. 1923

The house "Am Horn,"
Weimar. Floor plan

82

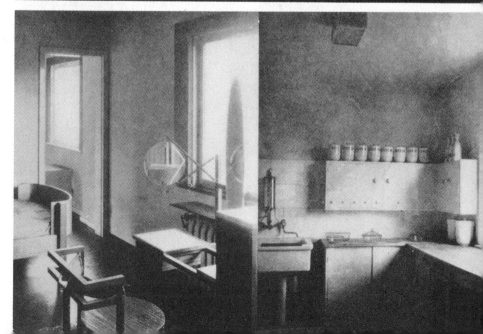

The house "Am Horn,"
Weimar. *Left* Corner of
bedroom. *Right* Kitchen

EXPERIMENTAL BUILDING "AM HORN"

It is hard to realize today to what impassioned pronounce-
ments the first experimental Bauhaus building, the house
"Am Horn," inspired its critics. Their opinions reflected
the conflict between their prejudiced conception of a home
and the effect produced by a new type of house conceived
in new terms.

The Bauhaus had attempted to crystallize the still un-
formulated desires of a new man—the post-war German
—who had not yet realized what he needed. This man
had to construct a new way of life from the debris of a
wrecked world—a way of life utterly different from that
of pre-war times. He had to recreate the world around
him with limited means in a limited space: a task preceded
of necessity by psychological readjustments.

Conservative critics made much of the famous Weimar
"Goethehaus" as an argument against the appropriateness
of the "Haus am Horn." But they were unexpectedly
countered by a young unprejudiced Canadian, Miss G.
Wookey, of the University of Toronto, who observed that
Goethe's garden house in the Weimar park was the only
building in Weimar that possessed a certain congenial
relationship to the Bauhaus.

Herbert Bayer:
Poster for 1923 exhibition

WEIMAR, 1924

The last Leipzig Fair was a distinct success. All Bauhaus
workshops were busy for five months filling orders. At this
time more than fifty firms were buying Bauhaus products
to such an extent that the scarcity of machinery and capital
made it impossible to fill all orders.

Orders were received from abroad, from Austria, England,
Holland, America.

Five hundred and twenty-six students were trained in the
Bauhaus between October, 1919, and April, 1924. A large
number of others took only the preliminary course. In 1923,
in order to maintain the highest possible standard, forty-
seven of these students were not admitted to the advanced
courses.

EXTRA-CURRICULAR ACTIVITIES

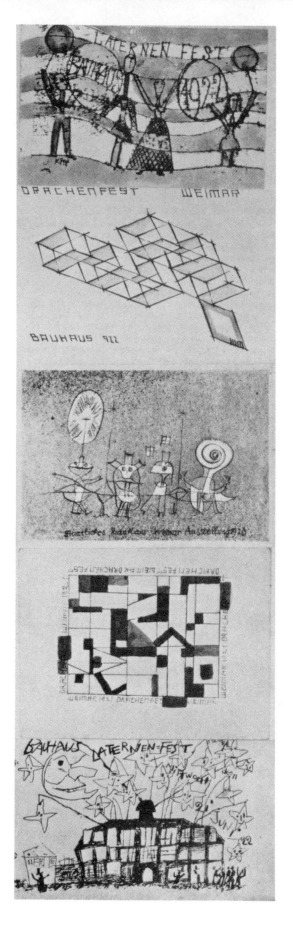

The "kite-festival" was a big yearly event. Every autumn a troop of Bauhaus students went out into the fields to fly the amazing kites which they had built. In the summer, there were parades at night through the peaceful streets of Weimar with paper lanterns of the students' own invention.

Postcards designed for kite-festivals and lantern parades by Klee, Molnár, Klee, Hirschfeld - Mack, Feininger, 1923

Peter Röhl: design for a program, 1921

BAUHAUS EVENINGS

Architects, scholars and painters who were in sympathy with the ideals of the Bauhaus generously contributed their services for "Bauhaus evenings." Among them were such celebrities as the architects Oud, Berlage and Poelzig; the pianist Rudolf Serkin; the violinist Adolf Busch, the composer Bela Bartok; the dancer Palucca; the writer Theodor Däubler; Professor Freundlich of the Einstein Institute; the physio-chemist Wilhelm Ostwald; and the biologist Hans Driesch. Thus the Bauhaus strove to keep in touch with the best and newest in other fields of science and art. The lectures, concerts and dance recitals brought together not only those actually connected with the Bauhaus but also the townspeople interested in the school. In this way they served as a link between the Bauhaus and the community.

THE FRIENDS OF THE BAUHAUS

The association known as "The Friends of the Bauhaus" proved of invaluable moral and financial help during the stormy years of development. Its council was composed of the following:

H. P. Berlage, The Hague
Peter Behrens, Berlin
Adolf Busch, Berlin
Marc Chagall, Paris
Hans Driesch, Leipzig
Albert Einstein, Berlin
Herbert Eulenberg, Kaiserswerth
Edwin Fischer, Berlin

Gerhart Hauptmann, Agnetendorf
Josef Hoffmann, Vienna
Oskar Kokoschka, Vienna
Hans Poelzig, Potsdam
Arnold Schönberg, Vienna
Adolf Sommerfeld, Berlin
Josef Strzygowski, Vienna
Franz Werfel, Vienna

The **Bauhaus band** started with the musical improvisations of a group of painters and sculptors on trips around Weimar. Accordion-music and the pounding of chairs, the rhythmic smacking of a table and revolver shots in time with fragments of German, Slavic, Jewish and Hungarian folk songs would swing the company into a dance. This dance music soon became known all over Germany and was played at artists' festivals everywhere; but since it could never be successfully transferred to paper, it remained gaily impromptu, even later when the instrumentation was expanded to include two pianos, two saxophones, clarinet, trumpet, trombone, banjos, traps, etc.

Ludwig Hirschfeld-Mack:
S Dance

EVERY MAN A MILLIONAIRE

The rapid devaluation of the German mark during the inflation years led to incredible grotesqueness in daily life. At the height of the economic crisis in 1923, money received in the morning had to be disposed of before evening of the same day for by that time it was likely to be valueless. When the Bauhaus Exhibition of 1923 opened, a million marks in paper money equaled in value one mark forty-seven pfennigs in gold. Four months later one reckoned in billions; a man paid for his lunch in billion mark notes. The one million mark note was designed by Herbert Bayer in 1923 for the State Bank of Thuringia. Two days later it was issued with the ink still wet.

Bauhaus whistling tune

Frage ?

Antwort !

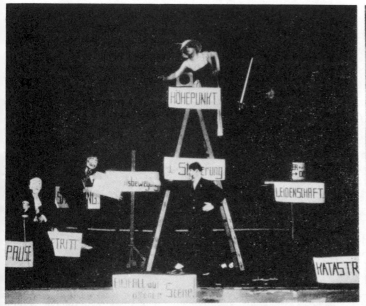

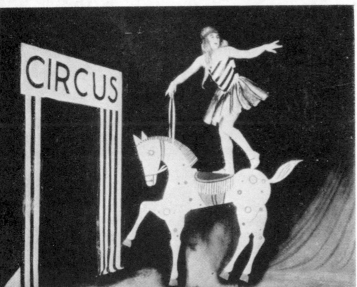

Top, Oskar Schlemmer,
1922; *bottom,* Xanti
Schawinsky, 1924: Impro-
vised sketches at Bauhaus
dances

Marcel Breuer: Birthday
greetings to Walter
Gropius

The **Bauhäusler** presented a highly curious appearance to the provincial eyes of the Weimar citizenry. Partly through pure fantasy, and partly through enthusiasm for clothes intended to forecast future styles, he wanted to express in dress his entire independence of conventional modes. He was so wrapped up in the fascinating task of discovering and shaping his own ego and his environment that he scarcely observed the radical contrast between his own intensive existence and the ordinary small-town life which surrounded him. Still less did he think of recording in word or photograph the life of those first few colorful and explosive years at the Weimar Bauhaus. Absorbed in living, he found no time for the task of observing and recording.

Marcel Breuer: Portrait of
Josef Albers. Etching

One student did tailoring work. Under Itten's influence, he made fantastic Bauhaus clothes: wide trousers without creases, narrow at the feet, high closed jacket with a belt, scarf held by a pin. After the first romantic years these clothes were discarded in accordance with Gropius' opinion that the artist of today should wear conventional clothing.

Like so many generations of young Germans, Bauhaus students went south to Italy. Mostly on foot, like vagabonds, they earned their living along the way as craftsmen, mechanics or painters.

The **Bauhaus canteen** enabled the students to eat well for little money. The poverty of a great many Bauhaus apprentices and journeymen made the canteen a vital necessity. It was made possible by the unselfish aid of Bauhaus members and friends. Some of the canteen work was done by the Bauhaus members themselves.

Every Saturday a **Bauhaus dance** was held either in Weimar or in one of the many nearby country inns. The great enthusiasm of the early days in Weimar found an outlet in spontaneous shows and parties for which fantastic masks and costumes were improvised. Improvised, too, were the posters which appeared in the Bauhaus lobby every week to announce the dances. For private celebrations, such as birthdays, a special kind of "gift design" (Geschenkgraphik) was developed. Somewhat influenced by Dadaism, these unconventional and imaginative designs played an important part in the development of lay-out and typography.

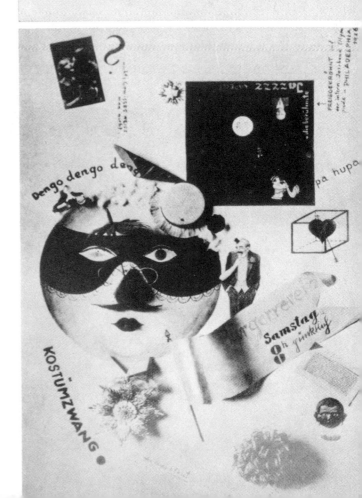

Herbert Bayer: Poster for
Bauhaus dance. 1923

PRELIMINARY COURSE: MOHOLY-NAGY

Owing to differences of opinion as to the actual conduct of the course, **ITTEN** left the Bauhaus in the spring of 1923. About this time Josef Albers, who had been a student at the Bauhaus, began to work actively on the development of the preliminary course. He took charge of the studies in materials and continued this work even when Moholy-Nagy was called to the Bauhaus shortly afterward to direct the preliminary course. Each taught independently and thus widened the scope of the teaching. Because of his unusual pedagogic gifts, Albers was formally offered a position as teacher at the Bauhaus after the institution had moved to Dessau. From then on, he directed the preliminary course during the first term, while Moholy-Nagy took over the second term. When Gropius and Moholy-Nagy left the Bauhaus in 1928, Albers continued to teach in both preliminary classes until the closing of the Bauhaus in April, 1933.

Suspended construction.
1923

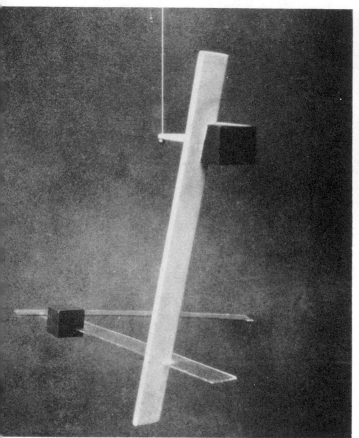

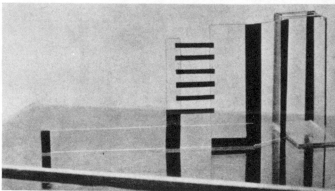

Irmgard Sörenson-Popitz:
Suspended construction.
1924

Charlotte Victoria: Study
in volume and space.
Glass and calico. 1923

PRELIMINARY COURSE: ALBERS

Toma Grote: Study in balance, based on specific gravities of various woods. Right half is made of heavy wood to balance projection of left half which is of light wood. Whole construction rests in perfect balance upon a single point. 1924

The work with materials in this course was planned to prepare the first semester students for later craft-studies in the various Bauhaus workshops. The students were introduced to a simple and elementary, but appropriate use of the most important craft materials, such as wood, metal, glass, stone, textiles and paint, and to an understanding of their relationships as well as the differences between them. In this way we tried, without anticipating later workshop practice, and without workshop equipment, to develop an understanding of the fundamental properties of materials and the principles of construction.

To this end we analyzed typical treatments and combinations of materials, and worked them out with our hands. For instance, we visited the workshops of box, chair and basket-makers, of carpenters and cabinet-makers, of coopers and cartwrights, in order to learn the different uses of wood, the different characteristics of flat grain and quarter-sawing, split, bent and laminated wood, and to learn the various methods of joining: glueing, nailing, pegging and screwing.

We tried to apply our knowledge to the making of useful objects: simple implements, containers, toys and even toy furniture, first of one material alone, later of several combined materials, but, as already indicated, using no machines and only simple everyday tools. Thus, at first, we studied material more or less on a traditional handicraft basis.

Paul Reichle: Construction. 1924

Soon, however, we expanded our practical work to allow more inventiveness and imagination, as a fundamental training for later specialized design. This development is briefly described in my article on our more developed preliminary course at Dessau, (page 114).

89

Illustrations are of work done in Moholy-Nagy's course.

OPPOSITION TO THE BAUHAUS

on the part of authorities

The Non-Political Character of the Bauhaus

Throughout its existence, the Bauhaus found itself involved in the political convulsions of post-war Germany. In Thuringia, the government ran the gamut from Left Socialist to the "People's Party," the forerunner of the National Socialist Party. The fact that the Bauhaus happened to open during a Socialist regime (the program had been initiated earlier under the patronage of the Grand Duke of Saxe-Weimar), caused it to be attacked by all subsequent governments on the grounds that the Socialists had started it. Gropius foresaw these difficulties. He found it necessary at an early date to prohibit political activity of any kind in the Bauhaus, and faculty and students held themselves aloof from participation in the work of any political party. Although the enemies of the school tried in every conceivable way to confirm their suspicions (they even went so far as to order house-to-house searches by the military authorities) they never succeeded in producing any convincing proof. But without its nonpartisan attitude, the institution would certainly have come to a premature end.

on the part of officials

90

From a letter from the Business Manager (Syndikus) of the Bauhaus to the Director

. . .Since October, 1922, I have done my utmost to further the development of the Bauhaus. Cooperation, which should have been a matter of course on the part of Government officials, notably the Department of Finance, has not been forthcoming; the attitude shown by superior officials is malevolent, obtuse and so inflexible as constantly to endanger the growth of the institution; furthermore, this attitude has entailed financial loss. Until recently it was possible to avert the most pressing dangers, but since the advent of the new government the official attitude, which had hitherto been indifferent, has changed into open animosity . . .

(signed) Emil Lange
29/3/1924

on the part of the crafts

The Bauhaus workshops prepared designs much in the manner of a laboratory for industrial and craft use. Not only was this in accord with the original conception of the Bauhaus; it also took the sting out of the attacks (foreseen from the start!) of craft organizations, which opposed the sale of actual objects produced at publicly financed schools as unfair competition with private enterprise. But the sale of Bauhaus designs in return for royalties on mass produced objects could not be denounced as competition with the handicrafts.

The shortsighted attitude of the craftsmen's organizations in Germany was one of the greatest obstacles the Bauhaus encountered. Instead of recognizing the Bauhaus as a natural link between craft and industry, they fought it, and feared it as a new factor likely to accelerate that decline of the crafts which had resulted from 20th century industrial development.

Bravo

Schlossermeister Arno Müller für die trefflichen Worte contra Bauhaus! Quousque tandem?

146

From a newspaper:
Bravo, Locksmith Arno Müller, for your telling words against the Bauhaus!
How long . . .?

PRESS COMMENTS 1923-1932

The critics of the Bauhaus showed a tendency, typical of the period, to narrow down the comprehensive Bauhaus program in order to make it fit in with one of the many different cultural ideologies then current. However, the Bauhaus never forced its natural growth, never chose a policy prematurely and preserved thereby its main source of strength. A characteristic critical estimate appeared in *Stavba*, the leading architectural periodical in Czechoslovakia, where, in *1924, Karel Teige* wrote: ". . . unfortunately, the Bauhaus is not consistent, as a school for architecture, as long as it is still concerned with the question of applied arts or 'art' as such. Any art school, no matter how good, can today be only an anachronism and nonsense . . . If Gropius wants his school to fight against dilettantism in the arts, if he assumes the machine to be the modern means of production, if he admits the division of labor, why does he suppose a knowledge of the crafts to be essential for industrial manufacture? Craftsmanship and industry have a fundamentally different approach, theoretically as well as practically. Today, the crafts are nothing but a luxury, supported by the bourgeoisie with their individualism and snobbery and their purely decorative point of view. Like any other art school, the Bauhaus is incapable of improving industrial production; at the most it might provide new impulses.

"The architects at the Bauhaus propose to paint mural compositions on the walls of their rooms, but a wall is not a picture and a pictorial composition is no solution of the problems of space . . . Modern artistic vitality has at last come to deny painting and sculpture as such."

In contrast to the above is a review of the exhibition of 1923 by the Swiss art historian, *Siegfried Giedion*[*], in *Das Werk*, Zurich, September, 1923:

"After three and a half years of existence the Bauhaus at Weimar called in its friends and foes to judge for themselves its aims and achievements. It is assured of respect in any case. It pursues with unusual energy the search for the new principles which will have to be found if ever the creative urge in humanity is to be reconciled with industrial methods of production. The Bauhaus is conducting this search with scant support in an impoverished Germany, hampered by the cheap derision and malicious attacks of the reactionaries, and even by personal differences within its own group.

"The Bauhaus is undertaking the bold and, in these times, almost presumptuous task of reviving art. It tears down the barriers between individual arts. . . It recognizes and emphasizes the common root of all the arts."

The opinion of a German trade paper, *Stein Holz Eisen (Stone Wood Iron)*, on the inauguration of the Bauhaus at Dessau, *1926*.

"On December 4th, the formal inauguration of the new

Bauhaus building will take place. The word 'Bauhaus' has become a rallying-cry for friend and foe. To do it justice, we must don neither the rose-colored glasses of boundless enthusiasm nor the black spectacles of blind refusal-to-see. It is possible to state quite soberly what the Bauhaus is worth to Germany and what it may be worth in the future. It should be valued as the first and, until now, virtually the only institution for practical experiment in new materials, new methods and new forms, the only institution concerned with the integration of all aspects of contemporary culture. It is understandable and human that such an experiment, in the midst of presentday chaos, should not proceed without clashes of opinion. . . . But that is not the main thing. The Bauhaus is of national importance; it concerns all Germany."

Walter Curt Behrendt[*] in the Deutsche Allgemeine Zeitung, October 2, 1923, commenting on the exhibition of 1923:

"Apprentices at the Bauhaus are taught by two masters, a craftsman and an artist, working in close cooperation. The difficulties of this novel method of education begin here. The dualism of this system can never lead to that unity of art and technics of which Gropius dreams . . . And after a careful scrutiny of the results obtained in Weimar, it is to be feared that this method at the Bauhaus cannot avoid creating again the same dangerous dilettantism . . . The problem remains, as before, how to educate human beings to meet the most urgent needs in the field of industrial production. The road chosen by the Bauhaus will not, we believe, lead to this goal . . . Nevertheless, the experiment begun here by a few courageous and steadfast men remains a valuable one in spite of all the problems it raises, and it should be allowed to continue under all circumstances."

Theo van Doesburg, 1924:

"When I first became acquainted with the aims of the Bauhaus, I was not only amazed but enthusiastic. Where else in the world was it possible to satisfy the new desire for a systematic art education, a desire which had begun to assert itself in all countries in the fields of art, science and technics? Where else but here in Weimar was a generation struggling for self-expression offered the possibility of developing its creative powers? Neither in France, nor England nor anywhere else was there an institution where the students themselves were encouraged to create, instead of being taught merely to repeat that which had already been created . . . The Bauhaus is open to criticism in many respects; as a whole it shall not and must not be attacked."

Inspired by the Bauhaus Exposition of *1923* Dr. Harkort, the proprietor and manager of a ceramics plant at Velten, near Berlin, wrote in the periodical *Die Kachel- und Töpferkunst (The arts of tile and pottery)*:

* Charles Eliot Norton Lecturer, Harvard University, 1938-1939.

* Special lecturer at Dartmouth College, 1934; late Technical Director of Research Station, Buffalo City Planning Association and lecturer at the University of Buffalo.

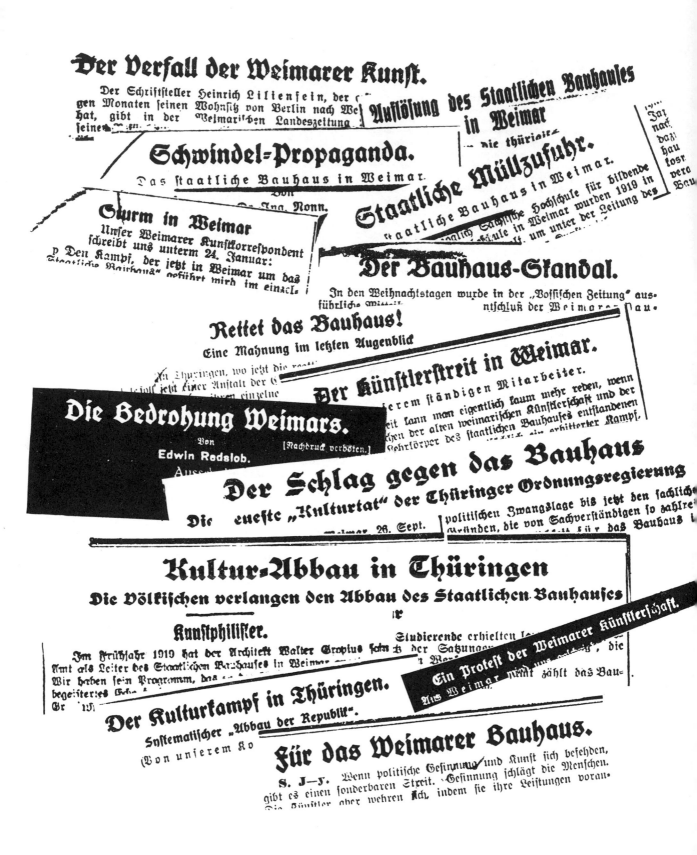

Der Verfall der Weimarer Kunst.

Der Schriftsteller Heinrich Lilienfein, der [...] gen Monaten seinen Wohnsitz von Berlin nach We[...] hat, gibt in der Weimarischen Landeszeitung [...] seines [...]

Auflösung des Staatlichen Bauhauses in Weimar

die thüring[...]

Schwindel-Propaganda.

Das staatliche Bauhaus in Weimar.
Von
Dr. Ing. Nonn.

Sturm in Weimar

Unser Weimarer Kunstkorrespondent schreibt uns unterm 24. Januar:
"Den Kampf, der jetzt in Weimar um das Staatliche Bauhaus geführt wird im einzel[...]

Staatliche Müllzufuhr.

Staatliche Bauhaus in Weimar.
[...]glich Sächsische Hochschule für bildende [...]schule in Weimar wurden 1919 in [...] um unter der Leitung des

Der Bauhaus-Skandal.

In den Weihnachtstagen wurde in der "Vossischen Zeitung" ausführlich mitteil[...]
[...]ntschluß der Weimarer Bau[...]

Rettet das Bauhaus!

Eine Mahnung im letzten Augenblick

In Thüringen, wo jetzt die re[...]
[...] soll jetzt einer Anstalt der G[...]
[...] ihren einzelne

Die Bedrohung Weimars.

Von
Edwin Redslob. [Nachdruck verboten.]

Der Künstlerstreit in Weimar.

[...]erem ständigen Mitarbeiter.
[...]eit kann man eigentlich kaum mehr reden, wenn
[...]hen der alten weimarischen Künstlerschaft und der
[...]en der alten weimarischen Bauhauses entstandenen
[...]hrkörper des staatlichen Bauhauses [...] ein erbitterter Kampf.

Der Schlag gegen das Bauhaus

Die neueste "Kulturtat" der Thüringer Ordnungsregierung

Weimar, 26. Sept.
politischen Zwangslage bis jetzt den sachlich[...]
[...]ründen, die von Sachverständigen so zahlre[...]
[...] für das Bauhaus [...]

Kultur-Abbau in Thüringen

Die Völkischen verlangen den Abbau des Staatlichen Bauhauses

Kunstphilister.

Im Frühjahr 1919 hat der Architekt Walter Gropius sein [...] der Satzung[...]
Amt als Leiter des Staatlichen Bauhauses in Weimar [...]
Wir haben sein Programm, das [...]
begeistertes [...]
Gr [...]

Studierende erhielten [...]

Ein Protest der Weimarer Künstlerschaft.

Aus Weimar [...] zählt das Bau[...]

Der Kulturkampf in Thüringen.

Systematischer "Abbau der Republik".
(Von unserem Ko[...]

Für das Weimarer Bauhaus.

s. J-y. Wenn politische Gesinnung und Kunst sich befehden, gibt es einen sonderbaren Streit. Gesinnung schlägt die Menschen, die Künstler aber wehren sich, indem sie ihre Leistungen voran[...]

"It is evident that a fundamental improvement in industrial production, which all informed persons agree is necessary, depends largely on the widespread and enthusiastic participation of artists. They should not remain aloof from this important task but undertake it as the most pressing problem of the present day; for its benefit they must sacrifice their own pleasant individual preoccupations.

"The Bauhaus wants to enlist an entire generation of artists in a struggle to solve the creative problems of industrialism. It used to be more or less a chance occurrence for a creative artist to find his way into a factory and master the problems put to him. This will now be done consciously and to an extent worthy of the importance of these problems.

"The ceramics industry, in particular, where esthetic considerations are so imperative and where industrial requirements have had a particularly devastating influence on artistic quality, should feel obliged to participate in the effort made at Weimar and should be eager to accept and develop what has been begun there."

Dr. E. Redslob, National Art Director of Germany, commenting on the plans for the House "Am Horn" to be erected for the proposed exhibition in 1923:
"Invited by the Director of the Bauhaus to make a statement concerning the plans for a house in the proposed exhibition in 1923, I affirm that I can hardly imagine, under present circumstances, a plan more suited for exe-

cution in an exhibition than the one submitted. As a matter of principle, I am sceptical about the construction of houses for display purposes, but in this case it is a question of a new type of building, the realization of which is likely to have far-reaching cultural and economic consequences. The need for a strictly economical method of construction, as well as our altered way of life seem to call for a new treatment of the one-family house in which it ceases to be an imitation of the villa with rooms of equal size. There is evidence that a type of design is developing which organically unites several small rooms around a large one, thus bringing about a complete change in form as well as in manner of living. Of all the plans I have seen, none appears to me to be so apt to clarify and to solve the problem as the one submitted by the Bauhaus. The plight in which we find ourselves as a nation necessitates our being the first of all nations to solve the new problems of building. These plans clearly go far toward blazing a new trail."

The relation between the Bauhaus and the State Government presented a problem which confronted almost all publicly appointed directors of cultural institutions in the new democracy: how far the democratic principle of the vote should be allowed to interfere with non-political matters. Koch, a democratic Secretary of State, finally settled the dispute by declaring that any kind of public voting on questions of art was an absurdity.

The **Deutsche Werkbund,** under the leadership of its president, the architect Hans Poelzig, adopted the same point of view, in a letter addressed to the government of the free state of Saxe-Weimar:
"The public controversy now raging around the Bauhaus at Weimar is no local matter; in more ways than one, it concerns all those interested in the growth and development of our art. It is always undesirable to confuse problems of art with political trends. The fury of political strife injected into all discussion of the work and purpose of the Bauhaus impedes any real consideration of the great and important experiment boldly going forward here. We trust that the officials and departments having jurisdiction over this matter will do their utmost to prevent political passions from destroying an undertaking which should not be measured by personal prejudices or by considerations foreign to art, but solely by its own straightforwardness and its own unimpeachable objectives."

F. H. Ehmke, a well known art teacher and typographer, commenting on the cover of the book, **Staatliches Bauhaus Weimar** (Bibl. no. 8), **1923:**
"Wholly concerned with shopwindow effects, or, if one wants to be nasty, sheer bluff; brutal in coloring, without refinement of form . . ."

Bruno Taut, architect, commenting on the Preliminary Course:
"The method of testing a student by letting him experi-

◄≡

A FEW HEADLINES

The Collapse of Weimar Art
Disintegration of the Staatliche Bauhaus in Weimar
Swindle-Propaganda
Storm over Weimar
Staatliche Rubbish
Bauhaus Scandal
Save the Bauhaus!
The Menace of Weimar
The Art War in Weimar
The Assault on the Bauhaus
Culture Demolition in Weimar
The Cultural Fight in Thuringia
Protest of the Weimar Artists

ment independently and freely often seems curious to the layman; but for the teacher it is the most infallible indication of whether a student has any creative ability and whether he can profitably be admitted to a specified workshop. This method of selection is, perhaps, one of the most important achievements of the Bauhaus."

Kole Kokk in the **8 Uhr Abendblatt, Berlin,** February, **1924,** wrote of the Bauhaus dances:

"The Ilmschlösschen (an inn) is far out in the country, in Oberweimar. What a delicate poetic name, and what a shack thus decorated! Through a narrow passageway one penetrates into a dance hall of medium size, of luxuriant ugliness. The decorative murals date assuredly from the '80's; they represent maidens playing the harp on some green meadow in paradise. Can it be that the pupils of Lyonel Feininger, of Kandinsky or Paul Klee are going to dance here? Idle doubts disappeared after an hour's enthusiastic participation! In this throne-room of Kitsch [cheap bad taste] there is more real youthful artistic atmosphere than in all the stylishly decorated artists' balls of Berlin. All is primitive, there is not the least refinement, nor is there that yawning blasé demeanor nor that overheated atmosphere which necessitates the stationing of a policeman in front of every dark recess at our balls in Berlin. Everything has been done by the Bauhaus students themselves. First of all, there is the orchestra, the best jazz band that I ever heard ragging; they are musicians to their fingertips. In invention and glorious coloring the costumes leave far behind anything that can be seen at our performances... The Bauhaus community, masters, journeymen, apprentices, form a small island in the ocean of the Weimar bourgeoisie. Four years of serious labors have not been able to accustom the Bauhaus people to the good folks of Weimar—and vice-versa. . . ."

In 1930 the *Salon des Artistes Décorateurs* in Paris included an exhibition of the *Deutsche Werkbund,* organized under the direction of Walter Gropius with the collaboration of Herbert Bayer, Marcel Breuer and László Moholy-Nagy. On this occasion **Paul Fierens** wrote in the **Journal des Debats, June 10, 1930:**
"In all European countries, the same ideas have been advanced, the same efforts are being made. In our own country they are too dispersed. In Germany, they are more concentrated; artists and industrialists are working together in the same spirit. The Bauhaus at Dessau represents a whole generation of explorers capable of exploiting the numerous resources of modern technics; it is a school and a laboratory at the same time. Germany has realized the importance of the problem, which she has considered in connection with the social readjustment now going on. And that is why, in the history of architecture and the industrial arts of the 20th century, Germany will have the lion's share."

In June, **1924, Dr. August Emge,** Professor of National Economy and Philosophy at the University of Jena, pub-
lished two lectures entitled **The Conception of the Bauhaus.** Basing his views on the theses set forth by Gropius in his essay, *The Theory and Organization of the Bauhaus* (Bibl. no. 9), Dr. Emge compared the "esthetic synthesis" of the Bauhaus with its "social synthesis."
After quoting the Gropius thesis "mechanized work is lifeless, proper only to the lifeless machine. . . . The solution depends on a change in the individual's attitude toward his work, not on the betterment of his outward circumstances," Dr. Emge writes: "A blunter rejection of Marxism and kindred Utopias is inconceivable. It is clearly stated here that harmonious creation is an ethical problem to be solved by the individual."
Later he alludes to the relation of the Bauhaus conception to the contemporary world: "A movement which is timely in the best sense of the word cannot be said to deny history.... It is difficult to determine just how the artist is affected by tradition. Tradition must live in a man—it cannot be cultivated in him. 'Once spirit has taken on material form,' says Hegel, 'it is futile to try to impose on it forms evolved by earlier cultures; they are like withered leaves thrust aside by buds which have been nourished from the same roots.' It may be true even in other fields of endeavor that tradition must make itself felt harmoniously, unobtrusively and subconsciously, but it is especially applicable in the realm of art. Esthetic tradition is embodied in style. But a style must be inborn in the artist and generic to its epoch as were the great styles of the past. All conscious attempts to gain insight into the essence of a style, all artificial preservation, lead to an historical attitude which is hostile to life and, considering the multiplicity of choice, to a chaos of style, in one and the same period."

Attacks on the Bauhaus
The following quotation from an article by **H. Pflug,** printed in the political weekly **"Die Tat"** in 1932, describes the unceasing warfare the Bauhaus was forced to wage against its adversaries.
"Different valuations may be placed on the role of the Bauhaus in the development of modern architectural design, but undoubtedly that role was a great one. The violence of the attacks testified to the strength and historical significance of Bauhaus ideas. The political attacks had as their basis psychological and philosophical resentment. Those no longer able or not yet willing to change and learn, realized that the Bauhaus stood for a new life and a new style in a new time. Philistines and reactionaries rebelled. All the animosity they could not unload elsewhere was directed against the visible embodiment of what they feared."

The following persons and societies participated in the flood of protests against the discontinuance of the Bauhaus at Weimar which were addressed to the Government of the State of Thuringia:

Professor Peter Behrens	Professor Bernhard Pankok
Professor Lovis Corinth	Dr. Max Osborn
Professor Albert Einstein	Professor Dr. Hans Thoma
Dr. Alexander Dorner	Professor Josef Hoffmann
J. J. P. Oud	Hugo von Hoffmannsthal
Professor Dr. C. Fries	Professor Oskar Kokoschka
Dr. Gerhart Hauptmann	Professor Max Reinhardt
Ludwig Justi	Arnold Schönberg
Miës van der Rohe	Professor Strygowski
Dr. Roland Schacht	Franz Werfel
Hermann Sudermann	Gräfin Kalkreuth
Professor Rohlfs	Dr. N. Muthesius
Professor Dr. Riemerschmied	and many others
Professor Hans Poelzig	

League of German Architects (Bund Deutscher Architekten)
Architects Society "Architectura et Amicitia," Amsterdam
German Werkbund (Deutscher Werkbund)
Austrian Werkbund (Österreichischer Werkbund)
Society of Social Building Trades (Verband Sozialer Baubetriebe)
Society of German Art Critics (Verband Deutscher Kunstkritiker)

Newspapers from the following cities recommend the continuance of the Bauhaus:

Berlin	Apolda
Bielefeld	Leipzig
Weimar	Hamburg
Dresden	Munich
Darmstadt	Frankfort
Jena	Stuttgart
Bremen	Heilbronn
Chemnitz	Hanover
Magdeburg	Karlsruhe
Erfurt	

Also protesting the discontinuance of the school at Weimar were the following publications:

Germany:	*Holland:*
Die Tat	Telegraaf, Bouwerkundig
Der Cicerone	Weekblad, Nieuwe Rotterdamsche Courant
Weltbühne	
Die Bauwelt	*Czechoslovakia:*
Kunstkronik im Kunstmarkt	Pragertageblatt
Schatzkammer	
	Hungary:
Switzerland:	A Magyar, Budapest
Neue Züricher Zeitung	
Das Werk	*U. S. A.:*
	The Freeman, New York

THE BAUHAUS QUITS WEIMAR

From a letter to the Government of Thuringia

Weimar, December 26th, 1924

The Director and masters of the State Bauhaus at Weimar, compelled by the attitude of the Government of Thuringia, herewith announce their decision to close the institution created by them on their own initiative and according to their convictions, on the expiration date of their contracts, that is, April first, nineteen hundred and twenty-five.

We accuse the Government of Thuringia of having permitted and approved the frustration of culturally important and always non-political efforts through the intrigues of hostile political parties. . . .

(signed by all the masters)

From a letter to the Government of Thuringia

Weimar, January 13th, 1925

We notify the Government of Thuringia that we, collaborators at the State Bauhaus at Weimar, shall leave the Bauhaus together with the leaders of the Bauhaus, because of the actions of the State Government . . .

(signed by all the students)

Menaced by an incomprehending and antagonistic government and conscious of their solidarity and rights as founders of the institution, the director and council of masters decided, at Christmas time, 1924, on the dissolution of the Bauhaus in order to forestall its destruction. In spite of all prophecies to the contrary, this step proved to be wise. The *esprit de corps* which had gradually developed among the students and masters withstood this trial. Of their own accord, the students informed the government that they stood with the director and masters and intended to leave with them. This united attitude was reflected in the entire press and decided the future of the Bauhaus. Various cities, Dessau, Frankfort, Hagen, Mannheim, Darmstadt, opened negotiations with a view to transplanting the Bauhaus. On the initiative of Mayor Hesse, Dessau, in the center of the mid-German coal belt, invited the entire Bauhaus to reestablish itself there. This invitation was accepted and, after carrying out their contracts in Weimar, masters and students moved to Dessau in the spring of 1925 and there began the reorganization of the Bauhaus.

a fresh start at **DESSAU, APRIL, 1925**

Joost Schmidt: cover from
a prospectus advertising
Dessau. 1928

ADVANTAGES OF THE SMALL TOWN

Only those familiar with the cultural quality and impor-
tance of the provincial German town can understand
why on two occasions a small town was chosen as the
site of the Bauhaus. Germany has an unusually large
number of small towns unique and inimitable in charac-
ter. Thanks to their civic structure and their spiritual
vitality, they provide an ideal environment for cultural
movements which require strong personal direction and
a favorable atmosphere. Comparatively simple adminis-
trative machinery; comparatively few authorities (whose
decisions can be quickly carried out); a community
whose various elements are clearly differentiated and
defined—these are the advantages of the provincial city.
Both in Weimar and in Dessau a fruitful working atmos-
phere, free from distraction, and the proximity of beauti-
ful natural surroundings were indispensable factors in
the lives of those who worked at the Bauhaus.

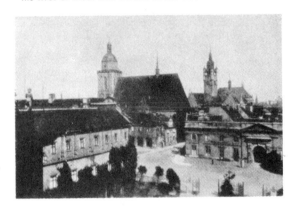

DESSAU. Mentioned for the first time in 1213. Since 1603
the seat of a line of the house of Anhalt. Important indu-
strial town and transportation center: Junkers Works (all-
metal airplanes), chemical industry, manufacture of mach-
inery, railroad cars, wooden articles, chocolate, sugar.
Renaissance palace, residence of the Dukes of Anhalt;
small palaces and town houses in baroque and neo-classic
styles. Near the town, at Wörlitz, are large 18th century
parks in the English "Romantic" style.

DESSAU BAUHAUS 1925-1928

Dr. Fritz Hesse, Mayor
of the City of Dessau

FACULTY AND STUDENTS

Almost all the former masters, Feininger, Gropius, Kandinsky, Klee, Moholy-Nagy, Muche, Schlemmer, remained with the Bauhaus when it moved to Dessau. Gerhard Marcks, however, went to teach near Halle since there was not money or room to reinstall his ceramics workshop in Dessau.

Five former students, Josef Albers, Herbert Bayer, Marcel Breuer, Hinnerk Scheper, Joost Schmidt, were appointed masters, and nearly all the Bauhaus students moved from Weimar to Dessau, where work was immediately begun in provisional quarters.

NEW BUILDINGS

The mayor of Dessau had approved an appropriation for seven houses with studios for the former Weimar masters and for a new building to house both the Bauhaus and the Municipal Arts and Crafts School. Construction, from Gropius' designs, was begun at once. Especially noteworthy was the city's decision to add to the Bauhaus building proper a wing with twenty-eight studio apartments, baths, laundry and dining hall for the students.

THE NEW CURRICULUM

The curriculum underwent several changes: joint instruction by a craftsman and an artist was abandoned. Henceforth each workshop was directed by one master, who had previously been trained in both craft and theory at the Bauhaus and was thus prepared to teach both. The department of architecture was considerably enlarged and the teachers of the Municipal School cooperated with it.

A department of typography and lay-out was added.

The principles of the Bauhaus were again clarified:

The Bauhaus is an advanced school for creative work. Its purpose is:

1. The intellectual, manual and technical training of men and women of creative talent for all kinds of creative work, especially building.

2. The execution of practical experimental work, especially building and interior decoration, as well as the development of models for industrial and manual production.

A business organization, the Bauhaus Corporation, was established to handle the sale to industry of models created in the Bauhaus workshops.

The Transitional Period at Dessau

After leaving Weimar, the Bauhaus had to move into temporary quarters in Dessau, pending the completion of its new building at the end of 1926. The workshops were set up on a floor of the Seiler factory; classroom instruction took place in the rooms of the existing Arts and Crafts School, which had also been placed under Gropius' supervision; and ateliers were provided for the artists in the old and, at the time, empty Art Museum.

The Mayor of Dessau, Dr. Fritz Hesse, was an eminently farsighted person, one of those notable individuals who demonstrate the importance of the small German city as a cultural factor. Owing to his energy and courage, the Junkers airplane works moved to Dessau. He encouraged cultural activity with the same tenacity. On his initiative, the Bauhaus was transferred from Weimar to Dessau; he loyally supported its principles; and thanks to him it was able to develop relatively undisturbed for a number of years.

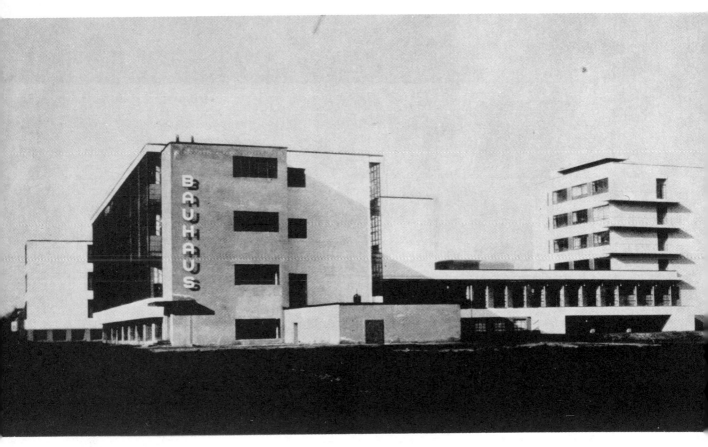

Walter Gropius: Dessau
Bauhaus. View from north-
west. 1925–1926

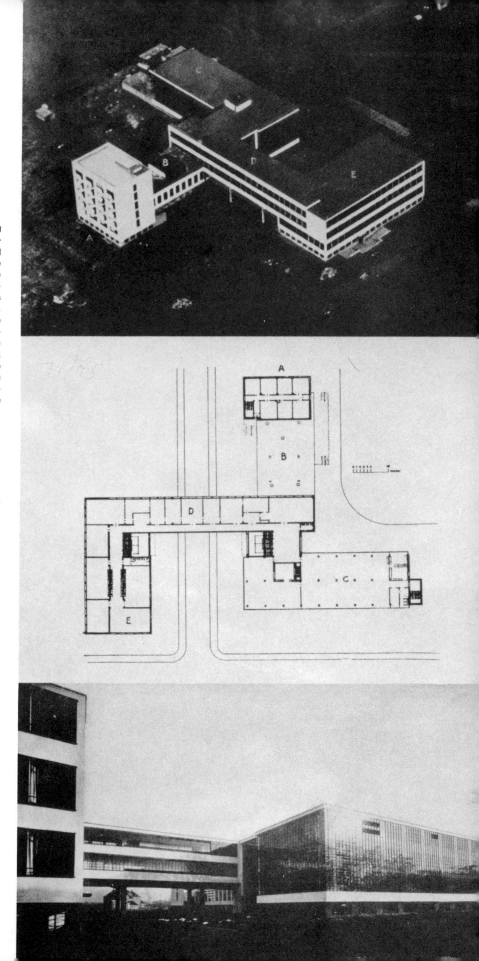

Walter Gropius: Dessau
Bauhaus. Air view.
1925–1926

A characteristic building
of the Renaissance or Ba-
roque has a symmetrical
façade, with the entrance
on the central axis. The
view offered to the specta-
tor as he draws near is
flat and two-dimensional.
A building expressing the
modern spirit rejects sym-
metry and the frontispiece
façade. One must walk
around this structure in
order to understand the
three-dimensional charac-
ter of its form and the
function of its parts.

**Plan of the Bauhaus:
Ground Floor**

Considerations to be kept
in mind in organizing a
plan:

proper orientation to the
sun

short, time-saving commu-
nication

clean-cut separation of the
different parts of the whole
flexibility, making possible
a reassignment of room-
uses, if organizational
changes make this neces-
sary.

A Studio wing

B Auditorium, stage and
dining-hall

C Laboratory workshop

D Bridge (administration
offices)

E Technical school
(from Bibl. no. 27)

Walter Gropius: Dessau
Bauhaus. View from south-
west. 1925–1926

THE BAUHAUS BUILDING
designed by WALTER GROPIUS

The Bauhaus building was begun by the city of Dessau in the autumn of 1925 and was completely finished in time for the formal dedication in December, 1926.

The whole building occupies an area of about 28,300 square feet, the volume is approximately 1,150,000 cubic feet. The total cost amounted to 902,500 marks, about $230,000.00, or roughly twenty cents per cubic foot. The cost of furnishing the building amounted to 126,200 marks. The building consists of (see plate opposite):

E. The wing which contains the Technical School (later Professional School), its classrooms and administrative quarters, instructors' rooms, library, physics hall, rooms for models. These are housed in a three story block (with basement). The two upper floors are connected with a bridge across the street, carried on piers. On the lower floor of this bridge are the administrative offices of the Bauhaus and, on the upper floor, the architectural department. The bridge (D.) leads to

C. The laboratory workshops and the classrooms. In the basement, half below and half above ground, are the printing plant, the dye-works, the sculpture room and the packing and storerooms, the servants' quarters and the furnaces.

On the ground (first) floor are the carpentry shop and the exhibition rooms, a large vestibule leading to the auditorium with a raised stage at one end.

On the second floor, the weaving room, rooms for preliminary courses (grundlehre), a large lecture room. The bridge connecting buildings 1 and 2 joins this floor.

On the third floor, the wall-painting workshop, metal workshop, and two lecture halls which can be connected to make a large exhibition hall. This leads to the upper story of the bridge, containing the architectural department and Professor Gropius' office. The auditorium (B.) on the ground floor, only one story in height, is connected with the

A. Studio wing, which contains scholarship students' quarters. The stage, situated between the auditorium and the dining hall, can be opened on both sides, so that spectators can sit on either side with the stage between them. On gala occasions, all the walls surrounding the stage can be removed, and thus all the space occupied by the dining hall, stage, auditorium and vestibule can be combined into one large hall for the occasion.

The dining hall communicates with the kitchen and several smaller rooms. In front of the dining hall is a spacious terrace, which in turn leads to the sports areas.

In the five upper stories there are twenty-eight studio apartments for students, and in addition each floor has a kitchenette. In the basement of the studio building there are baths, a gymnasium and locker room, and an electric laundry.

Material and construction of the project

Reinforced concrete skeleton with "mushroom" columns, brick masonry, hollow tile floors. Steel window-sash with double weathering contacts. The flat roofs designed to be walked on are covered with asphalt tile, welded together, the tile laid on insulation boards of "torfoleum" (compressed peat moss); regular roofs have the same type of insulation mentioned above, covered with lacquered burlap and a cement topping. Drainage by cast iron pipes inside the building. Exterior finish of cement stucco, painted with mineral paints.

The interior decoration of the entire building was executed by the wall-painting workshop, the design and execution of all lighting fixtures by the metal workshop. The tubular steel furniture of the assembly hall, dining room and studios was executed from designs by Marcel Breuer. Lettering was executed by the printing workshop.

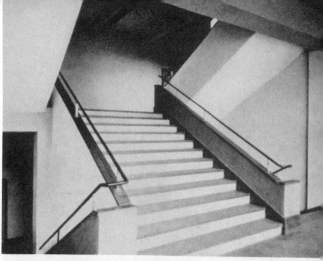

On December 4, 1926, the Bauhaus was formally inaugurated. The inaugural celebrations included an exhibition, lectures, motion pictures, as well as a dance in the new building. The inaugural address was delivered by National Art Director (Reichskunstwart) Erwin Redslob who had been born in Weimar and who had, from the very beginning, shown great interest in the Bauhaus. The reopening of the Bauhaus under more prosperous conditions was regarded as a great cultural event and brought more than 1500 visitors to Dessau. Two thousand attended a Bauhaus ball that evening.

Sixty press representatives were present at the Bauhaus opening in 1925.

Reports in the press indicated that only a few critics understood that the interior had been designed mainly by the workshops themselves. Most of them believed it had been designed by the architects and only executed by the workshops.

102

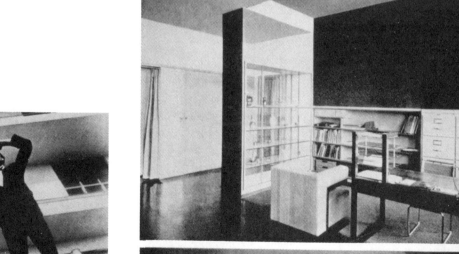

←≪
Walter Gropius: Dessau
Bauhaus. Staircase.
1925–1926

Walter Gropius: Dessau
Bauhaus. Corner of the
workshop wing, bridge
and technical school
beyond. 1925-1926

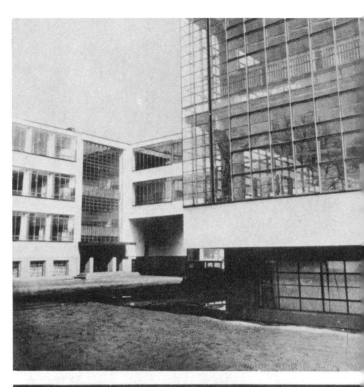

←≪
Walter Gropius: Dessau
Bauhaus. Night view.
1925-1926

Walter Gropius: Dessau
Bauhaus. Office of the
Director. 1925-1926
←≪

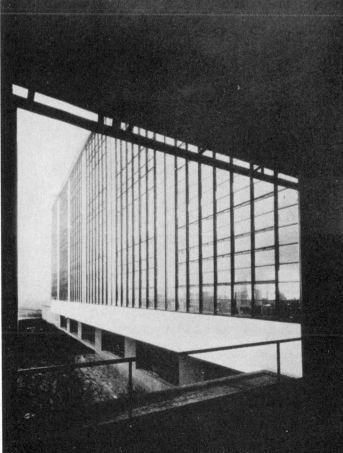

←≪
Walter Gropius: Dessau
Bauhaus. Dining room.
View toward stage end.
1925–1926

Walter Gropius: Dessau
Bauhaus. View from the
staircase toward the
workshops. 1925-1926

Life at the Bauhaus
in Dessau

Room in the studio
wing

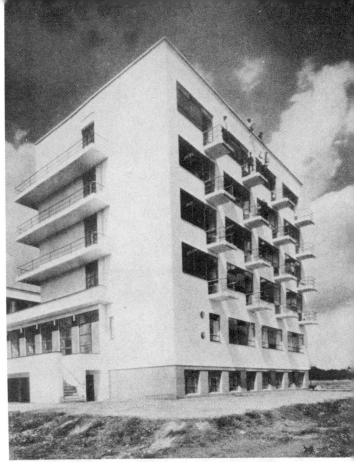

Walter Gropius: Dessau Bauhaus. View of students' studio building from southeast. 1925-1926

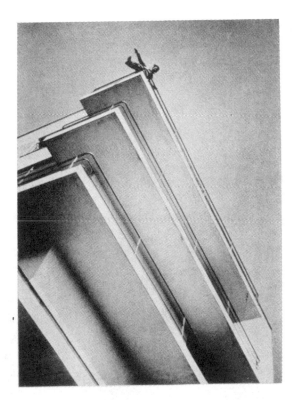

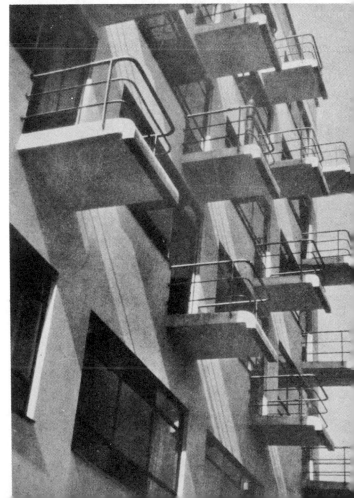

Walter Gropius: Dessau Bauhaus. Balconies of the students' studio building. 1925-1926

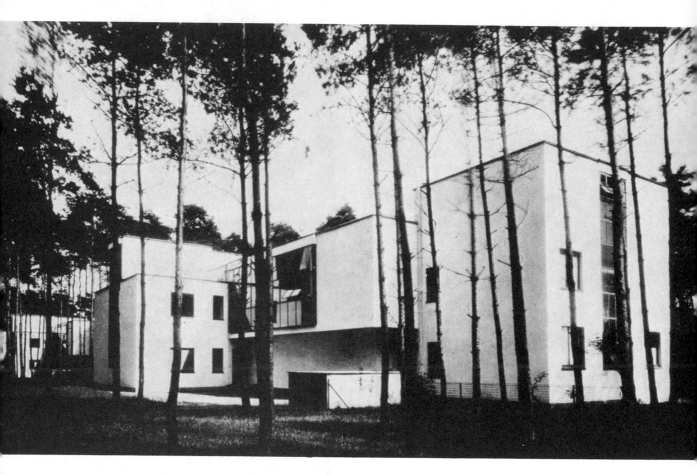

Walter Gropius: Masters'
houses, Dessau. 1925-1926

A few hundred yards from the main Bauhaus building were
three double houses and one single house built by the town
of Dessau for the Bauhaus masters. The interiors were
designed and executed by the Bauhaus workshops.

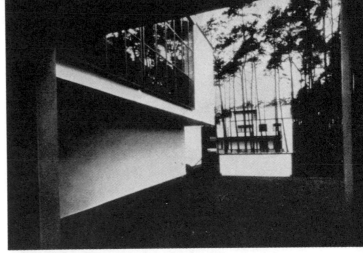

Walter Gropius: View of
masters' houses, Dessau.
1925-1926

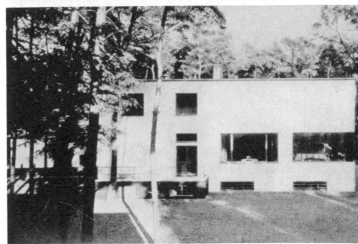

Walter Gropius: Director's
house, Dessau. 1925-1926

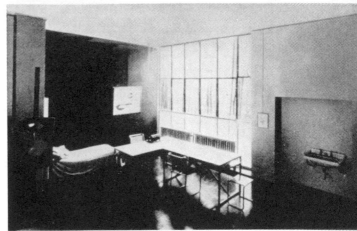

Walter Gropius: Studio
in a master's house,
Dessau. Interior designed
by L. Moholy-Nagy, 1926

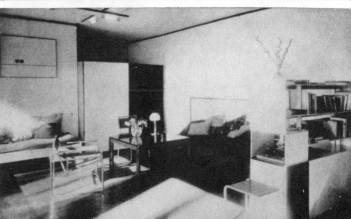

Walter Gropius: Living
room in a master's house,
Dessau. Interior designed
by L. Moholy-Nagy, 1926

Walter Gropius: City Employment Office, Dessau. Interior view. 1929

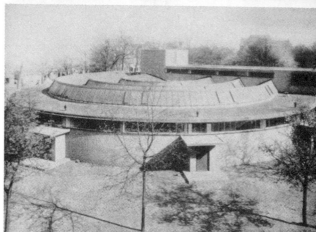

Walter Gropius: City Employment Office, Dessau. View showing radiating entrances for various vocational groups. 1929

In mid-September, 1926, 60 one-family houses using standardized units were begun in Törten, as part of a new housing project for the city of Dessau. Walter Gropius was the architect. By 1928 he had completed 316 houses, which were partly furnished by the Bauhaus workshops.

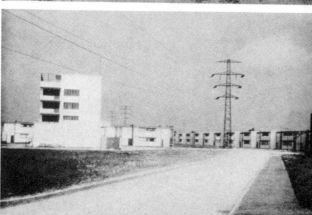

Walter Gropius: Dessau-Törten, a community of workers' houses. General view. 1926

Walter Gropius: Dessau-Törten. Structural scheme of typical units. 1926

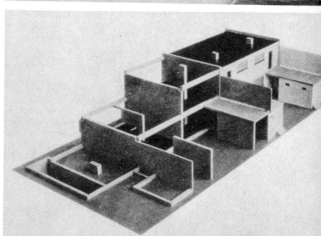

Walter Gropius: City
Employment Office,
Dessau. 1929

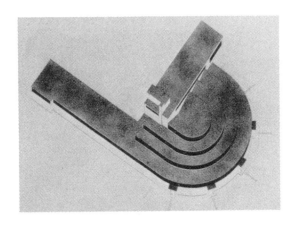

Anonymous: "Minimal
dwelling"

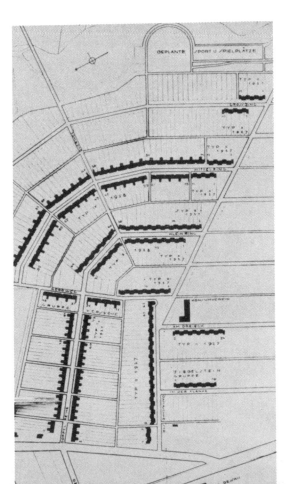

Walter Gropius: Dessau-
Törten. Site plan. 1926

Marcel Breuer: Bambos Houses. A project to house five Bauhaus masters. Two large rooms, separated as well as connected by the entrance hall and the kitchen and bathroom units are planned with an eye to the dual phases of family life (husband – wife; parents – children; day – night). A variation of the plan below includes a studio unit. An attempt was made to depart from the rigid horizontal–vertical composition prevalent in modern architecture. The sawtooth design of the roofs allows for clerestory windows, thus increasing sunlight and adding interest to the interior design. 1927

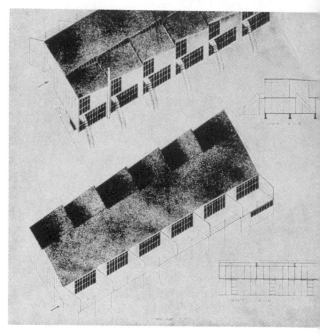

110

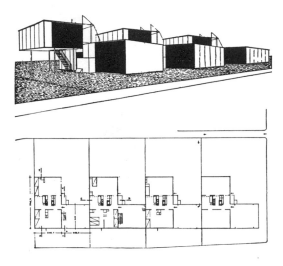

ARCHITECTURE DEPARTMENT

Specialists in Construction, Statics and Descriptive Geometry were appointed to the staff in Dessau in order to widen the scope of the architectural training. In 1927 Gropius succeeded in bringing the Swiss Hannes Meyer to the Bauhaus as instructor in Architecture. Hannes Meyer became head of the Architecture Department and, after Gropius left in 1928, Director of the entire Bauhaus for a short period. The pedagogic procedure followed in the architectural courses, as in all others, was the inductive method, which enables the pupil to form conclusions on the basis of his own observation and experience. Some of the points of Gropius' program were never realized, however, because of the shortage of funds.

HANNES MEYER, 1928

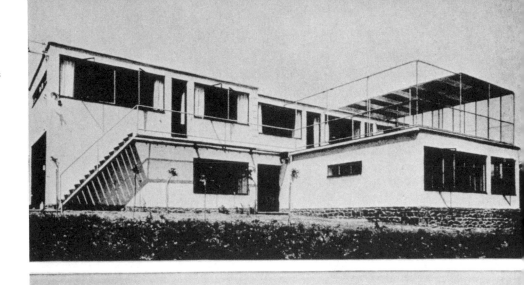

Hans Wittwer and Hans Volger: House for Dr. Nolden. Mayen. 1928

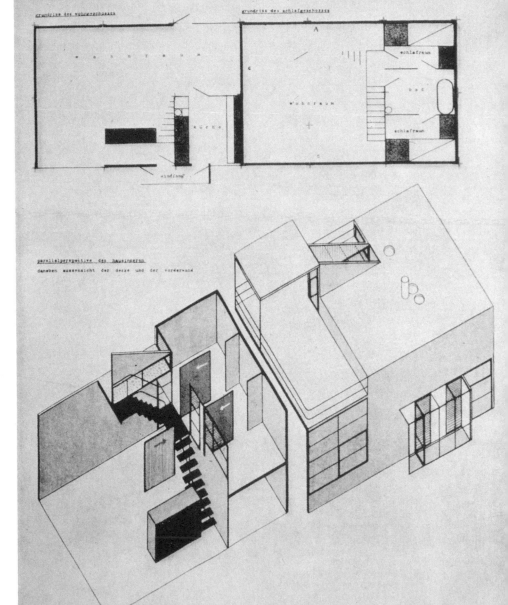

Marcel Breuer: Plan and isometric drawing of small metal house designed for prefabrication. 1925

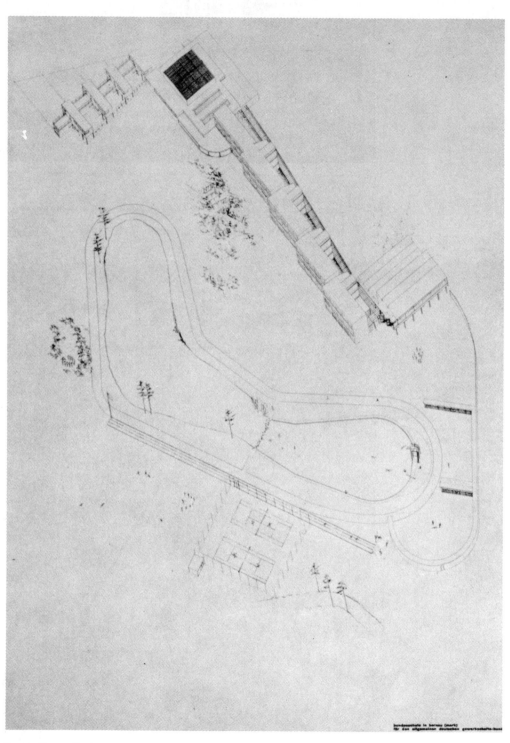

Hannes Meyer: Trade
Union School, Bernau.
Isometric view. 1928

113

Hannes Meyer: Trade
Union School, Bernau.
Plan. 1928

JOSEF ALBERS, 1926

CONCERNING FUNDAMENTAL DESIGN
by JOSEF ALBERS

Learning through experiment

Economy of form depends on function and material. The study of the material must, naturally, precede the investigation of function. Therefore our studies of form begin with studies of materials.

Industrial methods of treating raw materials represent the results of a long technological development. Technical education, therefore, has consisted chiefly in the teaching of established processes.

If such training is given alone, it hinders creation and invention.

The learning and application of established methods of manufacturing develop discernment and skill, but hardly creative potentialities. The ability to construct inventively and to learn through observation is developed—at least in the beginning—by undisturbed, uninfluenced and unprejudiced experiment, in other words, by a free handling of materials without practical aims.

To experiment is at first more valuable than to produce; free play in the beginning develops courage. Therefore, we do not begin with a theoretical introduction; we start directly with the material. . . .

In order to insure first-hand, manual knowledge of the material we restrict the use of tools. As the course advances the possibilities in the use of various materials as well as their limitations are gradually discovered. The most familiar methods of using them are summarized; and since they are already in use they are for the time being forbidden. For example: paper, in handicraft and industry, is generally used lying flat; the edge is rarely utilized. For this reason we try paper standing upright, or even as a building material; we reinforce it by complicated folding; we use both sides; we emphasize the edge. Paper is usually pasted: instead of pasting it we try to tie it, to pin it, to sew it, to rivet it. In other words, we fasten it in a multitude of different ways. At the same time we learn by experience its properties of flexibility and rigidity, and its potentialities in tension and compression. Then, finally, after having tried all other methods of fastening we may, of course, paste it.

Our aim is not so much to work differently as to work without copying or repeating others. We try to experiment, to train ourselves in "constructive thinking."

Constructions

To increase our independence of the traditional use of materials we solve certain given problems in technique and form by making original constructions out of a great variety of materials; out of corrugated paper and wire netting, for instance, or with match-boxes, phonograph needles and razor blades. These constructions must demonstrate the qualities and possibilities of the materials used by fulfilling the technical requirements set forth in the wording of the problem.

Sometimes the results of these experiments represent innovations in the application or treatment of material. But even when we evolve methods which are already in use, we have arrived at them independently, through direct experience and they are our own because they have been re-discovered rather than taught.

Study in plastic use of paper. Cut without waste from one piece of paper. The twisting is automatic result of lifting or stretching

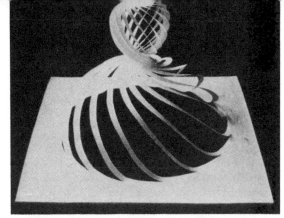

Exercise in transformation on one plane

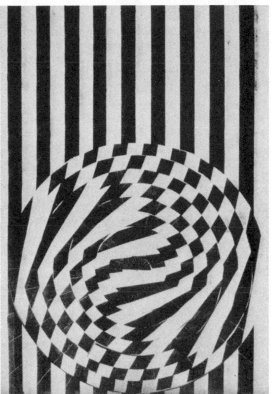

G. Hassenpflug: Study in plastic use of paper. Cut without waste from one sheet of paper. 4 feet high

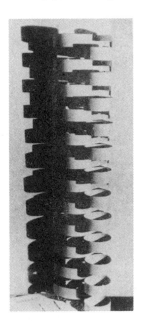

Margrit Fischer: Study in materials combining similar and different textures

We know that this learning through experiment takes more time, entails detours and indirections; but no beginning can be straightforward. Consciously roundabout ways and controlled mistakes sharpen criticism and promote a desire for improvement. . .

As the proportion of effort to achievement is a measure of the result, an essential point in our teaching is *economy*. Economy is the sense of thriftiness in labor and material and in the best possible use of them to achieve the effect that is desired.

Economy of labor is as important as economy of material. It is fostered by the recognition of quick and easy methods, by the constant use of ready-made and easily procured means, that is to say, by the correct choice of tools, by the use of ingenious substitutes for missing implements, by the combination of several processes or by restricting oneself to a single implement.

Learning in this way, with emphasis on technical and economical rather than esthetic considerations makes clear the difference between the static and the dynamic properties of materials. It shows that the inherent characteristics of a material determine the way in which it is to be used. It trains the student in constructive thinking. It encourages the interchange of experience and the understanding of the basic laws of form and their contemporary interpretation. It counteracts the exaggeration of individualism without hampering individual development.

Texture

Experiment with surface qualities is another method for the study of form and the development of individual sensibility. These exercises in textures alternate with the "construction" studies described above. They are not concerned with the inner qualities of the material, but with its appearance. Just as one color influences another by its value, hue and intensity, so surface qualities, both tactile and optical, can be related.

We classify the appearance of the surface of a material as to structure, facture and texture, which we differentiate carefully. These qualities of surface can be combined and graduated somewhat as colors are in painting. The systematic arrangement of surface qualities in scales and series makes one sensitive to the minutest

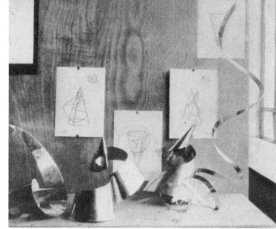

Werner Feist: Construction. Matchboxes

Studies in plastic use of tin. Transformation of a cone by cutting, bending, stretching and compressing. This sort of exercise replaced final examinations.

Study in plastic use of paper

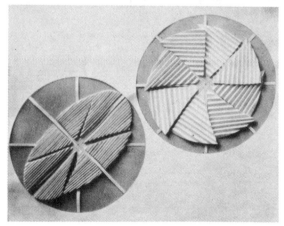

Study in plastic use of paper. Curved folds

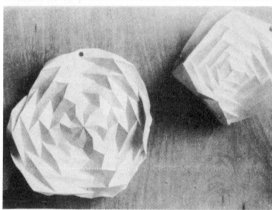

Study in plastic use of paper. Cut without waste from one sheet of paper. 4 feet high

First attempts to use cardboard plastically

Study in plastic use of paper

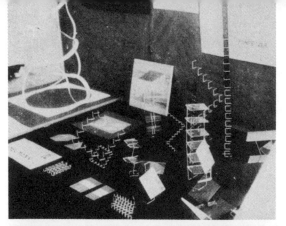

differences and the subtlest transitions in the tactile qualities of surfaces, such as hard to soft, smooth to rough, warm to cold, straight-edged to shapeless, polished to mat; also in the visual qualities of surfaces such as wide-meshed and narrow-meshed; transparent and opaque; clear and clouded.*

Through discussion of the results obtained from the study of the problems of materials, we acquire exact observation and new vision. We learn which formal qualities are important to-day: harmony or balance, free or measured rhythm, geometric or arithmetic proportion, symmetry or asymmetry, central or peripheral emphasis. We discover what chiefly interests us: complicated or elementary form, mysticism or science, beauty or intelligence.

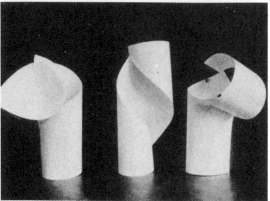

To summarize briefly: the *inductive* method of instruction proposed here has as its goal self-discipline and responsibility toward ourselves, toward the material and toward the work. It helps the student, in choosing his vocation, to recognize which field of work is closest to him. It develops flexibility. It leads to economical form.

118

We must, as students and teachers, learn from each other continually, in stimulating competition. Otherwise teaching is a sour bread and a poor business.

(from "Werklicher Formunterricht," published in Bibl. no. 30, 1928, nos. 2–3)

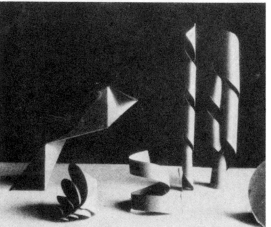

* "Structure" refers to those qualities of surface which reveal how the raw material grows or is formed, such as: the grain of wood or the composite structure of granite. "Facture" refers to those qualities of surface which reveal how the raw material has been treated technically, such as the hammered or polished surface of metal, or the wavy surface of corrugated paper. "Texture" is a general term which refers to both "structure" and "facture," but only if both are present. For instance, the "texture" of polished wood reveals both the "structure" (grain) and the "facture" (polishing).

These surface qualities can be perceived usually by sight and often by both sight and touch. Examples: the *structure* of highly polished wood can be perceived by eye but not by touch; the *facture* of a printed page can be perceived by sensitive fingertips but, of course, far more easily by the eyes; the *texture* of a carpet is easily perceived by both hand and eye.

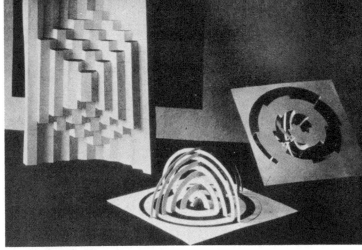

◄≪
Exhibition of a student's first semester work. These are chiefly studies in the properties of wire. 1927

Study in plastic use of paper. 1926

Study in illusory three dimensions

◄≪
Studies in plastic use of paper. Transformation of a cylinder through cutting and bending
◄≪

Study of three dimensions, actual and illusory

◄≪
Study in optical illusion. Flat wire netting arranged in one plane

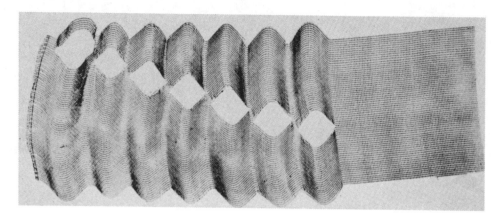

Study in optical illusion.
Flat wire netting

Above Georg Grosz; *below* P. Toliner: Studies in optical illusion. Three-dimensional effects achieved by repetition of two-dimensional elements: circles and parts of circles

G. Hassenpflug: Study in relationship between colors and forms. Inverse use of colors and forms. 1929

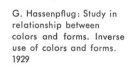

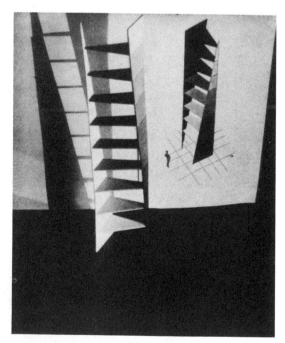

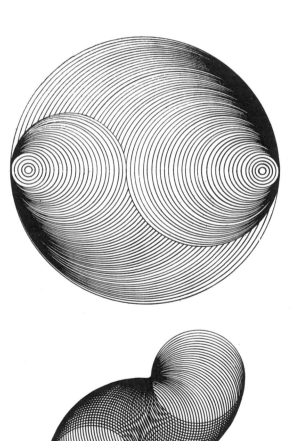

G. Hassenpflug: Study in plastic use of glass

Construction. Wooden sticks fastened together with razor blades. 9 feet high

Detail of construction at right

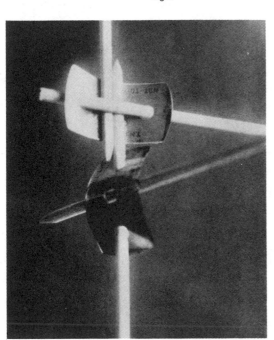

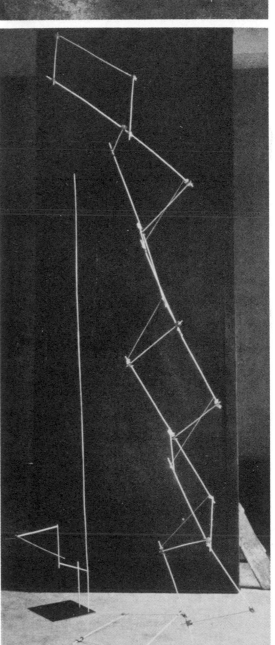

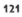

PRELIMINARY COURSE
MOHOLY-NAGY

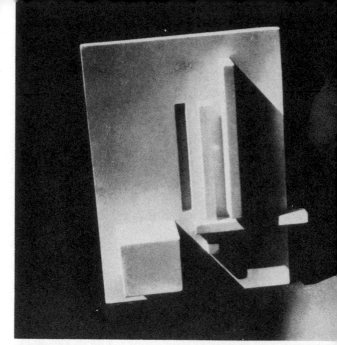

THE CONCEPT OF SPACE
by MOHOLY-NAGY

We are all biologically equipped to experience space, just as we are equipped to experience colors or tones. This capacity can be developed through practice and suitable exercises. It will, of course, differ in degree in different people, as other capacities do, but in principle space can be experienced by everyone even in its rich and complex forms.

The way to learn to understand architecture is to have direct experience of space itself; that is, how you live in it and how you move in it. For architecture is the functionally and emotionally satisfactory arrangement of space. Naturally, just as in every other field, long preparation is necessary before one can appreciate this essential character of architecture.

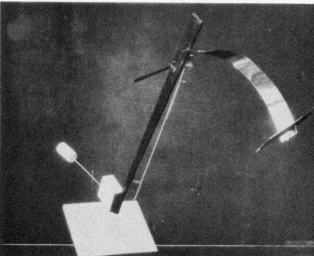

Most people, unfortunately, still learn architecture out of books. They learn how to tell the "styles" of the great monuments of the past—how to recognize Doric columns, Corinthian capitals, Romanesque arches, Gothic rosettes, etc. But these are only the tags of architecture; those who learn by the historical method can seem to know a lot when all they have really learned is to classify and date the monuments of the past. In reality, only a very few ever learn really to experience the miracle of esthetically arranged space.

In general the "educated" man today is incapable of judging works of architecture in a true way, for he has no idea of the real effect of pure space arrangement, of the balance of tense contrary forces, or of the flow of interweaving space.

Today spatial design is an interweaving of shapes; shapes which are ordered into certain well defined, if invisible, space relationships; shapes which represent the fluctuating play of *tensions* and forces.

Pure space arrangement is not a mere question of building materials. Hence a modern space composition is not a mere combination

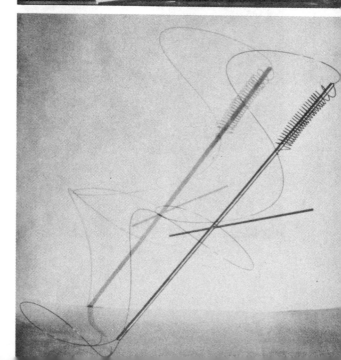

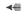

Klaus Neumann: Con-
struction. 1928

Hinrick Bredendieck:
Suspended construction.
Glass tubes fastened
together with thin wire.
1928

Marianne Brandt: Study in
balance. 1923

Gerda Marx: Study in
texture. *Below:* An attempt
at graphic transcription.
1928

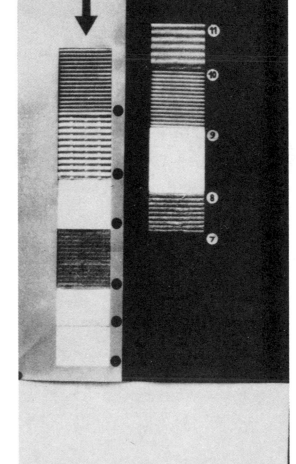

Werner Zimmermann:
Construction. Wire and
tubes. 1928

of building stones, not the putting together of differently shaped blocks and especially not the building of rows of blocks of the same size or of different sizes. Building materials are only a means, to be used as far as possible in expressing the artistic relations of created and divided space. The primary means for the arrangement of space is still space itself and the laws of space condition all esthetic creation in architecture.

That is, architecture will be understood, not as a complex of inner spaces, not merely as a shelter from the cold and from danger, nor as a fixed enclosure, as an unalterable arrangement of rooms, but as an organic component in living, as a governable creation for mastery of life.
(Adapted from Bibl. no. 29)

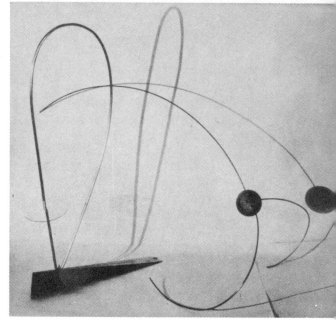

124

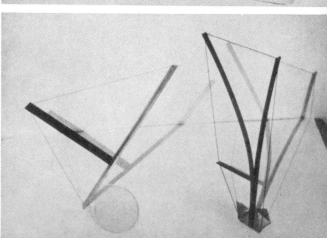

◀◀≡

Above Lothar Lang; *below*
Siegfried Griesenschlag:
Studies in texture. 1927

◀≡

Construction. Wire and
wood

◀≡

G. Hassenpflug: Bridge
illustrating vibration and
pressure of various mate-
rials. *Below:* an attempt at
graphic transcription. 1927

◀≡

Georg Grosz: Construc-
tion. 1924

SCOPE OF THE BAUHAUS TRAINING
Gropius:

"What the Bauhaus preached in practice was the com-
mon citizenship of all forms of creative work, and their
logical interdependence on one another in the modern
world. It wanted to help the formal artist to recover the
fine old sense of design and execution being one and the
same, and make him feel that the drawing-board is
merely a prelude to the active joy of fashioning. Build-
ing unites both manual and mental workers in a common
task. Therefore all alike, artist as well as artisan, should
have a common training; and since experimental and
productive work are of equal practical importance, the
basis of that training should be broad enough to give
every kind of talent an equal chance. As varieties of
talent cannot be distinguished before they manifest them-
selves, the individual must be able to discover his proper
sphere of activity in the course of his own development.
Naturally the great majority will be absorbed by the build-
ing trades, industry, etc. But there will always be a small
minority of outstanding ability whose legitimate ambitions
it would be folly to circumscribe. As soon as this elite
has finished its communal training it will be free to con-
centrate on individual work, contemporary problems, or
that inestimably useful speculative research to which hu-
manity owes the sort of values stockbrokers call 'futures.'
And since all these commanding brains will have been
through the same industrial mill they will know, not only
how to make industry adopt their improvements and in-
ventions, but also how to make the machine the vehicle of
their ideas."

(from Bibl. no. 32)

FURNITURE WORKSHOP

A piece of furniture is not an arbitrary composition: it is a necessary component of our environment. In itself impersonal, it takes on meaning only from the way it is used or as part of a complete scheme.

A complete scheme is no arbitrary composition either but rather the outward expression of our everyday needs; it must be able to serve both those needs which remain constant and those which vary. This variation is possible only if the very *simplest* and most *straightforward* pieces are used; otherwise changing will mean buying new pieces.

Let our dwelling have no particular "style," but only the imprint of the owner's character. The architect, as producer, creates only half a dwelling; the man who lives in it, the other half.

Marcel Breuer (from Bibl. no. 15)

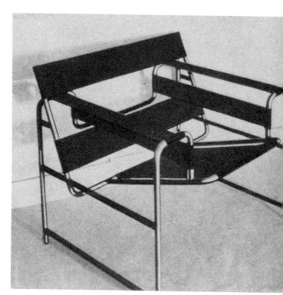

. . . the new interior should not be a self-portrait of the architect, nor should it attempt to fix in advance the personal environment of the occupant.

And so we have furnishings, rooms and buildings allowing as much change and as many transpositions and different combinations as possible. The pieces of furniture and even the very walls of a room have ceased to be massive and monumental, apparently immovable and built for eternity. Instead they are more opened out, or, so to speak, drawn in space. They hinder neither the movement of the body nor of the eye. The room is no longer a self-bounded composition, a closed box, for its dimensions and different elements can be varied in many ways.

One may conclude that any object properly and practically designed should "fit" in any room in which it is used as would any living object, like a flower or a human being.

Marcel Breuer (from *das neue frankfurt*, 1927)

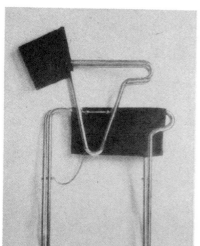

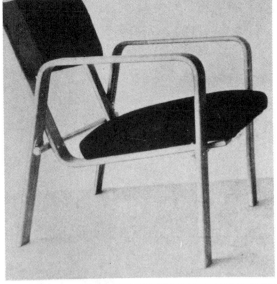

Josef Albers: Wooden armchair with spring back. 1926

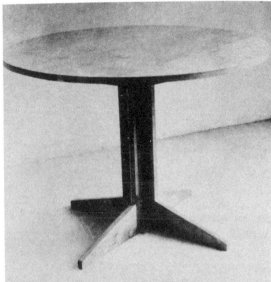

G. Hassenpflug: Folding wooden table. 1928

Marcel Breuer: First tubular chair. Fabric seat, back and arm rests. 1925

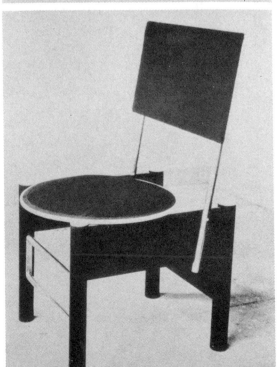

Marcel Breuer: Chair. Metal tubes and wood. Designed for a dining room. 1926

Marcel Breuer: Folding chair. 1928

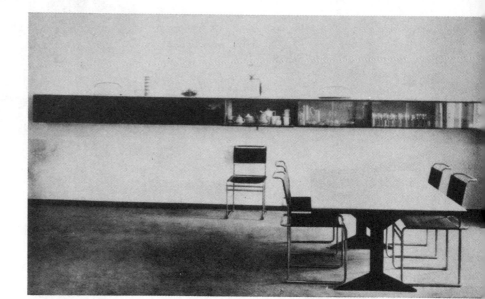

Marcel Breuer: Piscator
House, Berlin. Dining
room. 1927

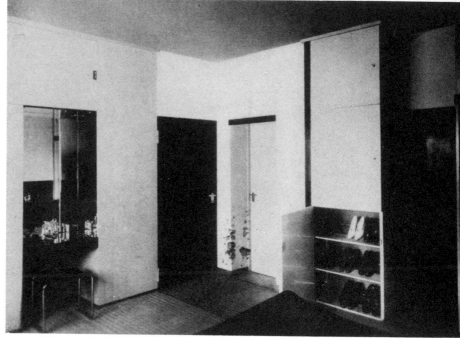

Marcel Breuer: Dessau
Bauhaus. Bedroom in
Director's house. 1926

Marcel Breuer:
Standardized furniture
units. 1927

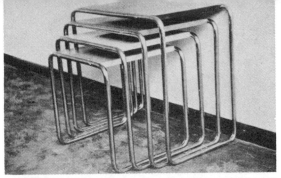

Marcel Breuer: Nest of four tables. Four different colors. 1926

Marcel Breuer: Harnisch-macher apartment. Wiesbaden. View of kitchen and dining space. 1927

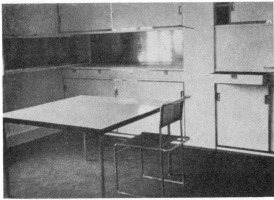

Walter Gropius: Dessau Bauhaus. Auditorium. Chairs by Marcel Breuer. 1926

Marcel Breuer: Tubular chairs. Fabric seat and back rest. 1926

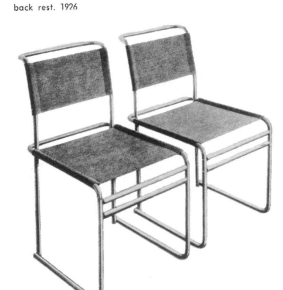

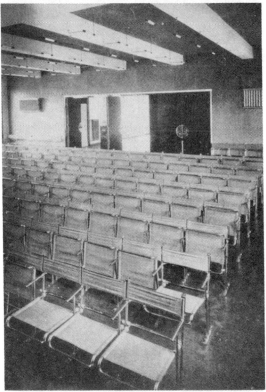

Carpentry workshop, Dessau

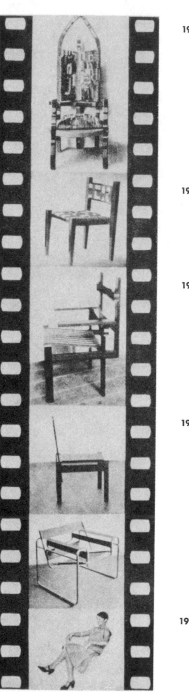

1921

1921 1/2

1924

1925

19??

130

A Bauhaus Movie lasting five years.
Author: Life demanding its rights.
Operator: Marcel Breuer who recognizes these rights.
Better and better every year; in the end we will sit on
resilient air columns. (from Bibl. no. 30, 1926, no. 1)

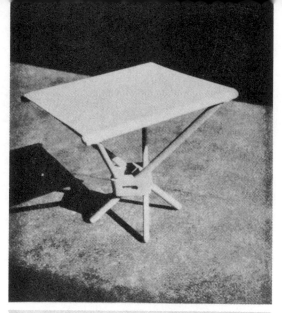

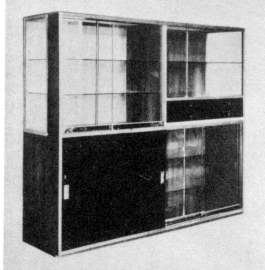

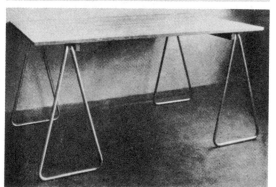

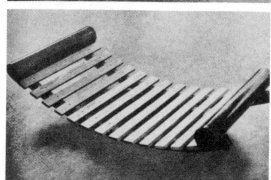

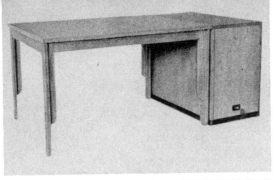

T. Mizutani: Collapsible
stool. Stretched fabric
seat. *Below*: Legs without
seat. 1926

Carpentry workshop:
Desk composed of table
and drawer unit. 1928

Carpentry workshop:
Drawer unit for desk. 1928

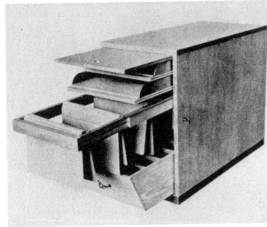

←⧻
Marcel Breuer: Dining
room cabinet. 1926

G. Hassenpflug: Folding
chair. Fabric seat and
backrest. 1928

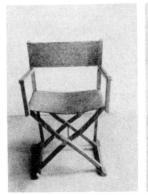 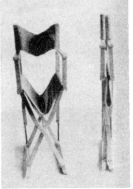

←⧻
Marcel Breuer. Wooden
table with tubular supports

P. Bücking: Chair
plywood seat. 1928

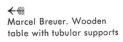

←⧻
Lotte Gerson: Child's
rocker. 1928

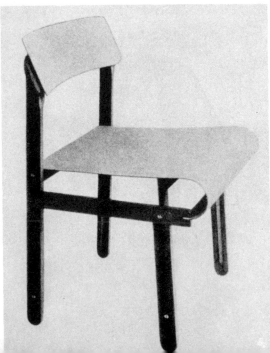

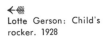

After Marcel Breuer had completed the first steel chair
at the Bauhaus, the Mannesmann Works were asked to
put steel pipe at our disposal for further experiments.
The request was refused on the grounds that such ex-
periments were unimportant. Today the production of
tubular steel furniture has taken on tremendous propor-
tions. It has spread all over the world, exercising a de-
cisive influence on many other aspects of interior design.

Some pages from catalogs
of factories producing
furniture designed at the
Bauhaus

Marcel Breuer: Swivel
chair. Steel tubing and
plywood

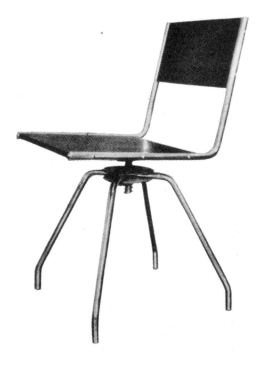

During 1925 the workshops of the Dessau Bauhaus executed orders for furniture, lighting fixtures, and designs in color for the following firms:

Nierendorf Gallery, Berlin

New Art Gallery, Fides, Dresden

King Albert Museum, Zwickau

Showrooms of the "Abstracts," Berlin

Children's Home, Oranienbaum

Uncle Tom's Cabin, restaurant, Berlin

and for a number of private apartments, including the masters' houses in Dessau and the new Bauhaus building.

COÖPERATION WITH INDUSTRY

The practical objective of the Bauhaus workshops—to evolve designs satisfactory from formal and technical points of view which should then be submitted to industry for production—was pursued on a large scale only after the Bauhaus had moved to Dessau. Designs for furniture, lamps, textile fabrics, metal- and glassware were accepted by manufacturers. The factories were then often visited by Bauhaus designers who studied the processes used and cooperated with technicians to simplify and improve the designs. Conversely, the factories often sent their technicians to the Bauhaus workshops to keep them informed about the development of designs. This was a great improvement over the ineffective dependence on paper projects against which the Bauhaus had rebelled as an inadequate means of communication between designers and industry.

ROYALTIES

Each workshop had the right to confer independently with industrial firms regarding technical problems, but commercial negotiations were handled by the Bauhaus Corporation. When a workshop considered a design ready for sale it was turned over to the Business Manager of the Corporation together with all the necessary drawings and descriptions of the processes involved so that contracts could be drawn up.

The income was divided between the Bauhaus Corporation and the school itself, which paid the designer. Half the royalty paid the school was credited to the Bauhaus fund, while the other half went to a welfare fund used to pay for designs which were considered valuable but which could not be disposed of for the time being.

Income from royalties rose steadily, until, under the direction of Mies van der Rohe, in 1932 it exceeded 30,000 marks.

Bauhaus products were exhibited at:

Leipzig Spring Fair

Gesolei, Düsseldorf

German Society of Women's Apparel and Culture, in various towns

Kestner Society, Hanover

Trade Museum, Basel

Art Museum (Kunsthalle), Mannheim

Werkbund Exhibition, Tokyo

The Bavarian National Museum, the Trade Museum of Basel, the Art Museum, Mannheim, and the Werkbund Exposition, Tokyo, purchased Bauhaus products for their respective collections.

METAL WORKSHOP

FROM WINE JUGS TO LIGHTING FIXTURES
by MOHOLY-NAGY

When Gropius appointed me to take over the metal workshop he asked me to reorganize it as a workshop for industrial design. Until my arrival the metal workshop had been a gold and silver workshop where wine jugs, samovars, elaborate jewelry, coffee services, etc., were made. Changing the policy of this workshop involved a revolution, for in their pride the gold- and silversmiths avoided the use of ferrous metals, nickel and chromium plating and abhorred the idea of making models for electrical household appliances or lighting fixtures. It took quite a while to get under way the kind of work which later made the Bauhaus a leader in designing for the lighting fixture industry.

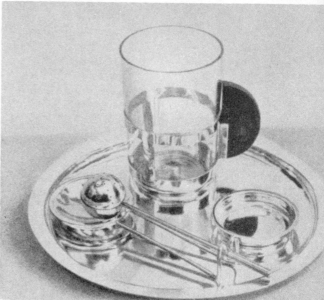

I remember the first lighting fixture by K. Jucker, done before 1923, with devices for pushing and pulling, heavy strips and rods of iron and brass, looking more like a dinosaur than a functional object.* But even this was a great victory, for it meant a new beginning. After this we developed lighting fixtures introducing such useful ideas as: the close-fitting ceiling cap; combinations of opaque and frosted glass in simple forms technically determined by the action of light; securing the globe to the metal chassis; the use of aluminium, particularly for reflectors, etc. All of these were adopted for industrial production. In addition to these innovations may be mentioned one which even today presents a very useful solution of one lighting fixture problem, especially in localities where the quick settling of dust makes ordinary lighting inefficient. This principle involves the use of concentric glass cylinders to avoid a glare. From this originated the louvre system of concentric rings of metal and, recently, of translucent plastics. The metal workshop also handled other prob-

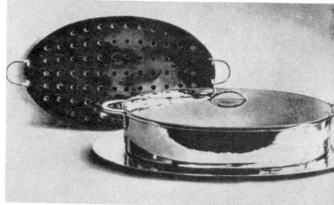

* Reproduced, Bibl. no. 8, page 116.

134

Marianne Brandt:
Egg-boiler. 1926

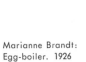
Draughting room of the
metal workshop, Dessau

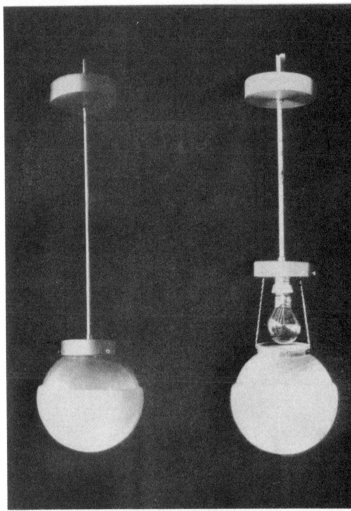

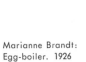
M. Krajewski and
W. Tümpel: Individual tea
set. 1923-1925

Marianne Brandt: Lighting
fixture. Frosted and plain
glass globe. Chains hold
globe while electric bulb
is being changed. 1925

Marianne Brandt: Fish
casserole. Silver-bronze
lined with silver. 1926

Josef Albers: Glass tea
set. 1925

Marianne Brandt:
Movable wall fixture with
adjustable reflector. 1925

lems of industrial design: utensils and household appliances.

The function of the metal workshop was a special one, involving simultaneously education and production. We therefore selected for young apprentices problems from which the use of materials, tools and machinery could be learned and which were at the same time of practical use. During those days there was so conspicuous a lack of simple and functional objects for daily use that even the young apprentices were able to produce models for industrial production (ash trays, tea holders, etc.) which industry bought and for which royalties were paid.

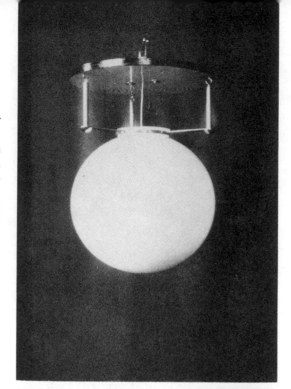

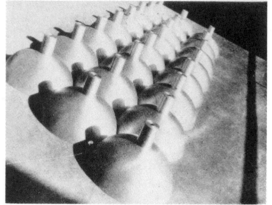

Marianne Brandt:
Industrially produced
lamp shades. 1926

M. Krajewski: Chromium
and frosted glass lighting
fixture. Hooks supporting
the globe are easily
adjustable. 1925

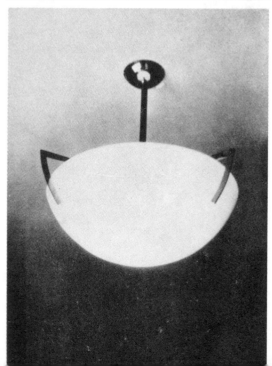

← ⫸
Marianne Brandt:
Chromium and frosted
glass lighting fixture. 1924

Marianne Brandt: Wall
fixture. c. 1925

Marianne Brandt: Night
table lamp with adjustable
shade. 1928

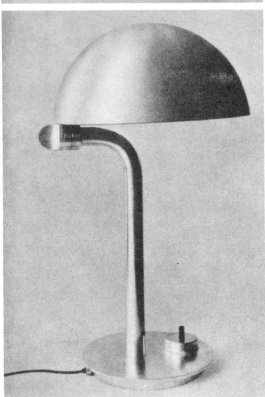

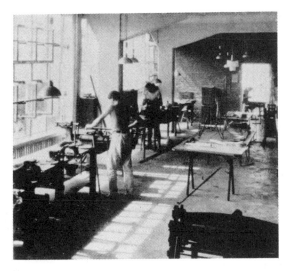

Metal workshop, Dessau

Marianne Brandt: Mirror
for shaving or makeup.
Dull aluminum reflector
lit by electric bulb behind
mirror. 1926

Marianne Brandt: Ceiling
fixture

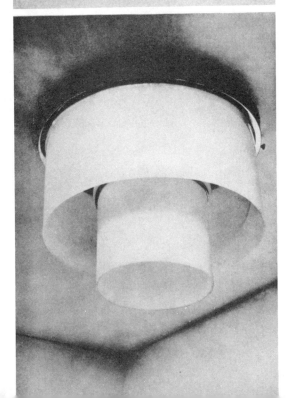

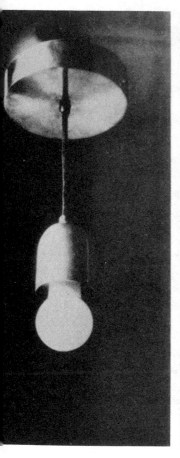

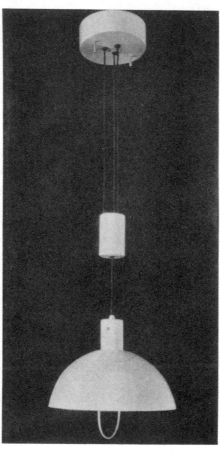

Marianne Brandt: Spun
chromium lighting fixture
for corridors. 1925

M. Brandt and
H. Przyrembel: Adjustable
ceiling fixture. Aluminum
shade. 1926

Marianne Brandt:
Lighting fixture for walls
or low ceilings. 1925

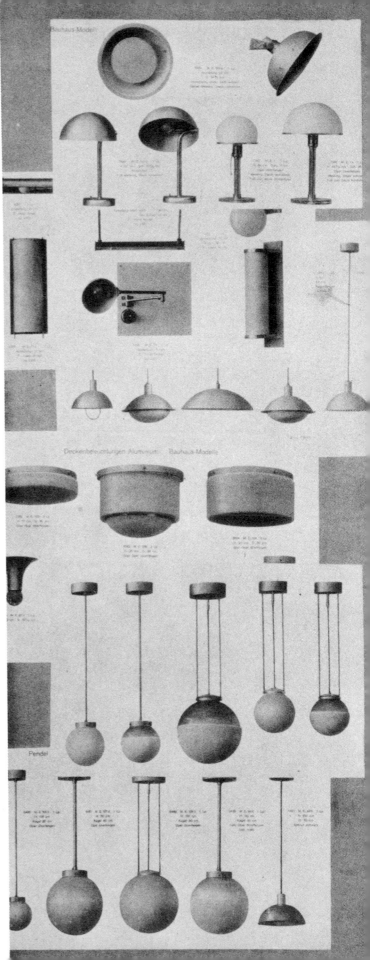

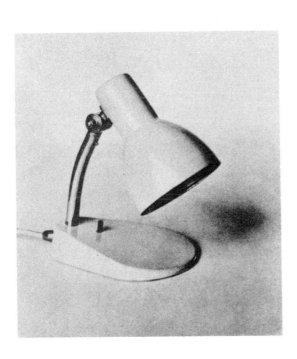

Metal workshop:
Adjustable desk lamp.
1924

Pages from catalogs of
factories manufacturing
lighting fixtures from
Bauhaus designs

WEAVING WORKSHOP

Gunta Sharon - Stölzl

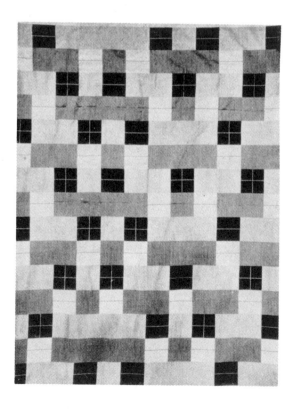

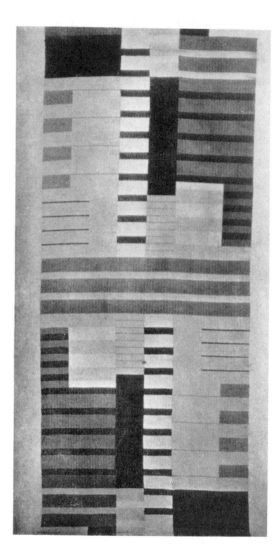

Anni Albers: Double-
woven wall hanging. Silk.
1925

Anni Albers: Tapestry.
Red and yellow silk. 1927

THE WEAVING WORKSHOP
by ANNI ALBERS

Any reconstructive work in a world as chaotic as post-war Europe had, naturally, to be experimental in a very comprehensive sense. What had existed had proved to be wrong—even to its foundations.

At the Bauhaus, those starting to work in weaving or in any other craft were fortunate to have had no traditional training. It is no easy task to discard conventions, however useless. Many students had felt the sterility of the art academies and their too great detachment from life. They believed that only manual work could help them back to solid ground and put them in touch with the problems of their time. They began amateurishly and playfully, but gradually something grew out of their play which looked like a new and independent trend. Technique was acquired as it was needed and as a foundation for future attempts. Unburdened by any practical considerations, this play with materials produced amazing results, textiles striking in their novelty, their fullness of color and texture, and possessing often a quite barbaric beauty.

This freedom of approach seems worth retaining for every novice. Courage is an important factor in any creation; it can be most active when knowledge does not impede it at too early a stage.

The weaving improvisations furnished a fund of ideas from which more carefully considered compositions were later derived. Little by little the attention of the outside world was aroused and museums began to buy.

It was a curious revolution when the students of weaving became concerned with a practical purpose. Previously they had been so deeply interested in the problems of the material itself and in discovering various ways of handling it that they had taken no time for utilitarian considerations. Now, however, a shift took place from free play with forms to logical composi-

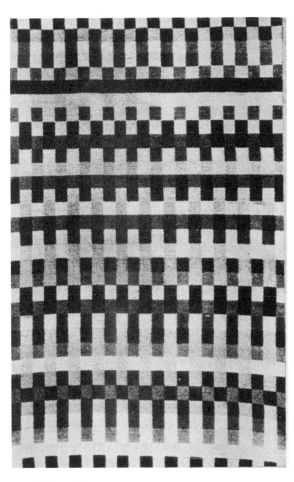

Anni Albers: Woven rug.
c. 1927

Weaving class, Dessau

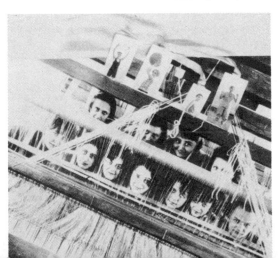

tion. As a result, more systematic training in the mechanics of weaving was introduced, as well as a course in the dyeing of yarns. The whole range of possibilities had been freely explored: concentration on a definite purpose now had a disciplinary effect.

The physical qualities of materials became a subject of interest. Light-reflecting and sound-absorbing materials were developed. The desire to reach a larger group of consumers brought about a transition from handwork to machine-work: work by hand was for the laboratory only; work by machine was for mass production.

The interest of industry was aroused.

The changing moods of the time affected the Bauhaus workers and they responded according to their ablitiy, helping to create new art forms and new techniques. The work as a whole was the result of the joint efforts of a group, each individual bringing to it his interpretation of a mutually accepted idea. Many of the steps were more instinctive than conscious and only in retrospect does their meaning become evident.

142

1927–1928

Anni Albers: Wall covering. Tan cotton, paper fibre and cellophane

Anni Albers: Drapery material. Wool and rayon

Anni Albers: Drapery material. Two shades of brown. Cotton and rayon

Anni Albers: Wall covering. Tan, brown. Cotton and cellophane

Anni Albers: Drapery material. Blue and white. Wool and rayon

Weaving workshop, Dessau

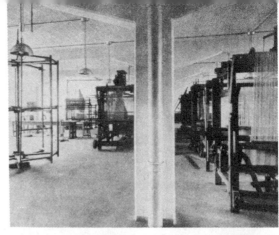

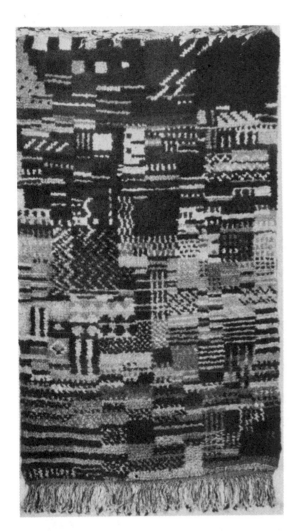

Otti Berger: Knotted rug.
Black, blue, red, gray

Gunta Sharon-Stölzl:
Coat material. Wool

Gunta Sharon-Stölzl:
Curtain material.
Cellophane

Otti Berger: Textile. White
cellophane and cotton

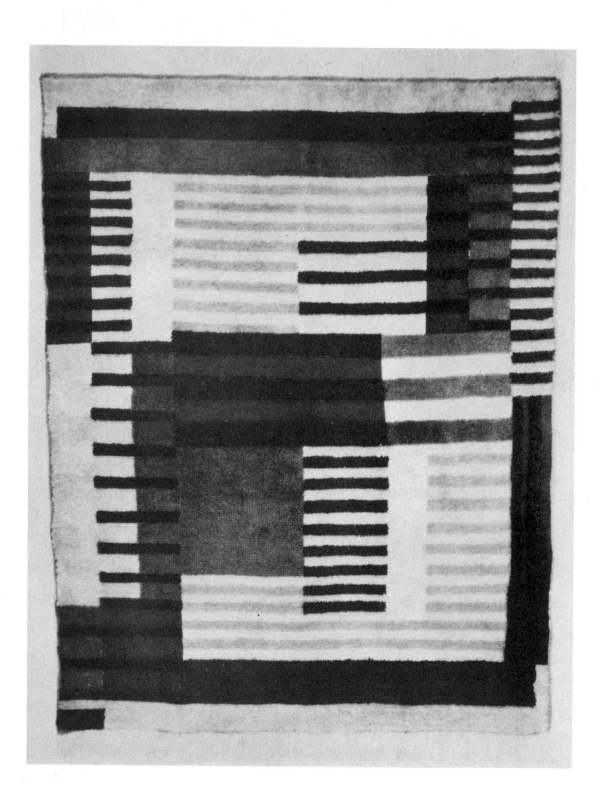

144

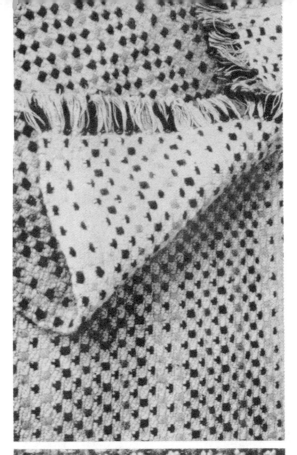

Lis Volger: Rug. Heavy wool and fine hemp

Otti Berger: Rug. White, black, brilliant blues, red, yellow. Smyrna wool and hemp

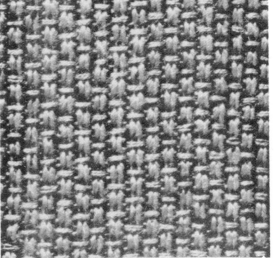

Anni Albers: Drapery material. Black and white. Cotton, rayon and wool

Anni Albers: Wall covering. Cellophane and cotton

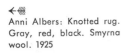

Anni Albers: Knotted rug. Gray, red, black. Smyrna wool. 1925

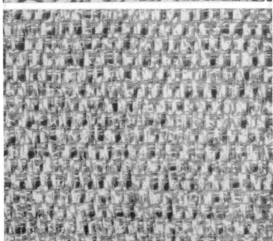

typography workshop

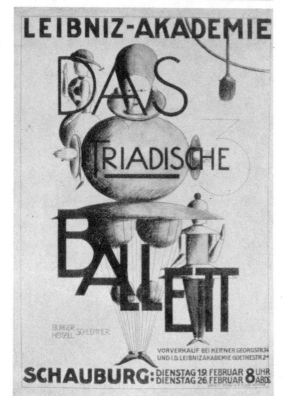

herbert bayer: page lay-
out. bauhaus prospectus.
printed at the bauhaus
workshop. 1925

oskar schlemmer: poster.
the triadic ballet.
lithograph

l. moholy-nagy: title
page. *neue arbeiten der
bauhaus werkstätten.*
1925

typography by herbert bayer

why should we write and print with two alphabets? both a large and a small sign are not necessary to indicate one single sound.

A = a

we do not speak a capital A and a small a.
we need only a single alphabet. it gives us practically the same result as the mixture of upper- and lower-case letters, and at the same time is less of a burden on all who write—on school children, students, stenographers, professional and business men. it could be written much more quickly, especially on the typewriter, since the shift key would then become unnecessary. typewriting could therefore be more quickly mastered and typewriters would be cheaper because of simpler construction. printing would be cheaper, for fonts and type cases would be smaller, so that printing establishments would save space and their clients money. with these common sense economies in mind the bauhaus began in 1925 to abandon capital letters and to use small letters exclusively. this step toward the rationalization of writing and printing met with outraged protests, especially because in german capital initials are used for all nouns. moreover, the bauhaus had always used roman or even sans serif letters instead of the archaic and **complicated gothic alphabet** customarily employed in german printing, so that the suppression of capitals added fresh insult to old injury. nevertheless the bauhaus made a thorough alphabetical house-cleaning in all its printing, eliminating capitals from books, posters, catalogs, magazines, stationery and even calling cards.

dropping capitals would be a less radical reform in english. indeed the use of capital letters occurs so infrequently in english in comparison with german that it is difficult to understand why such a superfluous alphabet should still be considered necessary.

to recall this typographical experiment *the balance of this volume, to page 217, will be printed without using capital letters.*

joost schmidt: handbills. 1924

147

herbert bayer: cover design. bauhaus prospectus. 1926

l. moholy-nagy: cover design. magazine *qualität.* 1926

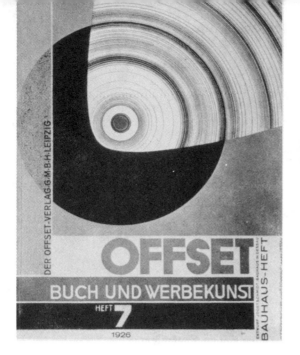

joost schmidt: cover
design. magazine offset.
1926

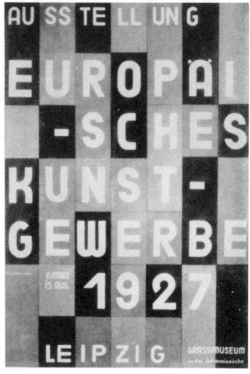

herbert bayer: poster.
1926

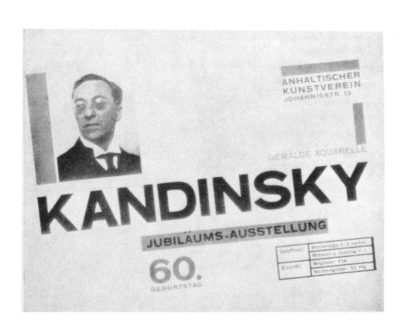

herbert bayer: exhibition
poster. printed in the
bauhaus printing shop.
1926

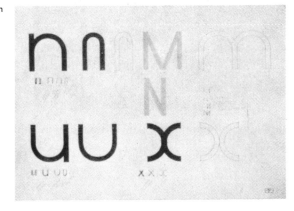

herbert bayer: *universal* type. condensed bold. characters at base show medium and light weights

herbert bayer: basic elements from which the *universal* type is built up: a few arcs, three angles, vertical and horizontal lines

herbert bayer: *universal* type. characters at base show bold, medium and light weights, 1925. improved, 1928

herbert bayer: research in the development of the *universal* type

l. moholy-nagy: book jacket. 1924

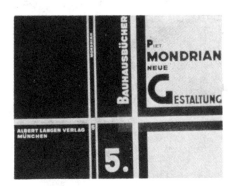

josef albers: stencil letters. design based on three fundamental shapes. 1925

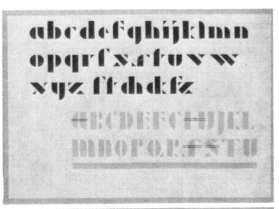

josef albers: stencil letters. basic elements from which the letters are built up. 1925

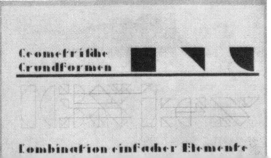

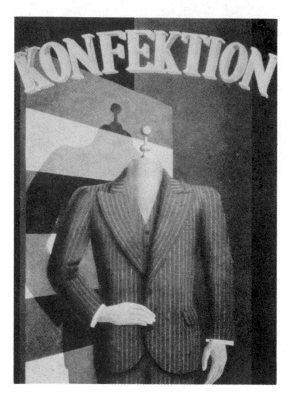

150

xanti schawinsky:
poster advertising men's
clothing. 1928

xanti schawinsky:
poster advertising hats.
1928. executed in italy.
1935

joost schmidt course in design

a anonymous: studies in contrast. given: a cross

b anonymous: studies in contrast. given: form of letter T

c anonymous: studies in illusion of distance and proximity for purposes of layout and display. given: form of letter z. free choice of additional elements

d anonymous: studies in composition. given: seven bars of equal size

e anonymous: studies in composition. given: nine squares of equal size

f anonymous: studies in thematic and optic contrasts

a

b

c

d

e

f

151

photography

no technical photographic workshop was in existence until 1929. photography, however, had a very important influence on all bauhaus work.

it was moholy-nagy who first encouraged the bauhaus to consider photographic problems. his course as well as his own photographic work (such as the photogram, or exposure without a camera) stimulated the students to make their own experiments. the bauhaus students, deeply concerned with new problems of space relations, responded eagerly to the new artistic possibilities of photography: bird's eye and worm's eye view, "negative effects," double exposure and double printing, microphotography and enlargements. not only was photography thus considered as an end in itself, but it was put to practical use in advertising layout, posters and typography. thus the bauhaus took an active part in the development of photographic art.

applied photography, by moholy-nagy

the most important development affecting present day layout is photo-engraving, the mechanical reproduction of photographs in any size. an egyptian pictograph was the result of tradition and the individual artist's ability; now, thanks to photography, the expression of ideas through pictures is far more exact.

the camera's objective presentation of facts frees the onlooker from dependence on someone else's personal description and makes him more apt to form his own opinion.

the inclusion of photography in poster design will bring about another vital change. a poster must convey instantaneously all the high points of an idea. the greatest possibilities for future development lie in the proper use of photographic means and of the different photographic techniques: retouching, blanking out, double printing, distortion, enlargement, etc.

the two new resources of poster art are: (1) photography, which offers us a broad and powerful means of communication; (2) emphatic contrast and variations in typographical layout, including the bolder use of color.

1923 (from bibl. no. 8)

152

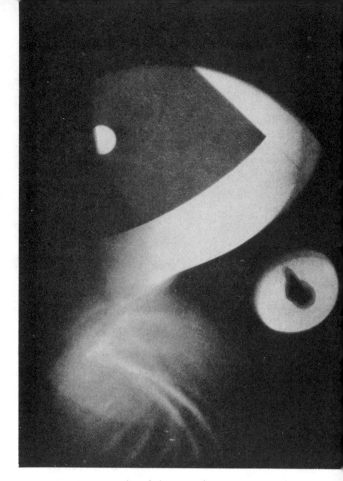

l. moholy-nagy: photogram. 1923

l. moholy-nagy: poster. photomontage

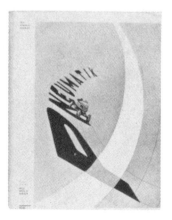

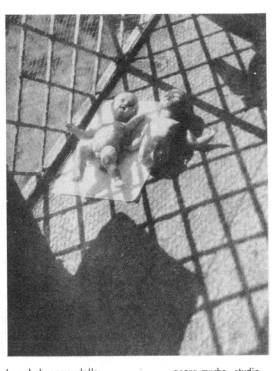

l. moholy-nagy: dolls.
1926

georg muche: studio
reflected in garden
crystal. 1923

l. moholy-nagy: leda and
the swan. photomontage.
1925

l. moholy-nagy:
photogram. 1922

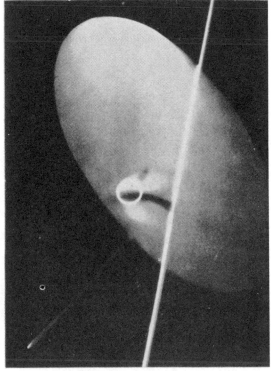

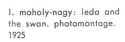

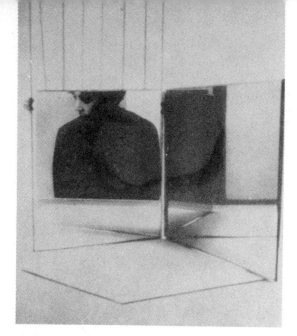

florence henri:
photography. 1927

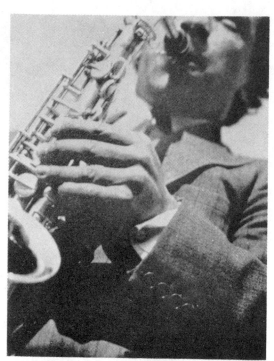

lux feininger:
photography. 1928

154

herbert bayer: balcony.
1928

werner feist: the pipe.
1928

anonymous: attention!
photomontage

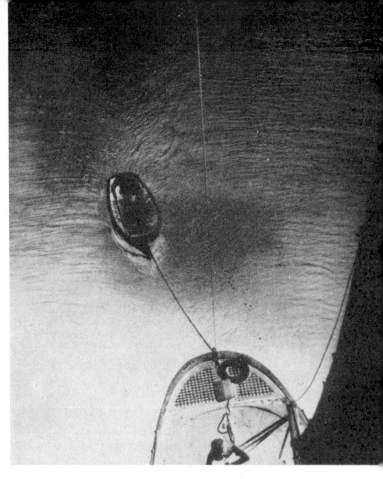

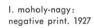
l. moholy-nagy:
negative print. 1927

herbert bayer: photo-
graph for cover of maga-
zine *bauhaus*. awarded
first prize in the exhibition
of foreign advertising
photography at the art
center, new york, 1931

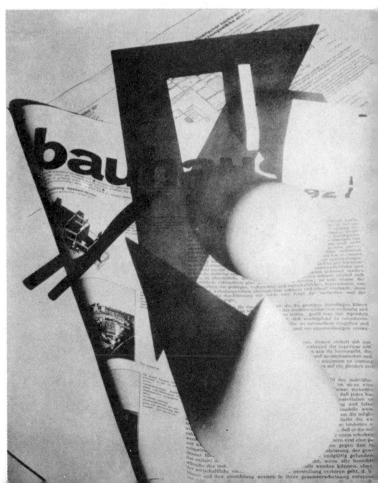

exhibition technique

in addition to exhibitions at the bauhaus itself, the following exhibition designs by bauhaus people may be mentioned:

herbert bayer, exhibition of the towns of dessau and zerbst, berlin, 1927

herbert bayer, hall of elementary typography, at the press exposition, cologne, 1928

herbert bayer and herman paulik, transportable pavilion for exhibition purposes, ventzky, 1928

alexander schawinsky and joost schmidt, junkers pavilion, gas and water exhibition, berlin, 1928

walter gropius, moholy-nagy, alexander schawinsky, marcel breuer, exhibition of housing problems (gagfa), berlin, 1929

walter gropius, moholy-nagy, marcel breuer, herbert bayer, werkbund exhibition, paris, 1930

herbert bayer, moholy-nagy, walter gropius, exhibition of the building unions (soziale baugewerkschaften), building exhibition, berlin, 1931

walter gropius and xanti schawinsky, building exposition, berlin, 1931

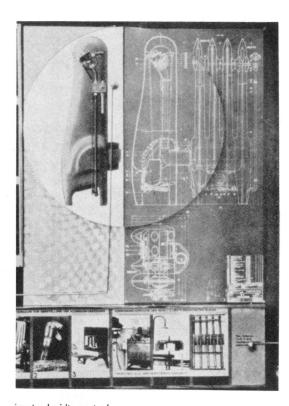

joost schmidt: part of display for junkers gas water heaters, gas and water exhibition, berlin. 1928

herbert bayer: design
for a transportable exhibi-
tion pavilion advertising
agricultural machinery.
1928

←◀◀◀
xanti schawinsky:
transparent display for
hot water boilers, gas and
water exhibition, berlin.
1928

←◀◀◀
xanti schawinsky:
plastic health poster in
junkers pavilion, gas and
water exhibition, berlin.
1928

heinz loew and franz
ehrlich: studies in
luminous advertising. 1928

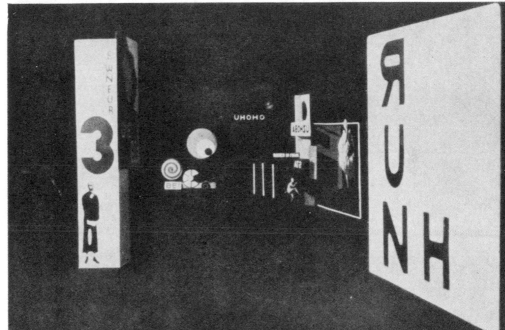

←◀◀◀
xanti schawinsky:
health poster in junkers
pavilion, gas and water
exhibition, berlin. 1928

xanti schawinsky:
pavilion for junkers gas
boilers, gas and water
exhibition, berlin.
executed by the bauhaus
workshops. 1928

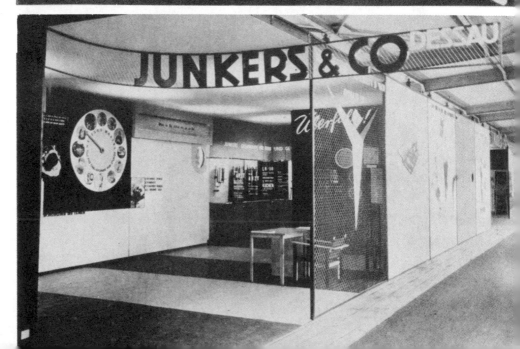

wall-painting workshop

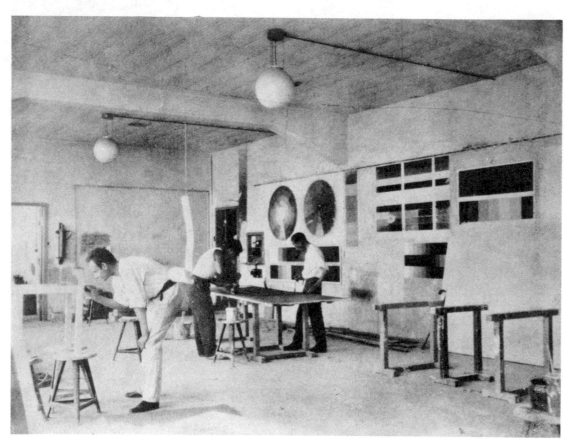

wall-painting workshop,
dessau. on the walls,
experiments in various
techniques and materials

158

hinnerk scheper: wall-painting designs. 1927

instruction in the workshop included instruction in theory of form, color and materials, and thorough practical training in actual painting.

1 technical composition of the painting ground
lime plaster, plaster of paris, gypsum plaster, marble and alabaster dust plasters for tempera painting; spatter painting (airbrush) on plaster, wood and metal; preparation of the ground for panel pictures

2 study of all known painting techniques of the past
fresco, casein and mineral paints
tempera, watercolor, calsomine, encaustic
oil paint, lacquer, metallic paint

3 fundamental principles of color harmony
chemical nature of oils, varnishes, lacquers, dryers and pigments

4 practical application of the new techniques discovered in the experimental workshop

5 projects for color schemes for given architectural models, plans and elevations

6 poster work

7 knowledge of tools, erection of scaffolding, the making of stencils and cartoons, working drawings, perspectives, models

8 taking dimensions, preparing estimates, bookkeeping

wall paper production was planned under gropius. actual execution took place under hannes meyer and, later, miës van der rohe. the emphasis was not on pattern but on texture: solid colors were used, and a number of new techniques were introduced. the influence on german manufacturers was very great; bauhaus wall paper was widely imitated.

⨠→

159

sculpture workshop

joost schmidt: paraboloid
sculpture. 1926–1928

f. ehrlich: sculptured
relief. 1928

joost schmidt: linear and
plastic forms

joost schmidt:
composition of primary
plastic forms. 1926–1928

joost schmidt: study in
comparison. positive and
negative conical volumes.
1926–1928

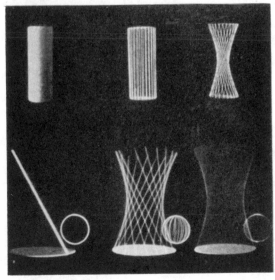

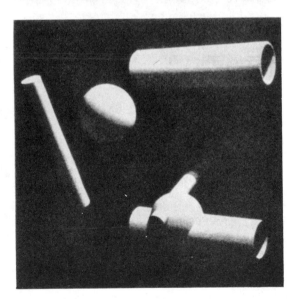

joost schmidt: comparative
forms. *top* transformation
of cylinder to hyperboloid.
bottom transformation of
line and circle to hyper-
boloid and sphere

joost schmidt: primary
plastic forms. 1926–1928

stage workshop

from a lecture with stage demonstrations by oskar schlemmer, delivered before the friends of the bauhaus, march 16, 1927, published in bibl. no. 30, 1927, no. 3, pp. 1, 2.

in weimar, where we had no theater of our own, we had to use one of the local stages for our productions. now, however, in the new building at dessau we are lucky enough to have our own theater.

we are interested in interior space treated as part of the whole composition of the building. stagecraft is an art concerned with space and will become more so in the future. a theater (including both stage and auditorium) demands above all an architectonic handling of space; everything that happens in it is conditioned by space and related to it. form (two-dimensional and three-dimensional) is an element of space; color and light are elements of form.

light is of great importance. we are predominantly visual beings and therefore purely visual experience can give us considerable satisfaction. if forms in motion provide mysterious and surprising effects through invisible mechanical devices, if space is transformed with the help of changing forms, colors, lights, then all the requirements of spectacle, a noble "feast for the eyes," will be fulfilled.

if we go so far as to break the narrow confines of the stage and extend the drama to include the building itself, not only the interior but the building as an architectural whole—an idea which has especial fascination in view of the new bauhaus building—we might demonstrate to a hitherto unknown extent the validity of the *space-stage*, as an idea.

let us consider plays consisting only in the movements of forms, colors and lights. if the movement is purely mechanical, involving no human being but the man at the switchboard, the whole conception could have the precision

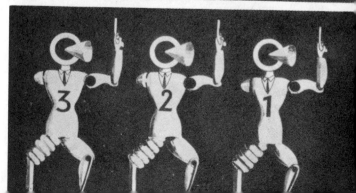

xanti schawinsky:
stage set for a
shakespearean play. the
units can be combined in
various ways. executed at
zwickau, 1926

←※
xanti schawinsky:
design for a theater
curtain

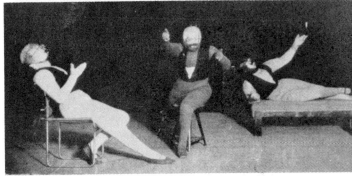

oskar schlemmer: *dance
of gestures*. danced by
schlemmer, kaminsky,
siedoff. 1927

←※
xanti schawinsky:
design for georg kaiser's
from morn till midnight.
1926

oskar schlemmer:
variations on a mask.
drawings for class in stage
theory

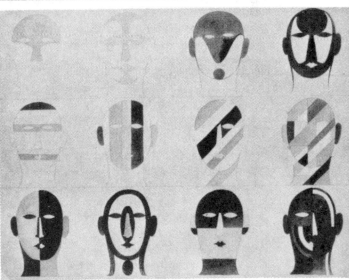

←※
xanti schawinsky:
figures for robbers' ballet
in *two gentlemen of
verona*. 1925

oskar schlemmer: stilt-
walkers, design for a
ballet. drawings for class
in stage theory. c. 1927

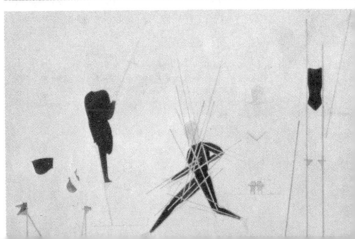

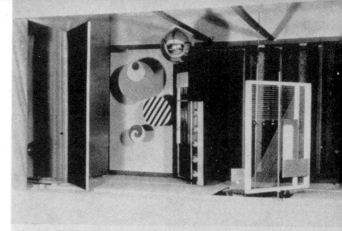

of a vast automaton requiring a tremendous technical equipment. modern engineering can produce such equipment; it is only a question of money.

but there is also the question of the extent to which such equipment would be justified by the effects obtained. how long can a spectator's interest be held by rotating, swinging, humming machinery, even if accompanied by innumerable variations in color, form and light?

is entirely mechanized drama to be thought of as an independent genre, can it dispense with man except as a perfect mechanic and inventor?*

since at present no such mechanically equipped stage exists, and since our own experimental stage until now has had even less equipment than the regular theaters, the human actor continues to be an essential element of drama for us.

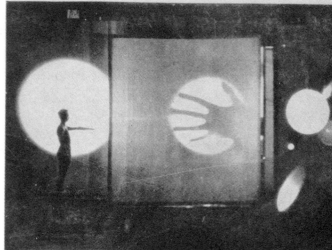

and he will remain so as long as there is a stage. he is the antithesis of the rationally constructed world of form, color and light; he is the vessel of the unknown, the immediate, the transcendental—an organism of flesh and blood as well as a phenomenon existing within the limits of time and space. he is the creator of an important element of drama, perhaps the most important—speech.

we admit that we have cautiously avoided this problem so far, not because it does not concern us, but because we are well aware of its significance and want to master it slowly. for the time being we are satisfied with the mute play of gesture and movement, with pantomime, but firmly believe that some day we shall develop speech quite naturally from them. we want to understand words, not as literature, but in an elementary sense, as an event, as though they were heard for the first time.

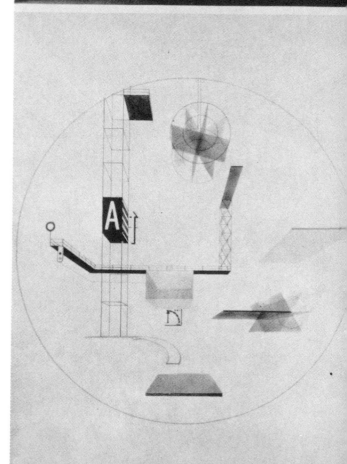

* i am speaking of completely independent mechanical automata, not of the mechanization and technical renovation of stage equipment — the theater of steel concrete and glass with rotating stage, film projections, etc.—which is meant to serve as a background for performances by human actors.

164

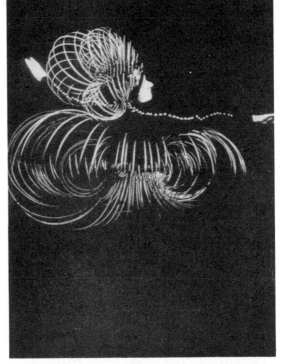

heinz loew: model of a
mechanical stage set. 1927

oskar schlemmer: spiral
figure from *the triadic
ballet*

←≪
light play. experiment
with different ways of
using light

←≪
xanti schawinsky:
preliminary sketch for a
space theater. 1926

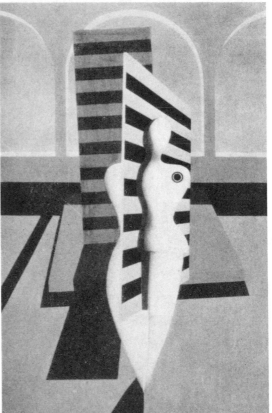

xanti schawinsky:
stage set. 1926

xanti schawinsky:
sketch. produced by stage
class

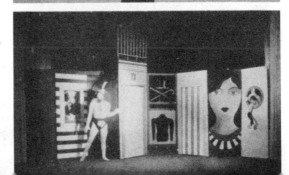

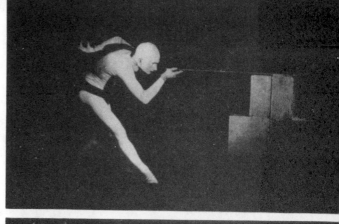

oskar schlemmer: *box play*. danced by siedoff

oskar schlemmer: *musical clown*. danced by andreas weininger

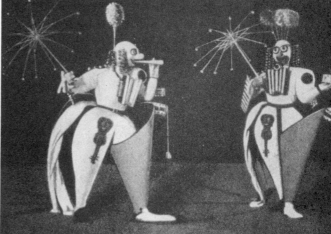

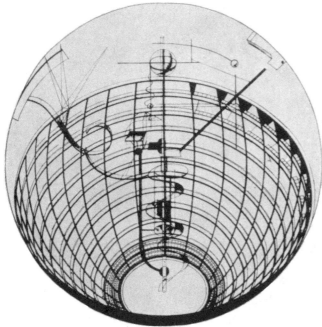

andreas weininger: design for a spherical theater. the spectators sit along the interior surface of the globe; each overlooks the whole interior, is drawn toward the center and is, therefore, in a new psychological, optical and acoustical relationship to the whole

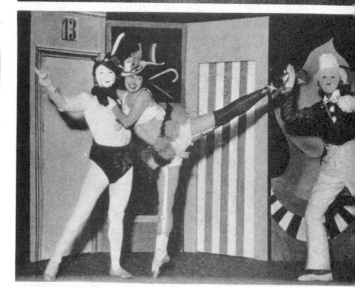

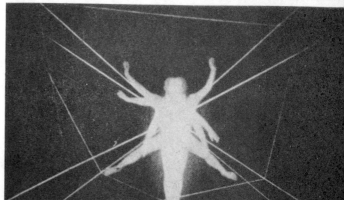

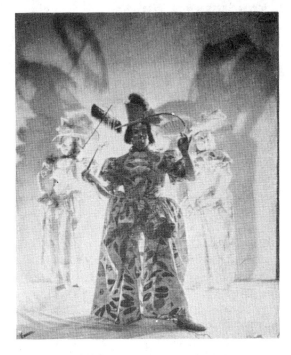

oskar schlemmer: *wives dance*. produced by stage class

oskar schlemmer: drawings of the human body. drawings for class in stage theory

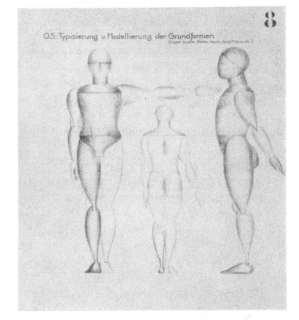

◄◄ xanti schawinsky: sketch. danced by schawinsky, kreibig, schlemmer. produced by stage class

stage class rehearsing on the bauhaus roof. black figure in center: oskar schlemmer

 oskar schlemmer: delineation of space by human figure. danced by siedoff. c. 1927

kandinsky's course

analytical drawing

first stage:

the students began with still-life compositions, and their first analytical problems were:

1 reduction of the entire composition to a simple, major form, to be carefully drawn within certain limits to be determined by the student himself.

2 distinguishing the characteristic forms of single parts of the still-life, studied separately and afterwards in relation to the whole composition.

3 rendering of the entire composition in a simplified line-drawing.

gradual transition to the **second stage** of instruction, briefly described as follows:

1 indication of the *tensions* discovered in the composition—rendered in line-drawing.

2 accentuation of the principal *tensions* through the use of broader lines or the use of color.

3 indication of the constructional *net* with its focal or starting points (see the dotted lines in drawing opposite; the objects suggested are a saw, a grindstone and a pail).

third stage:

1 the objects are considered solely as *energy-tensions*; the composition is reduced to arrangements of lines.

2 different possibilities of the composition: obvious and hidden construction (see drawing opposite).

3 exercises in the most drastic simplification of the whole and of the individual *tensions*—concise, exact expression.

subjects and methods can be described only very generally in these few words. in many cases there are more possibilities to be considered than have been indicated here. for instance, the main theme of a composition can be explored in relation to the most varied partial *tensions,* such as the significance of single parts of the composition, their weight, center, shape, character, etc.

the following must be added:

1 drawing instruction at the bauhaus is training in observation, in exact seeing and exact rendering, not of the external appearance of an object, but of its constructional elements, of their logical forces or *tensions* which are to be discovered in the objects themselves and in the logical arrangement of them. the handling of plane surfaces is preliminary to the handling of space.

2 drawing instruction is based upon the method in my other courses, and which in my opinion should be the method used in all other fields.

(from bibl. no. 30)

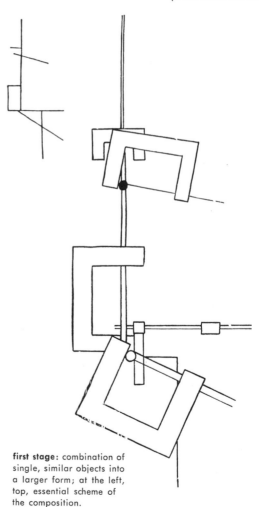

first stage: combination of single, similar objects into a larger form; at the left, top, essential scheme of the composition.

second stage:
objects recognizable (saw, grindstone, pail), main *tensions* indicated in colors, principal weights in broad lines; focal point of the constructional *net* in dotted lines
above: essential scheme of the composition

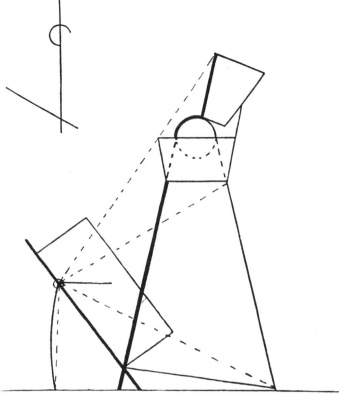

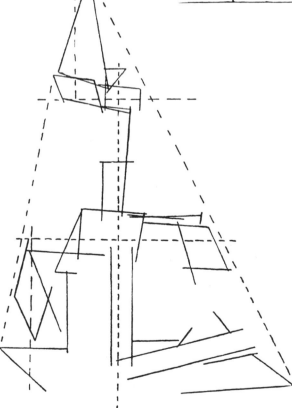

third stage:
left: objects completely translated into energy *tensions.* main construction indicated by dotted lines.
above: scheme.

paul klee: hall c.
oil on canvas. 1920.
courtesy buchholz gallery

paul klee speaks:

we construct and construct and yet intuition still has its uses. without it we can do a lot, but not everything. one may work a long time, do different things, many things, important things, but not everything.

when intuition is joined to exact research it speeds the progress of exact research. exactitude, winged by intuition, is temporarily superior. but exact research being exact research, it can get along, if tempo is disregarded, without intuition. it can get along as a matter of principle without intuition. it can remain logical, it can construct itself. it can boldly bridge the distance from one thing to another. it can preserve an ordered attitude in chaos.

art, too, has been given sufficient room for exact investigation, and for some time the gates leading to it have been open. what had already been done for music by the end of the eighteenth century has at last been begun for the pictorial arts. mathematics and physics furnished the means in the form of rules to be followed and to be broken. in the beginning it is wholesome to be concerned with the functions and to disregard the finished form. studies in algebra, in geometry, in mechanics characterize teaching directed toward the essential and the functional, in contrast to the apparent. one learns to look behind the façade, to grasp the root of things. one learns to recognize the undercurrents, the antecedents of the visible. one learns to dig down, to uncover, to find the cause, to analyze. (from bibl. 14)

administration

what authorities had to be consulted by the director when it was necessary to make important decisions affecting the internal conditions or external relations of the bauhaus?
at weimar, the whole institute, including the director, was under the jurisdiction of the ministry of public education; at dessau, this authority was vested in the municipal council.
the annual budget varied between 130,000 and 200,000 marks. at weimar it was prepared by the minister of public education and submitted to the thuringian *landtag*; at dessau the budget was prepared by the municipal council and submitted to the *stadtparlament*. in the bauhaus itself, the director had far-reaching powers. he was given "full charge of the creative and administrative activities of the bauhaus." in the early years, the faculty had a nominal right to vote on vital decisions. in the belief that problems affecting creative work can never be solved by

a majority, the right to vote was discarded in subsequent statutes; in fact, decisions by majority vote were dropped altogether. full responsibility was granted to the director by a unanimous vote.
the statutes provided, however, that all decisions had to be preceded by discussion. all instructors and the student representatives had the right to participate in these discussions. the formal consultants were:
1. for the sale of models to industrial firms: the business manager (syndikus) who was in charge of the commercial activities of the bauhaus and later of the bauhaus corporation.
2. for problems of internal organization and teaching: the bauhaus council, made up of masters teaching problems of form and technical instructors in the workshops (the latter were included only at weimar), the business manager, and the student representatives.

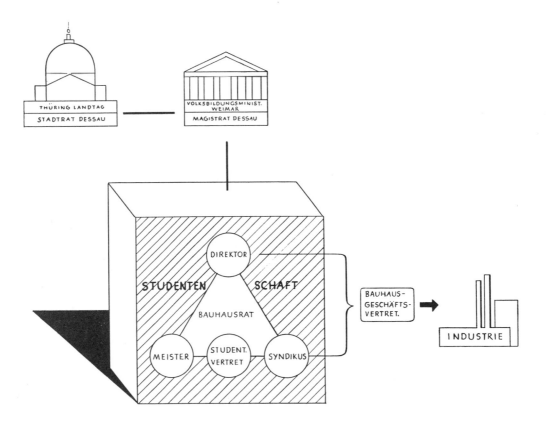

discussion in the bauhaus; influence of the student body
the basic conception of the bauhaus had so many rami-
fications that it gave rise to a vast number of problems
demanding solution. this led to spirited discussions in the
early years and even to violent controversies, not only
among faculty members, but between the faculty and the
student body (see klee's letter, *right*). as the years passed,
the educational system and its organization were fre-
quently revised as a result of these discussions. gropius
intended that the process of learning should merge im-
perceptibly into a communal task (as the first manifesto
put it, "the school is the servant of the workshop; and the
day will come when the school will be absorbed into the
workshop"). in accordance with these views, the students
were permitted to take an active part in shaping the poli-
cies of the bauhaus. the critical were challenged to formu-
late practical suggestions for improvement. this gave each
student a feeling of responsibility for the work as a whole,
and made it easier to clarify the problems agitating every-
one. there can be no doubt that this aspect of the students'
creative activity contributed largely to the institution's
subsequent successes.

in the course of time it became possible to give the student
body more and more direct influence in the affairs of the
whole organization. originally there was a student council
which was consulted from time to time by the director
later on, the students were granted the right to send one
delegate from each workshop to the faculty council when
vital decisions were to be made. still later, in dessau, one
or two student representatives attended all meetings of
the faculty council.

paul klee: letter to the faculty council
i welcome the fact that forces so diversely inspired are
working together at our bauhaus. i approve of the conflict
between them if its effect is evident in the final product.
to attack an obstacle is a good test of strength, if it is a
real obstacle.

critical estimates are always subjective and thus a negative
judgment on another's work can have no significance
for the work as a whole.

in general, there is no right nor wrong, but the work lives
and develops through the play of opposing forces just as
in nature good and bad work together productively in the
long run. (signed) paul klee
 december, 1921

from a manuscript used for a bauhaus evening discussion:
even if i try, i see no chaos in our time, that some painters
can't make up their minds whether to paint naturalistically,
abstractly or not at all does not mean chaos.

our needs are clear enough; the possibilities are limited
only by ourselves. the main thing is to lend a hand where
something needed is lacking, and to move with whatever
forces we can command toward a single-minded economical
solution. . . marcel breuer

in 1926 the first issue of the bauhaus periodical, **bauhaus:
zeitschrift für gestaltung,** was published, edited by gropius
and moholy-nagy, with the collaboration of all members
of the bauhaus. publication was continued for several
years; after 1928 under varying editorship.

extra-curricular activities

the bauhaus band

l. moholy-nagy: wall
display for a bauhaus
festival, 1925

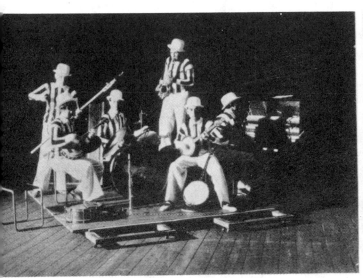

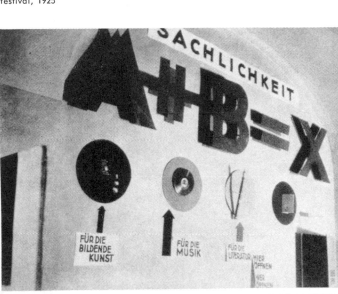

xanti schawinsky:
birthday greetings

montage from gift album.
1928

costumes for a bauhaus
party

beach life

174

nonne schmidt: visual re-
port of a trip to jugo-
slavia. montage. 1926

a bauhaus costume party

herbert bayer: invitation
to the white festival.
theme: white checked,
dotted and striped. 1925

photography by lux feininger.

nonne schmidt: page from
a birthday album, mon-
tage of pictures and news-
paper clippings. 1925

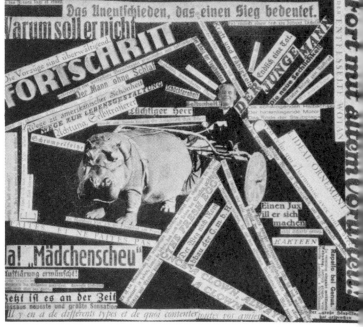

otti berger: gingerbread
figure baked for a birth-
day party

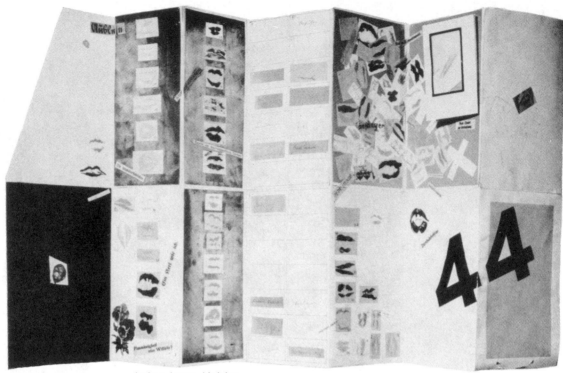

herbert bayer: birthday
gift to walter gropius.
screen imprinted with
kisses from students and
masters. 1926

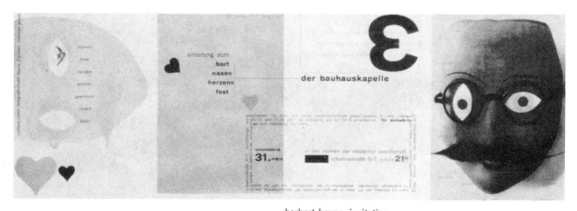

herbert bayer: invitation
to the beard, nose and
heart festival. printed at
the bauhaus workshop.
1928

the bauhaus band. photo-
graph by lux feininger

lou scheper: letter

xanti schawinsky: poster
for the beard, nose and
heart festival. 1928

painting, sculpture, graphic arts 1919-1928

"iconoclasts"—the "house without pictures"

the opposition of the bauhaus to conventional and academic ideas led to the charge of "iconoclasm." for instance, at one period the bauhaus reacted violently against the custom of overloading the walls of a house with all kinds of pictures. the bauhaus felt that the "wall" itself had to be rediscovered and its treatment experimented with in many ways, so that interest could be centered on the mural or relief which would exist as an integral feature of the room rather than on framed pictures which were too often casual afterthoughts. the "house without pictures" (haus ohne bilder) was merely the short-lived battle cry of a few extremists for, as a matter of fact, the bauhaus took the keenest interest in painting and sculpture. otherwise it would hardly have invited world-famous artists to join its faculty, nor would it have included so many paintings in its exhibitions. From the very beginning the student body included a number of artists who were allowed to devote themselves exclusively to painting.

paul klee: outdoor sport.
watercolor. 1923.
courtesy j. b. neumann

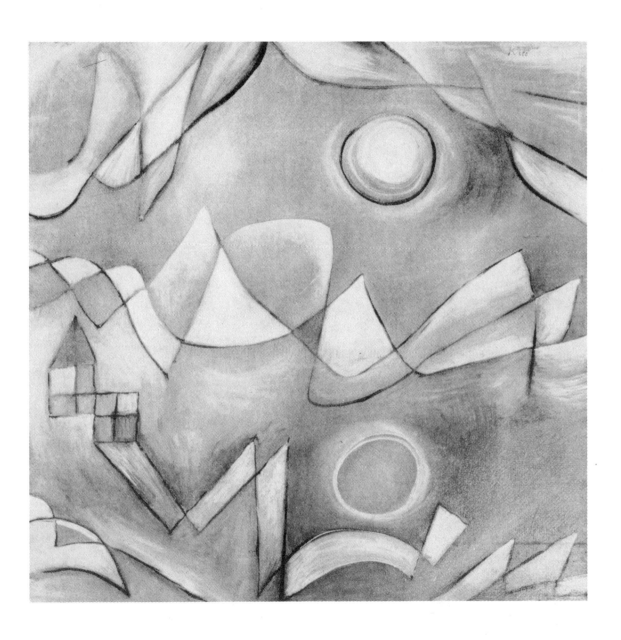

paul klee: arctic thaw.
oil on cardboard. 1920.
courtesy nierendorf gallery

lyonel feininger:
nieder-reissen.
oil on canvas. 1924

lyonel feininger:
village.
watercolor. 1923.

lyonel feininger: gothen.
oil on canvas. 1919.
courtesy nierendorf gallery

wassily kandinsky:
graduated black.
oil on canvas. 1927.
courtesy j. b. neumann

182

wassily kandinsky:
composition 307 modified.
oil on composition
board. 1925.
courtesy nierendorf gallery

wassily kandinsky:
colored woodcut. 1922

wassily kandinsky: serene.
oil on canvas. 1924.
courtesy j. b. neumann

johannes itten: cubic
composition. 1919

k. schwerdtfeger: relief.
glass and plaster. 1922

k. schwerdtfeger: torso.
tyrolean marble. 1922

oskar schlemmer:
free sculpture.
plaster. 1923

gerhard marcks:
the youth.
plaster. 1922-1923

oskar schlemmer:
architectonic relief. 1923

oskar schlemmer:
figure k¹.
lithograph. 1921.
(from. bibl. no. 3a)

oskar schlemmer:
architectonic relief. 1923

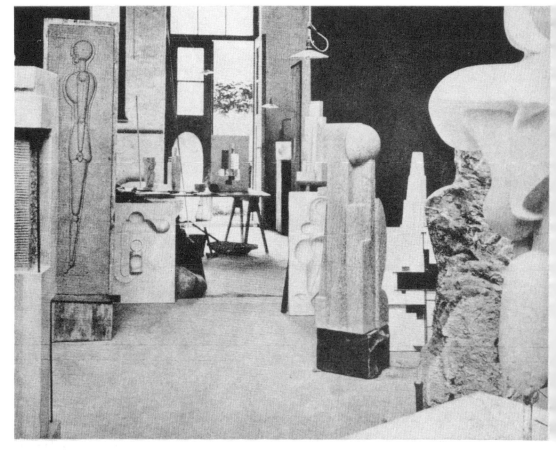

weimar bauhaus.
sculpture workshop

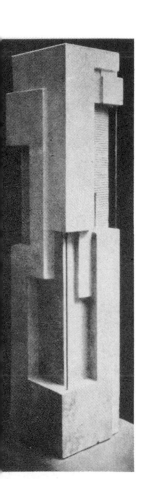

k. schwerdtfeger:
architectural sculpture.
sandstone

188

gerhard marcks:
mother cat.
woodcut. 1922.
courtesy j. b. neumann

gerhard marcks:
cain and abel.
woodcut. 1923

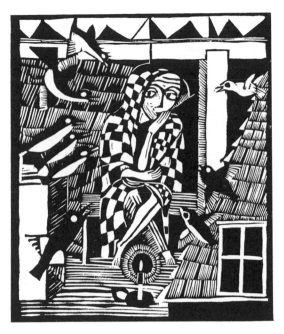

gerhard marcks:
the owl.
woodcut. 1921.
(from bibl. no. 3a)

friedl dicker:
fantastic animals.
lithograph. 1922

oskar schlemmer:
figure h².
lithograph. 1921.
(from bibl. no. 3a)

190

oskar schlemmer:
dancer. oil on canvas.
c. 1923

oskar schlemmer:
the bauhaus stairs.
oil on canvas. c. 1929.
courtesy philip johnson

l. moholy-nagy:
construction a 11.
tempera on canvas. 1924

l. moholy-nagy:
construction.
tempera on canvas. 1926

georg muche: still life.
colored lithograph. 1926

paul citröen:
after braque.
etching. 1923

herbert bayer: the five.
watercolor. 1922

l. moholy-nagy:
construction b 100.
tempera on canvas. 1928

josef albers: picture.
fragments of colored
glass bottles. 1921

194

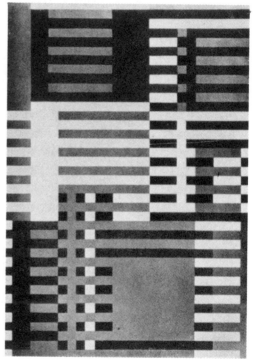

josef albers:
glass picture.
single pane. 1926

josef albers:
lattice picture.
stained glass. 1921

paul citröen: metropolis.
montage. 1921

rudolf baschant:
composition.
etching. 1922

oskar schlemmer:
variation.
red and black ink. 1924

196

photograph from maga-
zine showing crowd and
loudspeaker. the plates on
this and the opposite page
are individual variations
on this photograph, after
an idea of moholy-nagy,
which were made up into
a portfolio as a birthday
gift to walter gropius

paul klee: variation.
tempera. 1924

georg muche: variation.
pencil and wash. 1924

lyonel feininger:
variation.
watercolor and ink.

l. moholy-nagy:
variation.
pencil and wash. 1924

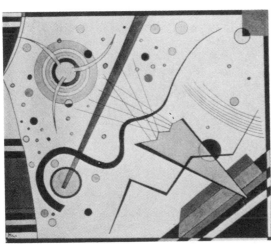

wassiliy kandinsky:
variation.
watercolor and ink. 1924

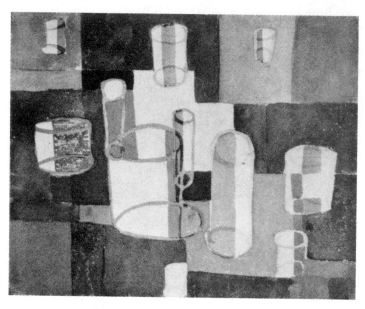

ludwig hirschfeld-mack:
composition. watercolor.
1922

198

werner drewes:
abstraction. pencil.
1927-1928

albert braun: watercolor.
1927

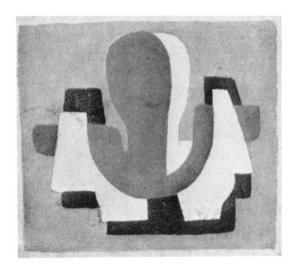

margrit fischer:
composition.
monotype, 1928

fritz kuhr: watercolor.
1928

k. schwerdtfeger: view.
etching. 1923

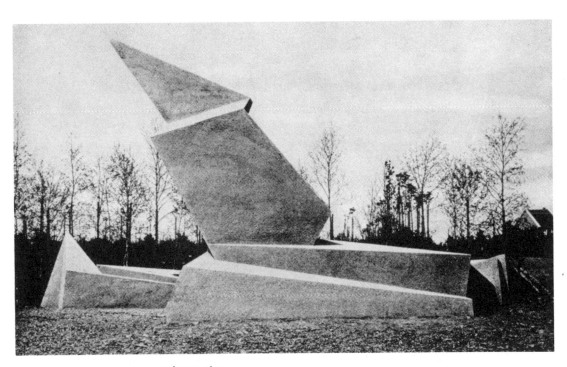

walter gropius
monument, weimar.
concrete. 1921

herbert bayer:
composition in space.
tempera. 1925

202

herbert bayer:
abstraction.
tempera and watercolor.
1928

xanti schawinsky:
suspended architecture.
tempera. 1927

xanti schawinsky:
tempera. 1926

administrative changes, 1928

early in 1928, gropius decided to leave the bauhaus. he issued this public statement: "i intend to leave the present scene of my activities, in order to exert my powers more freely in a sphere where they will not be cramped by official duties and considerations. the bauhaus, which i founded nine years ago, is now firmly established. this is indicated by the growing recognition it receives and the steady increase in the number of its students. it is therefore my conviction (especially since my public duties are steadily becoming more onerous) that the time has now come for me to turn over the direction of the bauhaus to co-workers to whom i am united by close personal ties and common interests . . ."

gropius recommended as his successor the swiss architect, hannes meyer, who was at that time in charge of the architecture department at the bauhaus. his selection was ratified by the municipal council of dessau.

the departure of gropius coincided with that of breuer, bayer and moholy-nagy.

hannes meyer continued as director until june, 1930, when conflict with the municipal authorities led to his resignation. the municipal council tried to persuade gropius to take charge once more, but instead he suggested the well-known berlin architect, ludwig miës van der rohe. this suggestion was followed and miës van der rohe served as director of the bauhaus until the school was closed by the national socialist regime in april, 1933. at the time of its closing, the bauhaus was occupying temporary quarters in berlin, where it had moved in october, 1932, when the national socialists took over the government of anhalt, in which the town of dessau is situated. since april, 1933, the national socialist party has used the bauhaus building as a training school for political leaders.

notwithstanding individual differences among the collaborators, bauhaus products had a certain similarity in appearance, as may be seen in this book. this was not the result of following slavishly a stylized esthetic convention, since it was against just such imitativeness that the bauhaus revolted. it was the outcome of a unifed conception of art developed by all the workers in common. at the same time, however, it was necessary to combat imitators and unintelligent admirers who thought that every unornamented building or implement was derived from the bauhaus "style" and who thus threatened to cheapen the meaning of bauhaus work. expressly stated: the goal of the bauhaus is not a "style," system, dogma, canon, recipe or fashion. it will live as long as it does not depend on form, but continues to seek behind changing forms the fluidity of life itself. the bauhaus was the first institution in the world with this anti-academic trend. it assumed the responsibilities of leadership in order to assure the victory of its ideas and to maintain the vitality of its own community. but the development of a bauhaus "style" would mean a return to academic stagnation and inertia. may it be preserved from such a death!

(from bibl. no. 27)

spread of the bauhaus idea

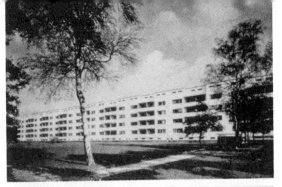

problems raised by the bauhaus were soon eagerly debated by the public at large. numerous lectures by the staff in germany and abroad, bauhaus books and exhibitions and, later, the magazine *bauhaus* kept the discussion of these problems alive and safe from the perils of academicism. bauhaus methods began to influence those responsible for other public art schools in germany and trained bauhaus students easily found teaching positions. the academy of fine arts at breslau, the arts and crafts schools in halle, stettin, hamburg and other cities adopted the pedagogical principles of the bauhaus. johannes itten founded a successful textile school at krefeld, and former bauhaus members started centers of fresh activity in hungary, the netherlands, switzerland, esthonia and japan.

the following pictures show some examples of how the bauhaus idea was carried on after 1928 in private practice.

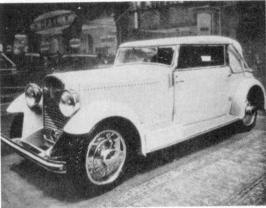

above walter gropius: apartment development for the city of berlin, berlin-siemensstadt. 1929

walter gropius. adler automobile. 1929-1931

walter gropius and e. maxwell fry: house for benn levy, london. 1936

below gropius and joost schmidt: display at an exhibition of copper and brass products. each plate of the spiral is of a different metal. the whole spiral slowly revolves. 1934

exhibitions in america

the bauhaus painters, especially feininger, klee and kandinsky, participated in many american exhibitions during the 1920's, notably those organized by the *société anonyme* of new york, under the direction of miss katherine dreier, and the *blue four* exhibitions arranged in new york and on the west coast by mrs. galka scheyer. schlemmer and others of the bauhaus theater exhibited at the international theater exposition, new york, 1926. the bauhaus was represented in the machine age exhibition, new york, 1927, and in an exhibition of modern printers and typography, wellesley college, 1928.

small exhibitions entirely devoted to the bauhaus were given by the harvard society for contemporary art, under the direction of lincoln kirstein, cambridge, december, 1930–january, 1931; at the john becker gallery, new york, january–february, 1931; and at the arts club of chicago, march, 1931.

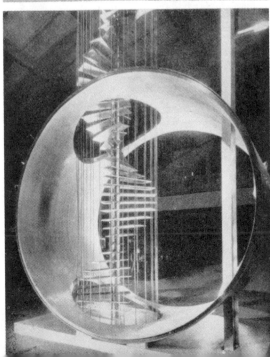

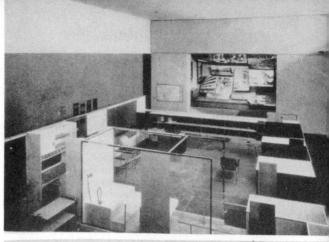

marcel breuer: living unit of an apartment hotel. werkbund exhibition, paris. 1930

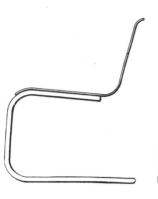

herbert bayer: scheme for display of photographs. page of catalog for werkbund exhibition, paris. 1930

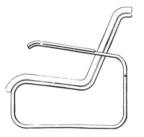

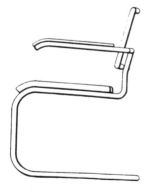

l. moholy-nagy: exhibition of bauhaus work. werkbund exhibition, paris. 1930

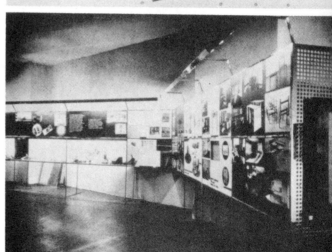

marcel breuer: designs for tubular chairs. c. 1928

m. friedländer: porcelain tea set designed for hotel use. executed by the staatliche porzellan manufactur, berlin

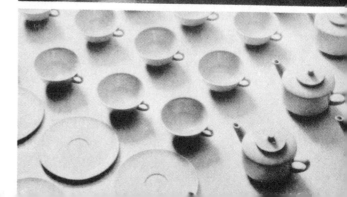

g. hassenpflug: trellis of metal tubing with plants designed for a flower show, berlin. 1935

g. hassenpflug: chairs designed for easy stacking.

g. hassenpflug: kitchen stool

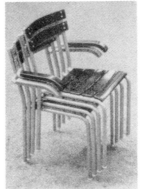

marcel breuer: project for a theater. 1929

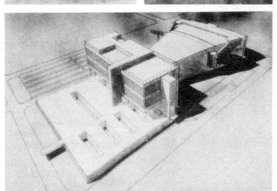

marcel breuer: dining room of the boroschek apartment. 1930

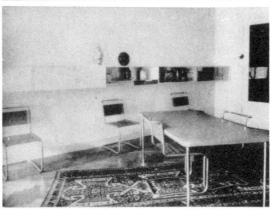

marcel breuer: project for a hospital. 1929

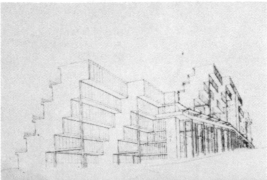

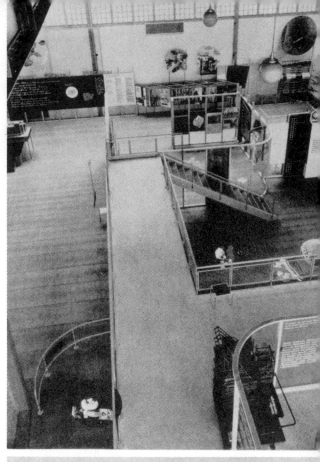

l. moholy-nagy, herbert bayer and walter gropius: display for the building unions. building exhibition, berlin. 1931

walter gropius: project submitted in a competition for a city hall in halle. 1928

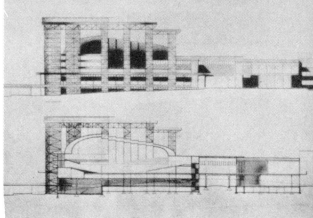

walter gropius: social rooms of an apartment hotel with adjoining swimming pool and gymnasium. werkbund exhibition, paris. 1930

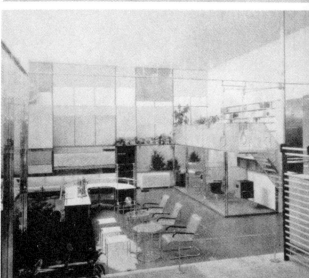

herbert bayer: outdoor signboard advertising a magazine

herbert bayer: comparison of the structure of the human body with that of buildings. page from the catalog of "the wonder of life" exhibition, berlin. 1935

herbert bayer: the function of the eye. page from the catalog of "the wonder of life" exhibition, berlin. 1935

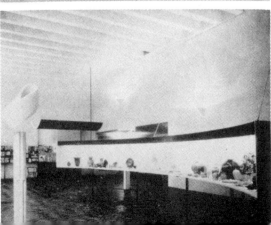

max bill: swiss pavilion at the triennale exhibition, milan. 1936

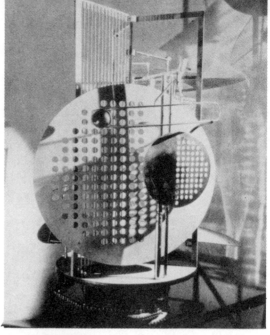

l. moholy-nagy: mobile sculpture. glass and different metals. illuminated to produce a variety of light effects. shown at the werkbund exhibition, paris. 1930

l. moholy-nagy: aviation exhibition, London. 1936

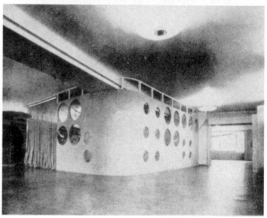

210

xanti schawinsky: cover of a pamphlet advertising olivetti typewriters. 1935

herbert bayer and l. moholy-nagy: display for the building unions. building exhibition, berlin. 1929

max bill: swiss pavilion at the triennale exhibition, milan. 1936

naum slutzky: lighting fixtures. 1928-1932

hans volger: designs for etched glass. executed by august keil, würzburg

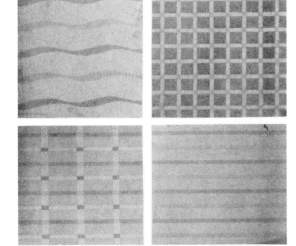

naum slutzky, lighting fixtures

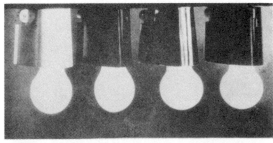

christian dell: wall fixture

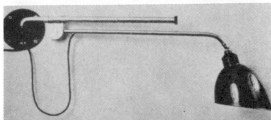

farkas molnár: apartment
house, budapest. 1933

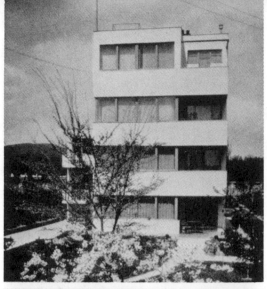

farkas molnár: private
house, budapest. 1933

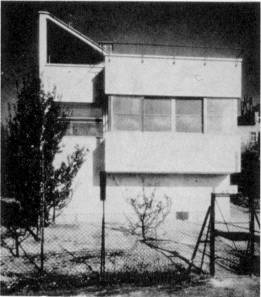

iwao yamawaki: living
room in the house of the
architect, tokyo

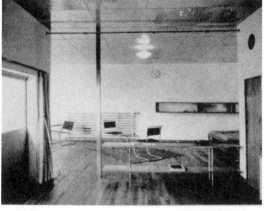

fred forbat: stadium,
zehlendorf. 1926

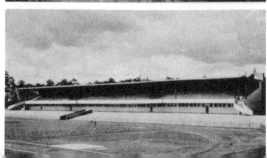

marcel breuer: table.
glass and rubber on a
steel frame. 1928

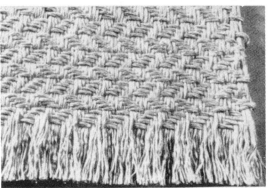

textiles, new techniques
and materials designed for
industrial production

otti berger: carpeting

otti berger: wall covering

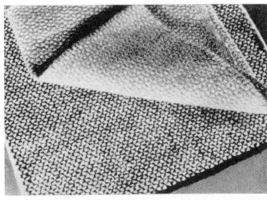

otti berger: washable up-
holstery material

213

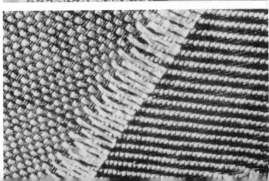

otti berger: material for
upholstery or curtains

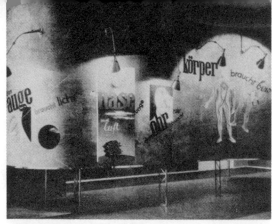

xanti schawinsky:
display at the building
exhibition, berlin. 1931

wilhelm wagenfeld: wine
glasses. executed by the
vereinigte lausitzer
glaswerke. c. 1935

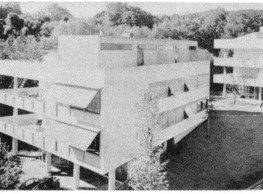

marcel breuer and alfred
roth: apartment houses,
zurich. 1935

marcel breuer and f. r. s.
yorke: pavilion for messrs.
p. e. gane ltd. at royal
show, bristol. 1936

marcel breuer and f. r. s.
yorke: model for a garden
city of the future

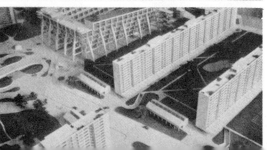

black mountain college

in the united states during the past few years, bauhaus teaching methods have been introduced by josef albers and alexander schawinsky at **black mountain college**, north carolina; by moholy-nagy, bredendieck and kepes at the **new bauhaus** in chicago; by walter gropius and marcel breuer in the department of architecture at **harvard university** and by miës van der rohe, hilbersheimer and peterhans in the department of architecture at the **armour institute**, chicago. former bauhaus students are also teachers at the **laboratory school of industrial design** in new york and at the **southern california school of design.**

above: elementary course, josef albers: study in changing a given pattern to produce new effects in texture

elementary course, josef albers: study in corrugated paper. new patterns and light effects.

weaving course, anni albers: don page: rib weave developed from three elementary weaves at left

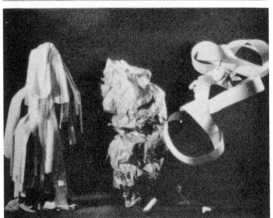

stage studies, xanti schawinsky: paper costumes. 1936

stage studies, xanti schawinsky: designs for forms to be carried like shields across the stage

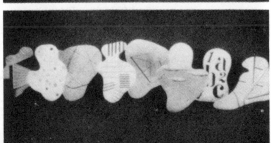

the new bauhaus, chicago

american school of design

director: l. moholy-nagy

photography course
nathan lerner: study in
light and volume. 1937

preliminary course
r. koppe: woodcutting

preliminary course
woodcutting. through
machine cutting, wood
acquires great elasticity
1938

laboratory school of industrial design, new york

(*formerly design laboratory*)

seymour wassyng: metal
construction. problem in
balance. 1937

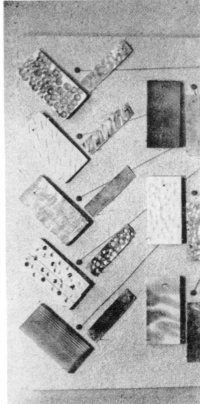

study in materials and
textures. 1937

victor sklaire: study in
surface effects produced
by the use of different
tools on wood and metal.
1938

marco vici: metal construc-
tion. problem in tension

BIOGRAPHICAL NOTES

ALBERS, Josef. Painter, especially on glass, photographer, typographer. Born, Westphalia, Germany, 1888.

1913–1923　Studied at Royal Art School, Berlin; Folkwangschule, Essen; Art Academy, Munich; Bauhaus, Weimar.

1923–1925　Bauhaus Weimar. Bauhaus apprentice, head of glass department; Lecturer on preliminary design; furniture design.

1925–1931　Bauhaus Dessau. Bauhausmaster. Professor of elementary course and drawing; later head of furniture workshop; wallpaper design.

1931–1933　Bauhaus Berlin, Introductory course, drawing, calligraphy.

1933–1949　Professor of Art, Black Mountain College, North Carolina. Lectures and Seminars, Harvard University and other universities.

1949–1950　Courses at Cincinnati Art Academy, Yale University, University of Mexico, Pratt Institute, Brooklyn, Summer School, Harvard University.

1950　Chairman, department of design, Yale University.

Bibliography:
Josef Albers: *Concerning Art Instruction.* Black Mountain College Bulletin No. 2. 1934.
Josef Albers: *Art as Experience.* Progressive Education, October 1935.
Josef Albers: *A Note on the Arts in Education.* American Magazine of Art, April 1936.
Josef Albers: *The Educational Value of Manual Work and Handicraft in Relation to Architecture.* New Architecture and City Planning, a symposium edited by Paul Zucker, Philosophical Library, New York. 1944.
Josef Albers: *Present and/or Past.* Design Magazine, Vol. 47, No. 8. April 1946.

BAYER, Herbert. Typographer, painter, designer, photographer. Born Haag, Austria, 1900; early schooling in Linz.

1917–1919　Served in the Austrian Army.

1919　Linz, studied architecture under Schmidthammer.

1920　Darmstadt, worked with architect, Emanuel Margold.

1921　Bauhaus, Weimar, study of wall-painting under Kandinsky. Typography.

1923–1924　Travel in Italy.

1924　Painting studio in Berchtesgaden.

1925–1928　Bauhaus, Dessau, teaching advertising, layout and typography.

1928–1938　Berlin, worked as commercial artist, typographer, exhibition designer, painter, photographer. Art manager of periodical *Vogue*, director of advertising agency Dorland.

1938–1946　New York, leading art advisor for John Wanamaker, and J. Walter Thompson, director of art and design for Dorland International, commercial artist, exhibition designer, painter.

1946　Aspen, Colorado, Design consultant for Aspen Development and Container Corporation of America.

1948–1953　Designed and edited *World Geographic Atlas* (C.C.A.), paintings, frescoes, interior decorating, architecture.

1956　Chairman, Department of Design, Container Corporation of America.

Bibliography:
Alexander Dorner: *The Way Beyond Art — The Work of Herbert Bayer.* Wittenborn & Schultz. Inc., New York. 1947.
Natura, Milan, **1935:** *Herbert Bayer, un maestro dell'arte grafica* by L. Poli.
London Gallery, London, 1937: *Herbert Bayer,* by Alexander Dorner.
PM Magazine, New York, 1940: *Contribution Toward Rules of Advertising Design* by Herbert Bayer; *Towards a Universal Type* by Herbert Bayer; *Fundamentals of Exhibition Design* by Herbert Bayer.
Graphis, Berlin, October-November, 1945.
Interiors, New York, July, 1947: *Notes on Exhibition Design,* showing work of Herbert Bayer.
Linea Grafica, Milan, January-February, 1954: *Herbert Bayer: Per un carattere tipografico universale.*
Idea, Tokyo, March, 1955: *Herbert Bayer* by Y. Kamekura.
Print, New York, July-August, 1955: *Personality in Print.*
Die Kunst, Munich, May, 1956: *Die Zwischenposition von Herbert Bayer* by Franz Roh.

BREUER, Marcel. Architect and industrial designer. Born Pecs, Hungary, 1902.

1920–1924　Bauhaus, Weimar.

1925–1928　Master at the Bauhaus, Dessau.

1925　Invented tubular steel furniture.

1928–1931　Traveled in Spain, North Africa, Greece, Switzerland, Italy and the Balkans.

1934–1937　Architect in London.

1937–1946　Associate professor of Architecture, Harvard University.

1946　Architect in New York.

Bibliography:
Peter Blake: *Marcel Breuer, Architect and Designer,* an Architectural Record Book, published in collaboration with The Museum of Modern Art, New York. 1949.
Marcel Breuer: *Sun and Shadow.* Dodd, Mead, New York. 1955.
Marcel Breuer: *Adventure in Architecture: Building the New St. John's.* Longmans, Green and Co., New York. 1958.

FEININGER, Lyonel. Painter and graphic artist. Born 1871, New York. Studied music with his father, Karl Feininger.

1887　Journey to Germany to study music. Decided instead to become a painter.

1887–1891　Studies at Arts and Crafts School in Hamburg and at Berlin Academy.

1892–1893　Travel to Paris. Work at Colarossi Studio. Illustrator for German, French and American periodicals.

1894–1906　Berlin. Cartoonist and illustrator.

1906–1908　Paris. Gave up illustrating to devote all his time to painting.

1908　Berlin.

1911　Travels to Paris. Influence of Cubism.

1913　Exhibition in Berlin together with "Blue Rider" group.

1919–1933 Taught at Bauhaus in Weimar and Dessau.
 1924 Founded group of "Blue Four" together
 with Kandinsky, Klee and Jawlensky. Exhibited
 in Germany and America.
1936 Returned to United States.
1937 After short visit to Germany settled in New York.
1938 Mural for Marine Transportation Building, and
 New York World's Fair, 1939.
Died January 13, 1956.
Feininger: A book on Feininger by Hans Hess is in prepar-
ation for 1959 (Kohlhammer Verlag, Germany).

GROPIUS, Walter.

Bibliography:

Walter Gropius: *Idee und Aufbau des Staatlichen Bau-
hauses, Weimar.* Munich, Bauhaus Press. Twelve pages.

Walter Gropius: *Internationale Architektur.* Bauhausbooks,
Volume 1, 1925. Illustrated, 111 pages. Jacket design by
Farkas Molnár. Second edition 1927.

Walter Gropius: Editor. *Neue Arbeiten der Bauhauswerk-
stätten.* Bauhausbooks. Volume 7, 1925, illustrated, 115
pages.

walter gropius: *bauhausbauten dessau.* Bauhausbooks.
Volume 12, 1930, illustrated, 220 pages.

Siegfried Giedion: *Walter Gropius.* Paris, Crès & Cie. 1931.

Walter Gropius: *The New Architecture and the Bauhaus.*
Translated from the German by P. Morton Shand, with a
preface by Joseph Hudnut. Newton 59, Mass. Charles T.
Branford Co.

W. Gropius: *Art Education and State.* Circle, London,
S. 238–242. From the "Yearbook of Education", 1936. Mon-
tague House, London, Faber & Faber.

Walter Gropius, *Rebuilding Our Communities.* Paul Theo-
bald, Chicago. 1945.

Architecture d'Aujourd'hui: *Walter Gropius et son école.*
Vol. 20, Numéro spécial. February 1950.

Giulio Carlo Argan: *Walter Gropius e la Bauhaus.* Giulio
Einaudi, Roma. 1951.

Walter Gropius: *Architecture and Design in the Age of
Science.* Spiral Press. New York. 1952.

Chikatada Kurata: *Walter Gropius.* Tokyo 1953.

Paul Linder: *Homenaje a Walter Gropius.* El Arquitecto
Peruano, Lima, Peru, April 1953.

Paul Linder: *Walter Gropius.* El Commercio, Lima, Peru,
May 1953.

W. Gropius: *Minha concepcao da ideia do Bauhaus.*
Arquitettura Contemporanea, Sao Paolo, Brazil, Nr. 2–3,
January 1954, S. 47–48.

Siegfried Giedion: *Walter Gropius, Mensch und Werk.*
Verlag Gerd Hatje, Stuttgart. 1954.

Walter Gropius, *Work and Teamwork* by Sigfried Giedion
Reinhold Publishing Co. New York, 1954.

Walter Gropius, *L'Homme et L'Oeuvre,* Sigfried Giedion
Morancé, Paris, 1954.

Walter Gropius. *L'Uomo e L'Opera,* Sigfried Giedion
Edizione di Communita, Milano, 1954.

Walter Gropius, by Robin Boyd, Sydney University Paper
August 1954.

The Synthetic Vision of Walter Gropius by Gilbert Herbert,
South African Architectural Record Dec. 1955.

Gropius in Japan, The International House of Japan
Tokyo, May 1956.

ITTEN, Johannes. Painter, sculptor, graphic artist, writer.
Born, Amt Thun, Switzerland, 1888.

 Studied in art schools at Berne and Geneva.
1912 Germany, Belgium, Holland; influence of van
 Gogh.
1913–1914 Stuttgart, painting under Adolf Hölzel.
1915 Vienna, started teaching.
1916 Started making constructions.
1919 Went to teach at Bauhaus, Weimar.
1923 To Switzerland.
 Taught at Lebenschule Aryana, Herrliberg near
 Zurich.
 Later founded his own school in Berlin and
 more recently taught weaving at Krefeld.
1938 Lives in Amsterdam where he is continuing
 scientific experiments in the expression of
 individual character through color.
 Now director of Kunstgewerbe museum, Zurich.
1938–1954 Director of Arts and Crafts school and museum,
 Textile Institute and Museum Rietberg, Zurich.
1954 Painter in Zurich.

KANDINSKY, Wassily. Painter, graphic artist, writer.
Born, Moscow, 1866, childhood in Italy; schools in Odessa,
Moscow; studied painting in Munich.

1903–1905 Tunis, Cairo, Rapallo.
1906 Paris, influenced by Gauguin.
1907 Berlin.
1908–1914 Munich.
1911 First abstract painting.
1912 Founded the Blue Rider group with Marc;
 published *The Art of Spiritual Harmony.*
1914 Russia.
1917–1921 Various organizing activities; teacher at Mos-
 cow Academy; director of Museum of Creative
 Arts in Moscow; establishment of other museums
 in many other cities of the Soviet Union.
 1920, professor at Moscow University.
 1921 Establishment of Academy of Art.
1921 Berlin.
1922–1933 Taught at Bauhaus, Weimar, Dessau.
 1923, vice-president of Société Anonyme,
 New York.
1934–1944 Paris.
 Died December 15, 1944, Neuilly-sur-Seine.

Bibliography:

Wassily Kandinsky: *Punkt und Linie zu Fläche; Beitrag zur
Analyse der malerischen Elemente.* Bauhausbücher.
Vol. 9. 1926. 198 pp., 102 ill., 25 plates, 1 colorplate.
Typography by Herbert Bayer. 2nd ed. 1928.

Hilla Rebay: *Kandinsky* The Solomon R. Guggenheim
Foundation, New York. 1945.

Kandinsky: *Regard Sur le Passé.* Galerie René Drouin,
Paris. 1946.

Hugo Debrunner: *Wir entdeckten Kandinsky.* Origo-Ver-
lag, Zürich. 1948.

Max Bill: *Wassily Kandinsky.* Folio with 10 facsimile reproductions. Holbein Verlag, Basel, 1949.

Max Bill: *Wassily Kandinsky;* with contributions by Jean Arp, Charles Estienne, Carola Giedion-Welcker, Will Grohmann, Ludwig Grote, Nina Kandinsky, Alberto Magnelli. Maeght Editeur Paris. 1951.

Wassily Kandinsky: *Essays über Kunst und Künstler.* Verlag Gerd Hatje, Stuttgart. 1955.

KLEE, Paul. Painter, graphic artist, writer. Born near Berne, Switzerland, 1879, of Bavarian and French parentage.

1898–1900	Studied in Munich under Franz von Stuck.
1901	Italy.
1902–1905	Berne. Series of grotesque engravings.
1905	Short stay in Paris.
1906–1920	Munich.
1912	Original member of the "Blue Rider" group, Munich.
1913	Exhibition at gallery "The Storm," Berlin.
1914	Founding member of New Munich Secession. Travel in Tunisia.
1920–1929	Taught at Bauhaus, Weimar, Dessau. 1924, participated in exhibition of "Blue Four" in New York.
1929	Traveled and studied in Egypt.
1930–1933	Professor at Art Academy, Düsseldorf, until dismissal in 1933.
1933–1940	Berne. Died June 29, 1940 at Muralto-Locarno.

Bibliography:

220

Paul Klee: *Padogogisches Skizzenbuch.* Bauhausbooks, vol. 2, 1925. 51 pp. 87 ill. 2nd ed. 1928.
Rudolf Bernoulli: *Mein Weg zu Klee.* Verlag Benteli AG., Bern. 1940.
Paul Klee. The Museum of Modern Art, New York. 1941.
Will Grohmann: *The Drawings of Paul Klee.* Kurt Valentin, New York. 1944.
Paul Klee: *Über die Moderne Kunst.* Verlag Benteli, Bern-Bümpliz. 1945.
Georg Schmidt: *Klee.* 10 facsimile reproductions. Holbein Press, Basel, 1946.
Hans-Friedrich Geist: *Paul Klee.* Hauswedell & Co., Hamburg. 1948.
Felix Klee: *Paul Klee.* 22 drawings. Eidos Press, Stuttgart, 1948.
Douglas Cooper: *Paul Klee.* Penguin Books. 1949.
Daniel-Henry Kahnweiler: *Klee.* Braun & Cie., Paris, E. S. Herrmann, New York. 1950.
Werner Haftmann: *Paul Klee.* (Der Meister am Bauhaus, 59 pp.) Prestel Press, Munich, 1950.
Will Grohmann: *Paul Klee.* Verlag W. Kohlhammer, Stuttgart. 1954.
Carola Giedion-Welcker: *Paul Klee.* Verlag Gerd Hatje, Stuttgart. 1954.

MARCKS, Gerhard. Sculptor, graphic artist, ceramist. Born, Berlin, 1889.

1907	Started studies, atelier of Richard Scheibe, Berlin, influenced by Kolbe and Gaul.
1914–1918	Served in German army.

1919–1925	Director, Dornburg pottery-workshop of Bauhaus, Weimar.
1925–1933	Teacher of ceramics, and later, Director, School of Arts and Crafts at Giebichenstein, near Halle.
1933	Settles in Mecklenburg.
1946	Professor at County Art School, Hamburg.
1950	Moves to Cologne.

MOHOLY-NAGY, László. Painter, constructivist, photographer, typographer, stage designer, author. Born 1895 at Borsod, Hungary; turned from the study of law at University of Budapest to painting.

1915–1918	Served in the Hungarian army.
1920–1923	Berlin, painting and writing for MA, De Stijl, Cahiers d'Art, etc. 1921–1922, first constructions in Germany.
1923–1928	Bauhaus, Weimar, Dessau, teaching the Preliminary Course, and director of metal workshop.
1928	Berlin, experiments with light and color in painting, photography and films. Commercial typography. Stage sets for State Opera and Piscator's Theatre.
1935–1937	London.
1937–1946	Director of the New Bauhaus (now Institute of Design, Chicago). Died November 24, 1946, Chicago.

Bibliography:

L. Moholy-Nagy: *Malerei, Photographie, Film.* Bauhausbooks vol. 8. 1925. 133 pp., ill. 2nd ed. with title: *Malerei, Fotografie, Film;* 1927. 140 pp., ill.
moholy-nagy: *von material zu architektur.* Bauhausbooks vol. 14, 1929. 241 pp. with 209 ill. in text.
L. Moholy-Nagy: *The New Vision, from Material to Architecture.* Translated by Daphne M. Hoffmann. New York, Brewer, Warren & Putnam, Inc., 1930. 2. Ed., New York, W. W. Norton & Co., 1938.
L. Moholy-Nagy: *The New Vision and Abstract of an Artist.* Wittenborn and Company, New York. 1946.
L. Moholy-Nagy: *Vision in Motion.* Paul Theobald, Chicago. 1947.
Sibyl Moholy-Nagy: *Moholy-Nagy, a Biography.* Harper and Brothers, New York. 1950.

MUCHE, Georg. Painter, author. Born 1895 in Querfurt.

1913–1915	Studied in Berlin and Munich.
1916–1919	Exhibitions at gallery "The Storm," Berlin. 1917, teacher at art school, "The Storm."
1920–1927	Teaches at Bauhaus, Weimar and Dessau. Head of weaving department. 1924, visited U.S.A. 1927, traveled to Paris.
1927–1931	Teacher at art school of Johannes Itten, Berlin.
1931–1933	Professor at art academy, Breslau.
1933–1938	Berlin. Studied technique of mural painting.
1939	Head of advanced class of textile art at textile engineering school, Krefeld.
1947	Traveled to England and Scotland.
1948–1949	Murals in public buildings of Krefeld and Düsseldorf.

Bibliography:
Georg Muche: *Buon Fresco. Briefe aus Italien über Handwerk und Stil der echten Freskomalerei.* 1938. 2. ed. 1950. Verlag Ernst Wasmuth, Tübingen.
Georg Muche: *Bilder — Fresken — Zeichnungen.* Verlag Ernst Wasmuth, Tübingen. 1950.

SCHEPER, Hinnerk. Born 1897 at Badbergen near Osnabrück.
Educated as mural painter, Arts and Crafts School and Art Academy, Düsseldorf, Arts and Crafts School, Bremen.
1919–1922 Bauhaus, Weimar. Master of Crafts.
1922–1925 Free-lance artistic activity (Color in architecture).
1925 Call to Bauhaus Dessau as master. Head of mural painting workshop.
1929–1931 Leave of absence from Bauhaus; called to Moscow as consulting specialist in color uses in architecture.
1931–1933 Resumption of teaching at Bauhaus, Dessau, until its dissolution.
1933–1945 Free-lance activities; private curator of monuments.
1945 Conservator of Berlin and consultant on color in architecture. Teaching at technical university of Berlin.
1953 State-conservator of Berlin.
1957 Died February 15, 1957.

SCHLEMMER, Oskar. Painter. Born 1888 in Stuttgart.
1906–1919 Studied at Academy of Fine Arts in Stuttgart, master pupil of Adolf Hölzel.
1915 Exhibition at gallery "The Storm", Berlin.
1916 Premiere of *"Triadisches Ballet"*.
1914–1918 Served in army.
1920–1929 Taught at Bauhaus, Weimar and Dessau. Head of department of fresco painting, later of wood and stone masonry workshop.
1925, building and management of Bauhaus stage at Dessau. Lectures about "Man".
1928, murals for Museum Folkwang in Essen.
1929–1932 Professor at Academy of Arts and Crafts, Breslau.
1932–1933 Professor at the United State schools of Art in Berlin. Lectures on "Perspectives".
1933 Dismissal as "decadent".
1933–1943 Lived in the country at Eichberg and Sehringen/Baden during years of defamation. From 1939, jobs in Stuttgart and Wuppertal. Died in Baden-Baden, April 13, 1943.
Bibliography:
Oskar Schlemmer: *Spiel mit Köpfen.* 6 lithographs in a portfolio. Bauhaus Weimar. 1923.
Oskar Schlemmer, ed.: *Die Bühne im Bauhaus.* Bauhaus Books, vol. 4, 1925. 87 pages with illustrations and one double color page. Design of title page by Oskar Schlemmer.
Art Portfolio: *10 drawings by Oskar Schlemmer.* Preface by Hans Hildebrandt. Eidos-Press, Stuttgart. 1947.
Art Portfolio: *Oskar Schlemmer.* Edited and with a preface by Dieter Keller. K.G. Stuttgarter Verlag, Stuttgart. 1948.
Georg Schmidt: *Oskar Schlemmer.* Portfolio with 12 facsimile reproductions and 8 drawings. Benteli Press, Bern-Bumpliz. 1949.
Hans Hildebrandt: *Oskar Schlemmer.* Prestel Press, Munich. 1952.
Willi Grohmann: *Edition of drawings.* In preparation.
Oskar Schlemmer: *His Diaries and letters,* edited by Tut Schlemmer. In preparation.

SCHMIDT, Joost. Engraver, painter, sculptor. Born 1893 at Wunstorf, Hanover. Grew up in Hameln/Weser.
1911–1914 Studied at Academy in Weimar. Master pupil.
1914–1919 War service and prisoner of war.
1919–1925 Bauhaus, Weimar. Studied sculpture and typography.
1925–1933 Taught at Bauhaus, Dessau. Head of department of sculpture and teacher of typography. Later head of commercial typography class.
1933 Branded as "cultural bolshevik". Loss of studio.
1945 Professor at Academy of Fine Arts, Berlin. Died December 2, 1948.

SCHREYER, Lothar. Ph.D. in law. Painter, author, stage designer. Born 1886.
1912–1919 Producer at Deutsches Schauspielhaus, Hamburg.
1916–1928 Editor of periodical *"The Storm"*.
1919–1921 Manager of "Storm" Theater in Berlin and Hamburg.
1921–1923 Master at State Bauhaus, Weimar.
1924–1927 Teacher at art school, The Way, Berlin and Dresden.
Since 1928, free-lance author and painter in Hamburg.

STÖLZL, Gunta. Born 1897 in Munich.
1914–1916 Studied at Arts and Crafts school, Munich, with Professor Engels.
1916–1918 Red Cross nurse.
1919–1925 Studied at State Bauhaus, Weimar. Contributed to creation of weaving workshop. Several months spent at dye and textile schools, Krefeld.
1926–1927 Teacher of textile workshop at Bauhaus, Dessau. Renewed building-up of technical installations; instruction of students for Bauhaus diploma.
1927–1931 Bauhausmaster. Head of production and apprentice workshop.
1929 By marriage, Sharon-Stölzl.
1931 Own workshop in Zurich. Close cooperation with firms and architects.
1941 By marriage, Stadler-Stölzl.

BIBLIOGRAPHY of BAUHAUS PUBLICATIONS

1919 **Programm des Staatlichen Bauhauses in Weimar.**
The first proclamation, 4 pp., including woodcut cover by Lyonel Feininger. Preface by Walter Gropius.

1921 **Zwölf Holzschnitte von Lyonel Feininger.**
Portfolio of 12 woodcuts printed and bound in the Staatliches Bauhaus, Weimar.

Neue europäische Graphik ... Hergestellt und herausgegeben vom Staatlichen Bauhaus in Weimar im Jahre 1921; zu beziehen durch Müller Co. Verlag, Potsdam.
Planned as a series of 5 portfolios (from the Bauhaus bookbindery), with title-page and table of contents. Portfolio 2, French artists, was not issued.

A **Erste Mappe: Meister des Staatlichen Bauhauses in Weimar.** 14 woodcuts, lithographs and etchings by Feininger, Itten, Klee, Marcks, Muche, Schlemmer and Schreyer.

B **Dritte Mappe: Deutsche Künstler.** 14 lithographs, woodcuts and linoleum cuts by Bauer, Baumeister, Campendonk, Dexel, Fischer, van Heemskerck, Hoetger, Marc, Schwitters, Stuckenberg, Topp, Waver. The plate by Hoetger was substituted for the announced plate by Ernst.

C **Vierte Mappe: Italienische u. Russische Künstler.** 11 etchings and lithographs by Archipenko, Boccioni, Carrá, Chagall, Chirico, Gontcharova, Jawlensky, Kandinsky, Larionov, Prampolini. A 12th plate, by Soffici, was announced but never issued.

D **Fünfte Mappe: Deutsche Künstler.** 13 etchings, lithographs, woodcuts and linoleum cuts by Beckmann, Burchartz, Gleichmann, Grosz, Heckel, Kirchner, Kokoschka, Kubin, Mense, Pechstein, Rohlfs, Scharff, Schmidt-Rotluff.

1922 **Satzungen, Staatliches Bauhaus in Weimar.**
Paper folder, containing six leaflets:

A **I. Lehrordnung.** 8 pp.

B **II. Verwaltungs-Ordnung.** 4 pp.

C **Anhang 1: Lehrkräfte und Plan der Lehrgebiete.** 4 pp.

D **Anhang 2: Lehrgebiete der Werkstätten; Prüfungs-Ordnung.** 4 pp.

E **Anhang 3: Verlag, Bühne, 2 pp.**

F **Anhang 4: Küche, Siedlung. 2 pp.**

Kandinsky. Kleine Welten: zwölf Blatt original Graphik. Berlin, Propyläen Verlag.
Portfolio of 4 etchings, 4 woodcuts and 4 lithographs, printed at Staatliches Bauhaus, Weimar, for Propyläen Verlag.

Ausstellung von Arbeiten der Gesellen und Lehrlinge im Staatlichen Bauhaus, Weimar, April/Mai 1922.
Single sheet.

1923 **Das Wielandslied der alten Edda, in der Übersetzung von K. Simrock. Holzschnitte von Gerhard Marcks. München-Weimar, Bauhaus-Verlag, 1923.**
Portfolio of 10 woodcuts, with 4 pp. text. Printed at the Bauhaus.

Staatliches Bauhaus, Weimar, 1919-1923. Weimar-München, Bauhaus-Verlag.
226 pp., 147 illus., 20 colored plates. Published by the Bauhaus in collaboration with Karl Nierendorf, Cologne. Typography by L. Moholy-Nagy, cover by Herbert Bayer.

Walter Gropius: Idee und Aufbau des Staatlichen Bauhauses, Weimar. München, Bauhausverlag G. m. b. H.
12 pp. Also appeared in 8 pp. 7-18.

1924 **Bauhaus Weimar.**
Special number of periodical *Junge Menschen*, Hamburg, 1924, vol. 5, no. 8, with articles by Bauhaus students.

Presse-Stimmen (Auszüge) für das Staatliche Bauhaus, Weimar.
72 pp. Two supplements were issued:

A **Nachtrag zu den Pressestimmen ... (März-April 1924),** paged 73-104;

B **Kundgebungen für das Staatliche Bauhaus, Weimar, Oktober, 1924,** paged 105-143.

1926 **bauhaus, dessau**
Prospectus, designed by Herbert Bayer.
Bauhaus-Heft.
Special number of periodical *Offset, Buch- und Werbekunst*, Leipzig, 1926, No. 7, pp. 356–410. Contributions by Gropius, Breuer, Moholy-Nagy, Albers, Bayer, Stölzl, Schlemmer; collected by Moholy-Nagy. Cover designed by Joost Schmidt.

1929 **bauhaus**
Prospectus, with words "junge menschen kommt ans bauhaus!" on rear cover. 44 pp., with articles by Klee, Kandinsky, Albers, Peterhans, Riedel, Meyer, schedule of classes, photographs of students' work, list of faculty.

Catalog of Bauhaus exhibition, Basel.

1925-1930 Bauhausbücher.
Series edited by Gropius and Moholy-Nagy, and published by Albert Langen, Munich. Designed (typography, bindings, jackets) by Moholy-Nagy except where otherwise indicated.

1 **Walter Gropius:** *Internationale Architektur.* 1925. 111 pp,. illus. Jacket designed by Farkas Molnár. 2d edition, 1927.

2 **Paul Klee:** *Pädagogisches Skizzenbuch.* 1925. 51 pp., 87 illus. 2d edition, 1928.

3 **Adolf Meyer.** ed.: *Ein Versuchshaus des Bauhaus in Weimar.* 1925. 78 pp., illus. Typography by Meyer.

4 **Oskar Schlemmer,** ed.: *Die Bühne im Bauhaus.* 1925. 87 pp., illus., inc. 1 folding color plate. Title-page designed by Oskar Schlemmer.

5 **Piet Mondrian:** *Neue Gestaltung, Neoplastizismus, nieuwe beelding.* 1925. 66 pp. Translated by Rudolf F. Hartogh and Max Burchartz.

6 **Theo van Doesburg:** *Grundbegriffe der neuen gestaltenden Kunst.* 1925. 40 pp., plus 32 illus., partly colored. Translated by Max Burchartz. Jacket designed by Theo van Doesburg.

7 **Walter Gropius,** ed.: *Neue Arbeiten der Bauhauswerkstätten.* 1925. 115 pp., illus.

8 **L. Moholy-Nagy:** *Malerei, Photographie, Film.* 1925. 133 pp., illus.
2d edition, with title *Malerei, Fotografie, Film*, 1927, 140 pp., illus.

9 **Wassily Kandinsky:** *Punkt und Linie zu Fläche; Beitrag zur Analyse der malerischen Elemente.* 1926. 198 pp., 102 figs. in text, 25 plates, 1 colored plate. Typography by Herbert Bayer. 2d edition, 1928.

10 **J. J. P. Oud:** *Holländische Architektur.* 1926. 107 pp., inc. 55 illus. 2d edition, 1929.

11 **Kasimir Malewitsch:** *Die gegenstandslose Welt; Begründung u. Erklärung des russischen Suprematismus.* 1927. 104 pp., inc. 92 illus. Translated by A. von Riessen.

12 **walter gropius:** *bauhausbauten dessau.* 1930. 221 pp., illus.

13 **Albert Gleizes:** *Kubismus:* 1928. 101 pp., inc. 47 illus. Translated by Frau Eulein Grohmann.

14 **moholy-nagy:** *von material zu architektur.* 1929. 241 pp., inc. 209 illus. For English translation, see no. 31.

1926-1931 bauhaus: zeitschrift für gestaltung. Quarterly periodical, 1926-1929, 1931. Editors: Gropius and Moholy-Nagy, 1926-8; Meyer and Kállai, 1929; Hilbersheimer, Albers, Kandinsky, 1931.

 L. Moholy-Nagy: *The New Vision, from Material to Architecture.* Translated by Daphne M. Hoffmann. New York, Brewer, Warren & Putnam, Inc., n.d. A translation of **29**. 2d edition, New York, W. W. Norton and Co., 1938.

1936 Walter Gropius: *The New Architecture and the Bauhaus.* Translated from the German by P. Morton Shand, with a preface by Joseph Hudnut. Boston, C. T. Branford Co.

1924 Anni Albers: *Weaving,* Bauhaus issue of magazine, Junge Menschen.

1934 Josef Albers: *Concerning Art Instruction,* Black Mountain College Bulletin, No. 2.

1935 Josef Albers: *Art as Experience,* Progressive Education, October.

1936 Josef Albers: *A Note on the Arts in Education,* American Magazine of Art, April.

1938 Anni Albers: *Work with Material,* Black Mountain College Bulletin, No. 5.

1940 Rudolf Bernoulli: *Mein Weg zu Klee,* Verlag Benteli Ag. Bern.

1941 Anni Albers: *Handweaving Today,* The Weaver, Vol. 6, No. 1, Jan.-Feb.

 Paul Klee, The Museum of Modern Art, New York.

1943 Anni Albers: *Designing,* Craft Horizon, Vol. 2, No. 2, May.

1944 Anni Albers: *One Aspect of Art Work,* Design Magazine, Vol. 6, No. 4, December.

 Josef Albers: *The Educational Value of Manual Work and Handicraft in Relation to Architecture,* New Architecture and City Planning, a symposium edited by Paul Zucker, Philosophical Library, New York.

Lyonel Feininger and Marsden Hartley, The Museum of Modern Art.

Will Grohmann: *The Drawings of Paul Klee,* Kurt Valentin, New York.

1945 Paul Klee: *Über die Moderne Kunst,* Verlag Benteli, Bern-Bümpliz.

Walter Gropius: *Rebuilding Our Communities,* Paul Theobald, Chicago.

Hilla Rebay: *Kandinsky,* The Solomon R. Guggenheim Foundation, New York.

1946 Anni Albers: *Constructing Textiles,* Design Magazine, Vol. 47, No. 8, April.

Josef Albers: *Present and/or Past,* Design Magazine, Vol. 47, No. 8, April.

Kandinsky: *Regard Sur le Passé,* Galerie René Drouin, Paris.

L. Moholy-Nagy: *The New Vision and Abstract of An Artist,* Wittenborn and Company, New York.

Georg Schmidt: *Klee, 10 Facsimile Reproductions,* Holbein Publishing Co., Basle.

1947 Alexander Dorner: *The Way beyond Art — The Work of Herbert Bayer,* Wittenborn & Schultz, Inc., New York.

L. Moholy-Nagy: *Vision in Motion,* Paul Theobald, Chicago.

Anni Albers: *Design, Anonymous and Timeless,* Magazine of Art, Vol. 40, No. 2, Feb.

1948 Anni Albers: *Fabrics,* Arts & Architecture, Vol. 63, No. 3.

Hugo Debrunner, *Wir entdecken Kandinsky,* Origo-Verlag, Zurich.

1949 Max Bill: *Wassily Kandinsky, Portofolio of 10 Facsimile Reproductions,* Holbein-Verlag, Basle.

Georg Schmidt: *Oskar Schlemmer, Portfolio of 12 Facsimile Reproductions and 8 Drawings,* Verlag Benteli, Bern-Bümpliz.

1950 Daniel-Henry Kahnweiler: *Klee,* Braun & Cie., Paris — E. S. Herrmann, New York.

Sibyl Moholy-Nagy: *Moholy-Nagy, a Biography,* Harper and Brothers, New York.

Ludwig Grote: *Die Maler am Bauhaus,* Prestel Verlag, München. Illustrated catalog of paintings at the Bauhaus until 1933.

1951 Giulio Carlo Argan: *Walter Gropius e la Bauhaus,* Giulio Einaudi, Rome.

Herbert Bayer: *Toward the Book of the Future,* Books for Our Time, edited by Marshall Lee, Oxford University Press, New York.

1954 Sigfried Giedion: *Space Time & Architecture,* Harvard University Press.

1958 Samuel Cauman: *The Living Museum, Experiences of the Art Historian and Museums Director Alexander Dorner.* New York University Press.
Wend Fischer: *Die Kunst des 20. Jahrhunderts,* 3 vols. Bau, Raum, Geraet. Piper Press, Munich.

INDEX OF ILLUSTRATIONS BY ARTISTS' NAMES

224